Sir William Russell Flint

R.A., P.P.R.W.S
1880–1969

Ralph Lewis
Keith S. Gardner

David & Charles

Acknowledgements

The first debt of thanks for this extended edition must, of course, be due to the author of the first edition, the late Ralph Lewis. A popular and well-respected Brighton art dealer, he single-handedly saw his great ambition through to fruition.

Now, as then, the enthusiastic co-operation of the Russell Flint family has been invaluable, not only in the freeing of copyright material but also in the provision of family photographs and other ephemera.

In order to present such a wide range of colour illustrations we have enjoyed the assistance of many private individuals as well as institutions. Thanks are thus due to Alan and Libby Gardiner, the late Peter Kisch, Everard Read, Ralph Rinaldi and Joyce Williams, to the auction houses of Bonham's, Christie's, Phillip's and Sotheby's, to dealers Richard Green and Andrew Mount, and to the Royal Academy, the Royal Society of Painters in Water-colours, the Rochdale Gallery, the Birmingham Art Gallery, the Walker Art Gallery, the Harris Art Gallery, the Royal Airforce Museum at Hendon and the *Illustrated London News*.

Much information and illustrative material is held in the archives of Sir William Russell Flint Galleries—to my colleagues there for covering for me while I indulged myself in the luxury of author-ship—many thanks. Finally, my thanks to Nissa Elsey who translated my scrawls into readable type, to John Youé who put it together and to all the team at David & Charles.

K.S.G.

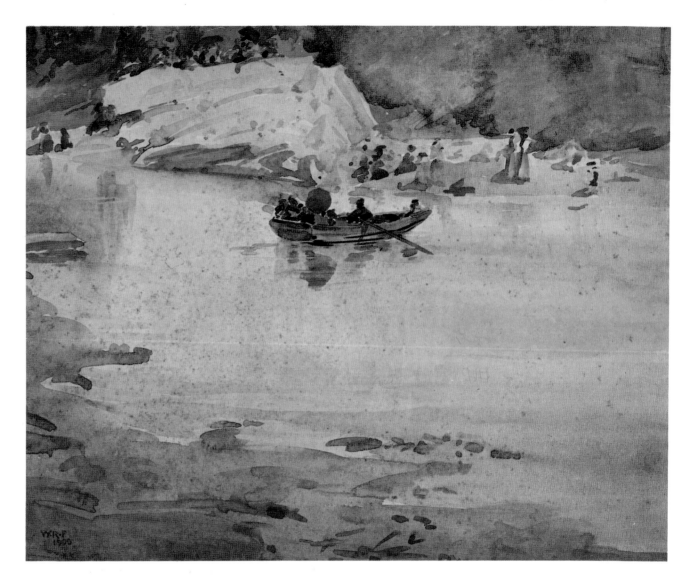

The Ferry Pitlochry, 1900
Water-colour 9″ x 11¼″

A DAVID & CHARLES BOOK
Copyright © David & Charles Limited 1988, 2004

David & Charles is an F+W Publications Inc. company
4700 East Galbraith Road
Cincinnati, OH 45236

First published in the UK in 1988
Reprinted 1989, 1991, 1993, 1995, 1997
First paperback edition 2004
Reprinted 2006

Illustrations Copyright © Susan Russell Flint 1988, 2004
Text Copyright © Keith S. Gardner 1988, 2004
Ralph Lewis' text Copyright © 1980, published by Charles Skilton Ltd.

on 4 April 1980, the centenary of the birth of William Russell Flint.

Ralph Lewis and Keith S. Gardner have asserted their right to be identified as authors of this work in accordance with the Copyright, Designs and Patents Act, 1988.

A catalogue record for this book is available from the British Library.

ISBN-13: 978-0-7153-1843-0
ISBN-10: 0-7153-1843-8

Printed in China by Hong Kong Graphics & Printing Ltd
for David & Charles
Brunel House Newton Abbot Devon

Visit our website at www.davidandcharles.co.uk

David & Charles books are available from all good bookshops; alternatively you can contact our Orderline on 0870 9908222 or write to us at FREEPOST EX2 110, D&C Direct, Newton Abbot, TQ12 4ZZ (no stamp required UK only); US customers call 800-289-0963 and Canadian customers call 800-840-5220.

Contents

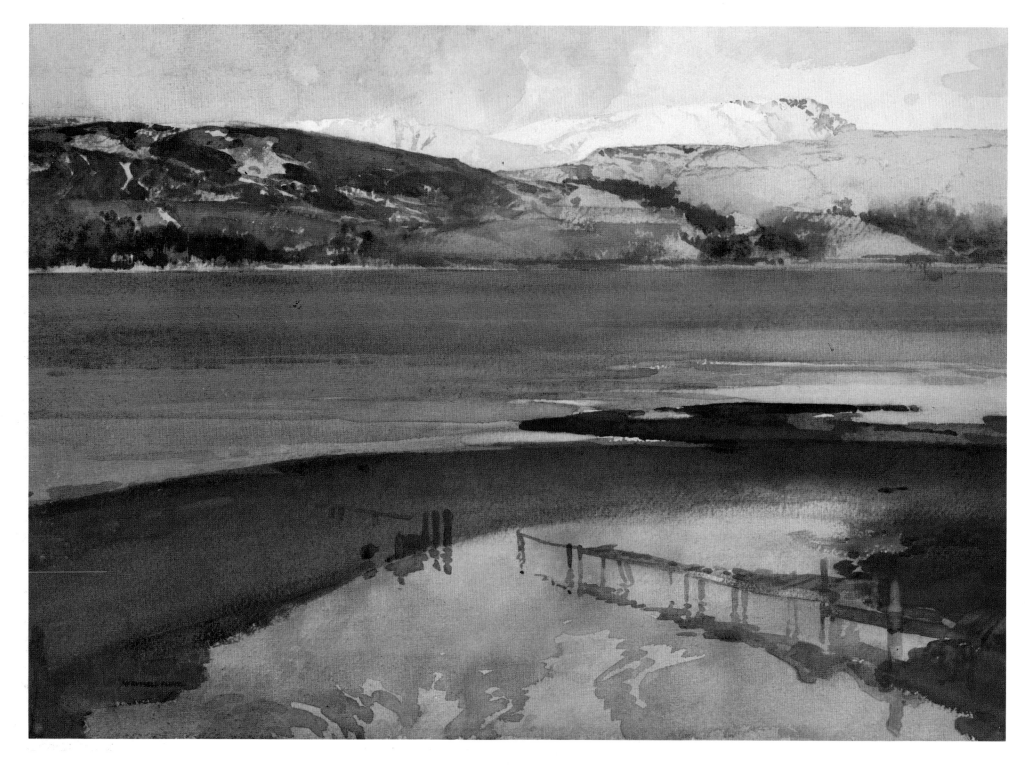

The Gareloch from Shandon, 1918
Water-colour $15\frac{1}{4}''$ x $21\frac{1}{2}''$
[*Courtesy Alan Gardiner*]

Preface

SIR WILLIAM RUSSELL FLINT, when nearly at the end of his long life, wrote his autobiography, *In Pursuit*, which was published posthumously on the occasion of what would have been his 90th birthday, in April 1970. One thousand and fifty copies were privately printed by the Medici Society and one thousand of these were for sale. The sumptuous limited edition, to which the average reader does not have access, contains 120 plates and drawings and is a factual account by Sir William of his life and achievements.

A large portion of the present book is based on his own words and thoughts. In putting forward his views and visions I hope that the atmosphere and events of the decades through which he lived and worked are evoked for the reader. He was a humble man, with a rare gift which he used for the pleasure of other people. This book is a personal one, a reflection of his art, his simplicity, his kindness and his respect for human nature, as well as all things natural.

The book is dedicated to his family and to those he honoured with his friendship.

It is exceedingly distressing that Francis Russell Flint, V-P.R.W.S., Sir William's only son, died accidentally in Spain as this book was in course of production. His assistance in the preparation of it and in the provision of illustration material was inestimable.

I have also to acknowledge with thanks assistance from various other sources in respect of illustrations, separately detailed.

The Introduction by Adrian Bury, R.W.S., a close friend of Sir William Russell Flint, is a valuable addition to the book, contributed as it is by a distinguished author well-known as a writer on water-colour and himself an artist in the medium.

RALPH LEWIS

Preface to the 1988 Edition

THE FIRST EDITION of Ralph Lewis's biography, launched by Charles Skilton to celebrate the centenary of Russell Flint's birth, was an immediate success. Unfortunately, two years later Ralph Lewis was dead. In the brief few years since that time, Sir William Russell Flint has become more popular than ever. His original paintings continue to command even higher prices in the auction rooms, and limited edition prints, whether signed or unsigned, are becoming increasingly difficult to obtain. That there is an even greater need now for a biography about this popular artist is evident, and so with the benefit of the archives held by the Russell Flint estate, including the method analysis by Percy Bradshaw, this new edition of Ralph Lewis's work is offered with a greatly extended illustrated section. This, it is hoped, will enable admirer and critic alike to appreciate to the full the skills, the feelings, and the wide range of techniques and subject matter employed by this truly remarkable artist.

KEITH S. GARDNER

Introduction

ADRIAN BURY, R.W.S.

IN THE INFINITE VARIETY of temperament, vision, technique, achievement, despair and triumph recorded in the long history of art, Sir William Russell Flint takes a unique place. At its best his work is perfect and above criticism. He was the greatest master technically of the elusive water-colour method of art—considering the quantity of his work, its versatility of subject, enchanting colour, sense of beauty and graceful idealism. Sir William drew and painted everything that interested him, and nearly everything did: landscape, mountains, skies, buildings, marine subjects, interiors, still-life and the human figure. Yet I have noticed a critical tendency to praise his dexterity with the brush and wash to the detriment of his creative and imaginative power.

Knowing Sir William's work as a whole and having watched him paint either out-of-doors or in his studio at Peel Cottage, Campden Hill, I can testify that the artist's technical infallibility was ever allied to a life-long meditation on the mystery of nature. He was a lover of beauty with an almost pious devotion and understanding. If, as some persons aver, Sir William was just a clever mannerist, the answer is that all artists, good or bad, are mannerists, manner being part of their personalities and identifiable as such. The point is, what kind of manner? In Sir William's case it was aristocratic which, according to the Greek meaning of the word, is 'best power'.

The artist combined thought, feeling and knowledge of the subject with confidence and love, and he communicated that love to the spectator in unmistakable terms. Such is the reason for his universal success with artists, connoisseurs and the public in general.

I have not the space, nor is it necessary, for me to enter into a long and detailed description of the artist's methods, to compare them with those of other equally famous practitioners, to try to place Sir William Russell Flint in relation to his great forerunners and celebrated contemporaries. Analysis of technique, however ingenious, has literary and scientific significance which can be interesting but not necessarily vital to the visual appreciation of art.

Nor need I concentrate on Sir William's career. During the last year or two of his life he spent much time compiling an Autobiography, *In Pursuit*, which was produced by the Medici Press in 1970 immediately after the artist's death, Sir William

having lived just long enough to finish the book. It was superbly planned and designed and replete with illustrations chosen by the artist himself, and must ever be the foundation of all biographical works on Sir William Russell Flint.

Mr Ralph Lewis has adroitly collated the facts of Sir William's life and career and collected numerous illustrations, including many from family sources. The result is the present attractive publication.

I have been asked to write this Introduction because during the last twenty-five years of his life I was often in touch with Sir William Russell Flint and was greatly honoured by his friendship. I had known and admired his work long before I met him at the gallery of the Royal Society of Painters in Water-Colours; and as a writer on art had praised it in various journals. My first meeting with the artist is remembered for the courtesy with which he received me and the interest he expressed in my own efforts as a poet and painter. He was grateful for what I had written about him and the R.W.S. Gratitude was very characteristic of him. He hoped that I would visit his studio at some time mutually convenient. This came about in due course and our meetings increased in number as our friendship developed.

I have known quite a few art geniuses so-called, some of them true to the popular idea that a genius is a gifted but irresponsible, not to say reprehensible, person unable to adapt himself to normal standards of civilisation. He or she suffers from a *malaise* called the artistic temperament.

Not so Sir William Russell Flint. There was nothing Bohemian about him. He always dressed in a tidy, conventional way, wearing none of the sartorial insignia often associated with artists. He had a gentle conversational style, with a slight Scottish accent, a spontaneous, whimsical sense of humour, discussed things with a careful choice of words, and was a good listener.

One was always at ease in his company for he never made one conscious of his celebrity. Rather the reverse. The artist would gladly show you some of his works if you were minded to see them, pleased but somewhat diffident if you praised them. I never found him completely satisfied with any of his pictures. There was often something that he wanted to improve upon. One of his many endearing characteristics was that he always seemed to be rather surprised at his splendid success, remarking that he had been very fortunate in winning such appreciation for the work that he loved doing.

As to Sir William's way of life it was well ordered and systematic whether at home or abroad. When in London the artist was in the habit of working in

the mornings from the model. Such regular concentration right up to the end of his life is the reason why he was one of the subtlest and most appealing of figure draughtsmen. I am justly surprised that he has not received special international commendation for his achievement in this respect. I believe him to be unsurpassed by any other artist in the British School and equal to if not better than various French eighteenth-century figure draughtsmen of great renown. Sir William's water-colours of the human form have a kind of magical intuition of youth and beauty. The explanation, if such be possible, is that constant practice throughout a lifetime resulted in a faultless style. The refined vision was the artist's birthright. Sir William's discipline to and respect for his genius was a notable fact.

Working abroad, painting landscapes, the artist did not change his disciplinary rhythm. A light breakfast, the assembling of his art materials and a quick walk from the village hotel to some nearby rural scene. Having decided on a subject he fixed his tripod easel, which could be moved to lay the drawing-board at any angle. He used heavy water-colour paper that did not need stretching and would literally 'stand up to the subject', and briefly indicate with chalk the salient figures of the composition, the while studying its general design, colour and atmospheric and tonal effect. He would then proceed to paint with direct and explicit touches. To watch him was like watching an expert letter-writer. He knew what to say and how to say it.

If things went well, and they frequently did, the half-imperial size picture was all but completed in about three hours. With complicated subjects, needing foreground figures, the artist might leave a space of white paper on which to compose and insert the figures at his convenience in the studio. Although he enjoyed finishing the work on the spot he did revise some of his landscapes until the effect approximated to his fastidious intention, but never seemed to lose the brilliance of the *premier coup*. Knowledge and continual practice again.

After painting out-of-doors in the morning, Sir William would hasten back to the hotel, partake of a modest lunch—and then a siesta. Should the weather hold fine he would go out again in the afternoon, find another subject and work on it for two hours or more. Then back to the hotel for dinner and relaxation. Maybe he would take a walk round the village, noting subjects for interpretation if the opportunity should occur. The artist retired to bed reasonably early, thus to be ready for what I called our morning quick march to begin work on time.

As far as I can recollect, Sir William was about seventy when I first accompanied him to France; but he had of course been making these Continental excursions ever since he was a young man and the number of water-colours of French, Italian and Spanish subjects that he left to posterity must be very large. He also loved painting in his native Scotland and worked occasionally in Wales and the English countryside.

The weather played a significant part in the happiness and productivity of these travels. The artist knew France and its meteorological vagaries intimately, and I recall an incident that proves Sir William's resolute character. We had arranged to go to Monteuil and stay at the Hôtel de France. Sir William generally took his car with him and as we drove from Calais towards Montreuil the rain began to fall and the light became a dismal, unrelieved grey pall of sky. We could only hope that the morrow would bring back the sunshine and warmth. On the contrary, we were faced with the prospect of another miserably rainy day with no possibility of working out-of-doors.

Sir William looked at the sky. His generally optimistic expression set in a hard frown. 'I don't like the look of the weather,' he said. 'I *know* this climate in northern France. We could suffer weeks of it. Let's go south in search of the sun.' So we set off in the artist's faithful if somewhat elderly Vauxhall and spent the day motoring until we arrived at a charming little place on the Loire well known to Sir William, where we were hospitably welcomed by *Madame La Patronne*, delighted to see Sir William again and only too happy to minister to our comfort. After that tremendous effort at the wheel of the car we had caught up with the sun and we spent three happy weeks under ideal painting conditions. I mention this occasion merely to prove that the artist could be as technically efficient in disposing of weather obstacles as he could be determined to solve any and every problem relating to his art.

Socially, I and a few other close friends always found Sir William amiable and considerate. Like most of us he had his troubles and difficulties but kept them to himself. He was ever kindly and generous, particularly to young artists who wanted his advice and encouragement. He was remarkably patient with strangers from abroad who just wanted to meet him.

A young American water-colourist who had a profound admiration for Sir William's work asked if it would be possible for me to arrange a meeting. The American had been in Italy and was just returning to the States via London. I was not very

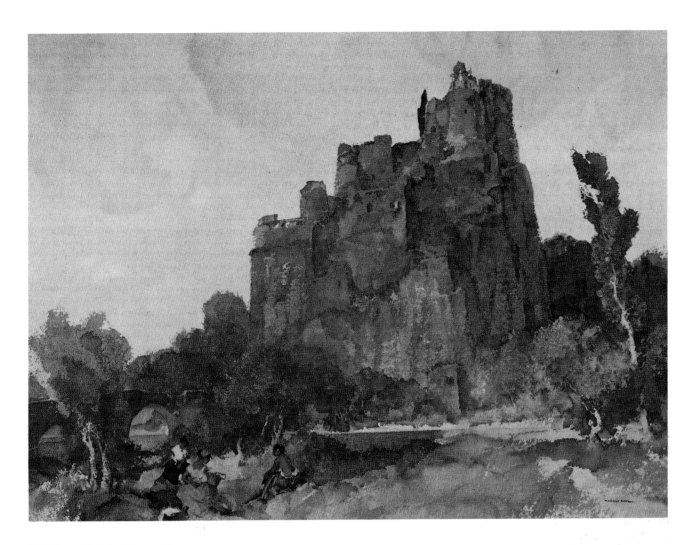

Picnic at la Roche, 1966
Water-colour 19″ x 26½″

hopeful, for I knew that Sir William was especially busy that week and going abroad himself at the end of it. However, I telephoned and explained the matter, adding that the young American artist was an unusually good water-colourist. Sir William paused for a few moments before answering me and then said, 'I have very little time to spare but can see your friend precisely at 11 a.m. tomorrow. He can have an hour of my time and then must go as I have an important engagement at noon. Bring him along.' I warned the young artist of the circumstances attaching to his visit and took him to Peel Cottage, Campden Hill, Sir William's home and studio. We spent an inspiring hour with the artist and then faded out. This occurred nearly twenty years ago and my American friend, now verging on middle age, and famous, still speaks of this event as one of the happiest and most memorable of his life.

Sir William, however, was never gregarious. Like

many fine artists who by their genius have brought much happiness into the world, he was not averse to solitude. In fact art was his life and he had little time to spend in ordinary social activities.

The marvel is that he could do so much painting and still find time to attend to the essentials of his official life as a member and Trustee of the Royal Academy, President of the Royal Society of Painters in Water-Colours and President of the Old Water-Colour Society's Club; and attending private views, council meetings, etc. I also wondered how Sir William coped with so much correspondence, answering letters in his own beautiful and very legible handwriting. I doubt if he at any time employed a secretary regularly.

Sir William was a charming and eloquent conversationalist, particularly on subjects dear to his heart: the joy, not unmixed with anxiety, of creating or trying to create the masterpiece, or descriptions of

places that he loved for their beauty, antiquity and character. He did not care for television and much preferred looking at some book on a great artist, reading poetry or listening to music, of which more anon. He was very amusing about the fatuous remarks that persons made as to the tricks he employed in water-colour painting. He discussed the silly rumours on page 136 of the catalogue of his Exhibition at the Royal Academy Diploma Gallery 1962:

This Exhibition's catalogue gives me a chance to declare flatly and forcibly that all tales of unusual devices are utter nonsense.

Respect for the medium which has dominated my life makes me recoil from unworthy expedients. Technique is to a painter what grammar is to a writer. In simple fact I use no methods which have not been explained *ad nauseam* in scores of introduction manuals and articles, and I am unaware of having introduced anything actually new in technique. The explanation of whatever is puzzling—and I know it is puzzling even to experienced and skilful colleagues is *control* as nearly absolute as possible over an elusive medium, a control acquired by constant practice and enthusiasm for something like three-quarters of a century. Since childhood I have painted in water-colour.

I never heard Sir William Russell Flint criticise unkindly the work of other artists, but he was not slow to praise it when it deserved praise. Any sort of mastery expressed in water-colour excited his admiration. 'Very good, very good,' he would say with a quiet sincerity.

Sir William avoided art politics, regarding them as a waste of time. He disliked any kind of sensational publicity, and I doubt if he was ever involved in controversial crises as some of his brother Royal Academicians were. He had strong feelings about the destructive elements in modernist art but neither the time nor the inclination to argue about it.

When I first knew him Sir William was sixty-five. He had by then done enough excellent work in many media to eternise his name, and he still looked a young fifty. The truth is that he was ageless.

I have mentioned his Royal Academy Diploma Exhibition. The gathering together of 344 exhibits and the compiling of the catalogue, which included not only the numbers and titles of the pictures but also graceful or learned paragraphs in relation to them and some of his friends, occupied the artist for a long time. Sir William was delighted with this important episode in his life, and regarded the Exhibition as a great honour. He was devoted to the Royal Academy. His exhibits there throughout his long life helped to publicise his gifts, bring him and the R.A. mutual acclaim. The question that may have haunted him was whether he would live long enough to witness this consummation of his career. He certainly did, and in fine form as the saying goes, although he was eighty-two when the Exhibition opened in 1962: and he had seven more years to go, *and to work.*

Genius has been described as an infinite capacity for taking pains. I would modify this generalisation and suggest an infinite capacity of phenomenal energy to create something worth creating. I doubt if Sir William Russell Flint worked harder in his life than during the last twenty years of it, and it may be that the Diploma Gallery Exhibition restored his youth and further inspired his love of art and literature. He had always been an accomplished writer with a lyrical style complementary to his water-colour manner, and has a number of books to his credit which are listed at the end of this volume. He was also a profound student of poetry. We spent many hours at Peel Cottage, after dining at a favourite nearby restaurant, reading in turn various classics such as the Sonnets of Shakespeare and verses by other Elizabethans, coming forward to the best 18th-, 19th- and 20th-century poetry. For a change we would share a musical evening, and with the aid of a record-player Beethoven and other great musicians were 'of the company'. Those evenings had a kind of dream-like quality of peace and contentment and proved that whatever Sir William did, from painting a water-colour to entertaining a friend, was done with whole-hearted and generous interest—part of the disciplinary rhythm that I have already mentioned.

I have always regarded Sir William Russell Flint as a great artist and a *great man* (the two are not always synonymous), in the sense that he planned his life so as to make the most of his many talents, to add more beauty to the world, and give happiness to his dependents, friends and humanity at large. I feel sure that Willie Flint from his childhood was conscious of a singular destiny and determined to fulfil that destiny.

You will read in the biographical section of this book how he endured, from the age of fourteen to twenty, apprenticeship to a commercial lithographic factory with hard-faced employers and uncongenial colleagues. The young artist did his work, such as it was, conscientiously but with a brave philosophical detachment. To him such an experience was just an episode and would pass. He had given his word and served his time. A difficult discipline. Nothing, however, could prevent him from becoming the artist he resolved to be.

Escaping to London, he found his second 'job' hardly an improvement on that lithographic apprenticeship, save that he could leave it when he chose. I have often imagined this lonely lad in London supporting himself by producing detailed medical drawings illustrating the horrifying effects of leprosy and other diseases. Eighteen months of this morbid ordeal and he resigned to become an illustrator of books and magazine stories.

Good fortune, however, was on the way. Willie Flint began to realise his ideal when, after showing some of his drawings to Bruce Ingram, Editor of the famous *Illustrated London News*, he was taken on to the staff of that journal. He did that strenuous work for four years until 1907, and then said farewell to the *I.L.N.*

The time was propitious for the publication of limited editions of the classics, and young Flint was commissioned to illustrate Malory's *Morte D'Arthur*, Chaucer's *Canterbury Tales*, *Theocritus*, the *Odyssey* and other immortal literature. Such work brought the artist close to his ideal of making a living out of water-colours. These illustrations were, in fact, the harbinger of the great career to come. He was at liberty to use his lofty imagination and develop his figure technique.

But 'the war to end all wars' was in the offing. It is a strange coincidence that William Russell Flint was made an Associate of the Royal Society of Painters in Water-Colours in the fatal year of 1914, and was to become involved in that war as Lieutenant R.N.V.R., attached to the Royal Naval Air Service, and later Captain R.A.F., and Admiralty Assistant Overseer, Airships, 1918-19. The artist rejoiced that he was made a full R.W.S., in 1917. In 1924 he became an A.R.A., and full member in 1933. He was President of the R.W.S., 1936-56, and was knighted in 1947.

Discipline had won throughout and would continue to win until Sir William Russell Flint's death in 1969. His career was a remarkable sequence of logical events. From a humble and difficult beginning he attained the very summit of art. Destiny never had a more deserving candidate for fame.

THE ARTIST
Ralph Lewis

I

WILLIAM RUSSELL FLINT was born in Edinburgh on 4 April 1880. The family lived in Lutton Place and subsequently moved to Rosefield Place, Portobello, when Russell Flint was seven years old. His mother, Jane Flint, was one of Scotland's first woman civil servants. His father, Francis Wighton Flint, was a ticket writer and also a skilful illuminator. He possessed the medieval miniaturist's skill in devising fanciful borders and decorations. He was merry, observant and hardworking. His son enjoyed watching him work and was shocked when his father died at the age of 52.

Russell Flint had a brother, Robert Purves (Bertie), and a sister, Charlotte Elizabeth (Lottie), who studied playing in Vienna under Theodor Leschetizky. Willie had painted and drawn persistently since he was five years old. At first he was economically monochromatic—usually the one colour he used was vandyke brown. He then progressed to the next stage of two colours—Prussian blue and vandyke brown. His nose was put out of joint when his friend, Andrew Ferguson, put to good effect a combination of Hooker's green and burnt sienna. When he compared his work with other friends in those days he found a curious tendency to bring objects closer than intended. This tendency can be detected in several of his paintings; his distant views became near views.

There were no family discussions on the artistic career that was his destiny. His first experience of school was at Miss Clinkscales' seminary at Portobello. When he advanced to Daniel Stewart's College for Boys in Edinburgh he drew maps of Scotland, with all the firths, bays, sounds, peninsulas and islands, so accurately that he was accused of tracing them. His boyhood hobbies included making and sailing model yachts. He was proud of his tool-set and was able to hollow out and carve models which were perfect examples of symmetry and careful detail.

He served his apprenticeship as a lithographic artist and designer in a printing works in Edinburgh between the years 1894 and 1900. He said of this period of his life: 'What I missed during those sensitive years is incalculable but in compensation I acquired the habit of discipline and the skill which have served me well.'

On 12 August 1900, he left his native Edinburgh for London. He was then twenty years of age. In order to study in London, he took a post as a medical illustrator until 1902, recording leprosy, bullet wounds from the Boer War and diseases of the eye. He changed to commercial designing and magazine illustrating at that time, and from 1903 until 1907 was on the staff of *The Illustrated London News*. But from his earliest boyhood, emulating his father, he painted in water-colours.

In those early years of his life, Russell Flint pursued his ambition to become a figure draughtsman. This started when he caught sight of a young housemaid on her knees scrubbing the front steps of a neighbour's house in Portobello as he was on his way to school. Her graceful movements, he said later, instilled an ambition. In London, he was industrious and admitted that he must have believed at the time that the work was the be-all and end-all of life. Previously he had spent his Saturday afternoons cycling into the countryside. Now he explored the British Museum in his free time, making careful drawings of anything which attracted him. Eventually he spurned regular employment and made the most of his freedom. He was offered some jobs—not many—but just enough to enable him to survive. He attended Heatherley's

A commercial illustration by W.R.F., Edinburgh, 1900

Art School for three days and evenings a week. There he practised 'black-and-white', for his ambition was to become an illustrator of magazine stories. On other days he did commercial work. Occasionally he was given black and white work—story illustrations for *The English Illustrated, Pearson's Magazine* and *The Idler*. He found, however, that he could not save a penny and, as a young Scot, this irked him. There was one particularly bad time when he had to seek financial help from home. That was a personal disgrace, he felt, and suffered remorse over the incident for the rest of his life.

In December 1903, impecunious and anxious, he finally plucked up enough courage to call at the offices of *The Illustrated London News* in Milford Lane, off the Strand. He climbed the rickety stairs with reluctance but was finally interviewed by the Editor, Bruce Ingram (later Sir Bruce Ingram). Ingram liked the specimen drawings which Russell Flint showed him. Russell Flint was commissioned to make two half-page illustrations, at the current rate of eight guineas a page, from the galley proofs of a story entitled 'The Gates of Brede', by Max Pemberton, for the Christmas week issue of the magazine. Although Russell Flint had been forced to do a great deal of figure work without models in the past, he engaged three models for his new commission—a fat man, a thin man and a homely looking girl. While he was working on the illustrations, he was also instructed to visit the Court Theatre in Sloane Square to prepare a drawing of Laurence Housman's Christmas play, *Snowdrop*. This was a relatively easy task, like the other illustrations, but his next commission in January, 1904, was more difficult. He was asked to prepare a full page of illustrations for *The Illustrated London News*, and a half page for *The Lady's Pictorial*, of the private theatricals of Chatsworth where, annually, the Duke and Duchess of Devonshire entertained King Edward and Queen Alexandra.

Russell Flint was given a kind reception, and found that A. J. Balfour and Campbell-Bannerman, the politicians, were fellow-guests. He saw King Edward for the first time when the monarch returned to the house, slouched and weary on his cob, accompanied by the Duke of Devonshire who was walking beside him on that wintry afternoon.

In his eyes they both appeared to be tired elderly gentlemen evoking sympathy rather than awe.

Later that evening, Russell Flint dressed up and waited in the narrow corridor leading into the theatre. When the King and Queen were seated an overture was played and the curtain went up on the amateur theatricals. Russell Flint was not an amateur, however, and realised that Bruce Ingram

had intended the occasion to be a test of his artistic capability. When he had recorded all the material that he considered could be used, he left quietly before the end of the performance. The incident was one of many: he spent much time recording topical subjects under difficult conditions. Payment for these was less than the payment for non-topical subjects which could be painted at leisure. Eight guineas per page was the rate for topical illustrators and ten guineas per page for non-topical ones. An illustrator needed considerable concentration to make sketches in a darkened auditorium throughout a play on the First Night. Afterwards, he would have to dash back to his studio, work all night and then take the finished picture to Milford Lane by ten o'clock in the morning.

Russell Flint, at this period of his life, was never late in delivering his drawings to his editors, but in time he found that it was a mistake to deliver a drawing even five minutes earlier than it was required. If he did deliver his work before the last minute then editors searched for faults and flaunted their limited artistic knowledge like all-knowing dictators.

At the age of twenty-four, Russell Flint fought to overcome his natural shyness when attending important events which he was commissioned to record. He made four drawings of groups of Carmelites for *The Illustrated London News* during March 1905. The magazine had been given the inside story of the hard life lived behind those enclosed walls by, Russell Flint surmised, some retreating novice or one released from her vows. Others of stronger faith, however, he was assured, contentedly endured their self-imposed prison.

Although Russell Flint was busy and happy at this time, his own life was enclosed by loneliness. No thought of marriage had entered his head. One of the elderly lady students at Heatherley's Art School suggested that he should overcome his shyness and invite a friend of hers, who would be an ideal model for him to paint, to tea in the small top floor studio he rented at 19 George Street, off Portman Square. When the girl accepted his invitation, to a self-conscious cherry-cake tea, he fell in love with her. She was Sibylle Sueter, daughter of Fleet-Paymaster J.T. Sueter, R.N. and sister of Admiral Sir Murray Sueter, C.B., R.N. On 12 August 1905, exactly five years to the day since Russell Flint had left Edinburgh, they were married. Sibylle said that he never proposed to her but, when he had made his decision, just announced: 'Then we'll get married.'

He was able to get married because Cassells, the publishers, paid handsomely for his illustrations for

Sir Rider Haggard's *King Solomon's Mines*. He later humorously noted that all weddings are of course boring, except one's own, and the bride is the only person of any interest to the onlookers.

The bride's friends, all conventional Church of England, scarcely hid their astonishment at the spacious dignity of the Presbyterian Church in George Street, off Portman Square, where the couple were married. It was also unbelievable that a girl belonging to a Service family could have thought of marrying an artist, at that time considered to be one of dubious prospects and with no hope of a pension. The honeymoon was brief: one week at Dieppe. There were thirty-two illustrations for *King Solomon's Mines* to be completed yet, and a new home to be set up. But it was a warm August that year, and the Russell Flints were in love.

Sibylle's brother Murray was working at the British Embassy in Berlin at the time of her engagement. He was a thoughtful person and when he learnt that his favourite sister had become engaged to an artist he decided to do something which he believed would be helpful for his future brother-in-law. Murray did not know a great deal about art and artists but he did know that pictures required frames. He therefore bought lengths, metres long,

Sibylle, Russell Flint's wife, 1904

of German picture frame mouldings and shipped them home, fortunately not addressed to the artist's small studio. Russell Flint always gave careful consideration to the mounts and frames used for his paintings, well aware of the delicacy of watercolours. When he saw the imported German frames, they were so obviously ugly that he did not realise they were intended as a gift. His comments on them ensured their use elsewhere.

Russell Flint considered that the Sueters were a romantic family. They had been connected with the sea since the reign of Elizabeth the First, either as sailors or shipbuilders, or both. Sibylle's mother, when widowed, brought up seven children on a naval pension of sixty pounds a year. The children were clever and handsome, with the exception of Maud, the eldest, who was fortunately gifted with a saintly nature and willing hands. Mary, another sister, was ruthless, witty and a magnet for men. Some considered her to be a paragon of virtue, because she fooled them all with the good deeds she performed, invariably at other people's expense. Fortunately, what Russell Flint had already seen and experienced during his work for *The Illustrated London News* helped him to cope with his new relations.

Portobello was never forgotten but it seemed far away from the life Russell Flint experienced in London. When he was married, he and his wife started their life together at a house in Eyot Gardens, St Peter's Square, Hammersmith, which his previous landlady, a French woman, Zoë Énard, emphasised would be 'very bad for business'. Edwardian London was filthy in wet weather but the pace of life was leisurely. Russell Flint was paid for his commissions in bright gold sovereigns, which had value and stability, like his marriage. Young men of wealth were perfectly dressed by perfect tailors, although they were not ruled by fashion so tyrannically as women were. King Edward popularised the homburg hat in green velour with a bow at the back. Manners were as impeccable as the clothes of the period, which Russell Flint sketched for his illustrations. Women were treated with courtesy in those days before 'equality', and fathers were treated with respect. Artists were invariably treated as 'Bohemians' and with a certain degree of suspicion of their private lives. There was horse-traffic and mud on the streets, with the occasional motor-car. Crossing-sweepers with brooms kept a clear passage here and there, earning a penny tip for touching their caps. If a 'toff' dared cross without offering a tip he might suffer being spattered with dirt. There were traffic jams. Horses reared as much as their harnesses would allow and drivers cursed. Among

them, hansom cabbies, the smart ones top-hatted and high on their hind seats, cracked their long whips in apparent fury but really in friendly rivalry. Big bearded policemen patiently disentangled the mêlée. In those days no policeman ever looked young.

William and Sibylle Russell Flint were part of that London scene in the early years of their marriage, which was remarkably harmonious. Russell Flint continued to paint and illustrate with greater freedom and assurance than before his marriage. His contentment consisted not in great wealth but in few wants.

'A water-colour can best be only a simplified interpretation of its subject', he maintained. 'In a picture, everything depends upon the manner of its subject's presentation.'

He, like his wife, was well aware that a loving heart was the beginning of all knowledge.

2

'From the moment books came to be illustrated, authors must have suffered many surprises', Russell Flint pointed out. 'To whatever extent writers may have visualised their literary characters it is extremely unlikely that artists represented them as their creators thought of them.'

Many authors, however, were well satisfied when Russell Flint depicted their heroes and heroines in a distinguished and much prettier way than they had imagined them. It was a form of flattery for fictional portrait sitters.

Before the First World War, Russell Flint was a busy illustrator. Max Pemberton, 'Q', Kipling, Conrad, Somerset Maugham and many others were authors whose works he illustrated. Rider Haggard was well satisfied with the drawings for *King Solomon's Mines*. The artist revelled in depicting the blood-thirsty old hag Gagool, the witch-doctor, and the beautiful, but doomed, Foulata. He was never reproved for inadequacy but he was once called to task by *The Church Times* in 1909.

In the early days of the Medici Society, Russell Flint was commissioned by its founder—Philip Lee Warner—to illustrate George Long's translation of *The Thoughts of the Emperor Marcus Aurelius Antoninus*. The commission he had been given after *King Solomon's Mines* was for *Song of Solomon*, which he enjoyed illustrating. By contrast, the Marcus Aurelius commission was a troublesome one. *The Church Times* condemned the illustration of Tiberius

reclining on a couch, attended by three female cup-bearers ready to satisfy his slightest whim. A dancer, twirling two hoops for his entertainment, had an anxious expression—probably for good reason—as she performed on the elaborate mosaic floor. The illustration was criticised for being too luxurious in character for a grave work. But Russell Flint was generous-hearted and accepted criticism of value even when, in later years, his work was assessed in a condescending manner.

'Yet by his own idiosyncratic means,' wrote Colin MacInnes in *The Sunday Times* of 24 January 1971, 'he almost unfailingly achieved his end, which was to portray, in his figure painting, a decorous, almost genteel, bohemian sensuality, and, in his landscapes, an idealised wonderland.'

His work, however, has a durable quality because he accurately portrayed subjects as he saw them as well as creating, in his presentation, an art of escape. He liked beauty, sentiment and melody. Any assessment depends on whether you prefer the world seen through the eyes of an artist striving for beauty or a world-weary view of a bleak landscape, with figures in it portrayed at their ugliest moments. Critics, in the past, have been described as legless men trying to teach running.

Publishers have usually been aware that good illustrations help to sell a book. Russell Flint believed that when an author provides a pictorial subject, sometimes an oasis in a desert of philosophical words, an artist is justified in seizing upon it and using it for illustration. The monthly illustrated story magazine, in the early part of the present century, was a staid affair compared to the glossy productions that are expected today. Photographers had yet to make their mark and editors, therefore, employed illustrators—either through direct and friendly contact or through an 'Artists' Agent'. Russell Flint never used an agent: he preferred direct contact with an editor.

'Of course the merits of black and white drawings varied greatly', he said. 'To depict story-tellers' characters vividly required a fair degree of imagination and insight. Draughtsmanship and technique were essential. The toil involved in producing even a half-page with a group of figures in movement was greater, far greater, than in many paintings hung in the Royal Academy.'

Fees were low for illustrators and few of them could put aside money for hard times. It was strange, however, that only a few of the many highly competent illustrators of the early part of the present century ever developed into picture or portrait painters as Russell Flint developed. He admitted being surprised by the fact that during

the twenty years he served on the Council of the Artists' General Benevolent Institution, which comprised architects, sculptors and painters, the members' understanding and appreciation of book and magazine illustration were virtually nil. The fact also distressed him. The Royal Academy had considered illustrators and painters in water-colours unworthy of membership for one hundred and seventy-five years although copyist engravers were more fortunate and were admitted to membership. The admission of draughtsmen and water-colour painters to the Academy was achieved by Russell Flint, much to his delight.

In 1908, he transferred his thoughts, brushes and pens to devotional fields after completing the illustrations for *The Song of Songs* and *King Solomon's Mines*. Philip Lee Warner, who was then a partner with Chatto and Windus, the publishers, suggested to Russell Flint the idea of an illustrated edition of Thomas à Kempis. The idea appealed to the illustrator and, after he had completed his work on the decorations, he realised that he had achieved in them a style of craftsmanship similar to his father's work. Philip Lee Warner liked the drawings for *The Song of Songs*, commissioned some more and used them for the first of his beautifully printed Riccardi Press volumes when he founded the Medici Society.

Printing always interested Russell Flint and he noticed that each professional copper-plate printer had his own recognisable mannerism. When an expert pulled a proof for him the result was not satisfactory on one occasion.

'I meekly made suggestions,' Russell Flint recalled, 'but I was told I would soon learn to work to suit his printing! After that I bought my own press.'

It was a dreadful old press and he had to put on such pressure that teeth of the cogwheels used to snap off. On it, however, he printed nearly all his own plates.

Two illustrations of Naples, which Russell Flint completed in 1907, were commissioned before he had visited that city. He used his wife as a model for one of the two people in the illustration of *In A Neapolitan Restaurant*. That illustration, and the *Via Caracciolo*, appeared in the *Pall Mall* magazine and were sufficiently accurate to prompt an American authoress, Marie Van Vorst, to write and compliment him with the words: 'You must love Naples as I do.'

Two and a half years after his marriage, he illustrated, in colour-collotype, limited editions of classical authors—Homer, Theocritus, Marcus Aurelius, Chaucer, Malory, Charles Kingsley and Matthew Arnold—all for the Medici Society and its founder, Philip Lee Warner. Late in 1912 he

went to Italy with his wife for a year. During 1912 and 1913, William and Sibylle Russell Flint rented a studio in Rome. They enjoyed many excursions—very economically—but on each trip they made to Tivoli the weather was bad. The big falls attracted him as subject matter but he did not complete a painting of the Cascatelle Grande until March 1961, when, in the company of Adrian Bury, the weather and light were suitable for a painting.

The rented Studio Del Ponte was in the grounds of the Villa Strohl-Fern, just beyond Rome's Porta del Popolo. The room was a simple box, which had been built on a bridge over a sunken road. The studio was isolated and had a solid iron door, but to the young couple it was rather romantic. The Emperor Domitian once had a villa there in the midst of the cliffs, caverns and a strange rock tunnel that sloped down to a cold, subterranean stream. The landlord was a shrewd, hard-headed Alsatian, a sculptor who resembled a horse and created cement trees adorned with tin leaves as his personal contribution to the art of those times. Russell Flint found a local model, Peppina, who came from Anticoli Corrado in the Sabine Hills. She was a reliable and cheerful girl, who dressed in peasant clothes and thick orange stockings. She was perfectly willing to pose in the nude when asked to do so, and appears in two of the colour plates of *Theocritus*, which Russell Flint made for the Riccardi Press edition. One day, she arrived at the studio wearing a large, flashy engagement ring and black fish-net stockings which were visible tokens of her engagement to a man whom she claimed was a wealthy Roman. Her boy-friend in Anticoli, however, was hot-headed and set out on his bicycle to seek vengeance on Peppina and her new lover. When the news of his intentions reached the studio, the Russell Flints had to bolt the iron door and remain under siege until the *carabinieri* caught up with her boy-friend and locked him up after he had fought with Peppina's brother, who was determined to defend her honour. Latins, in those days, were jealous of rivals but never doubted an artist's intentions.

There were many stocky peasant girls to provide Russell Flint with figure material, particularly in the Sabine Hills where they picked their way gracefully among the boulders, as they carried large bundles of wood upon their heads. They carried their burdens on their heads instead of in them. Russell Flint was also aware of the drama and people that could be discovered in religious settings. During 1912, he stopped with his wife in the Benedictine convent at the top of Subiaco. There he was able to study the nuns at close view, within

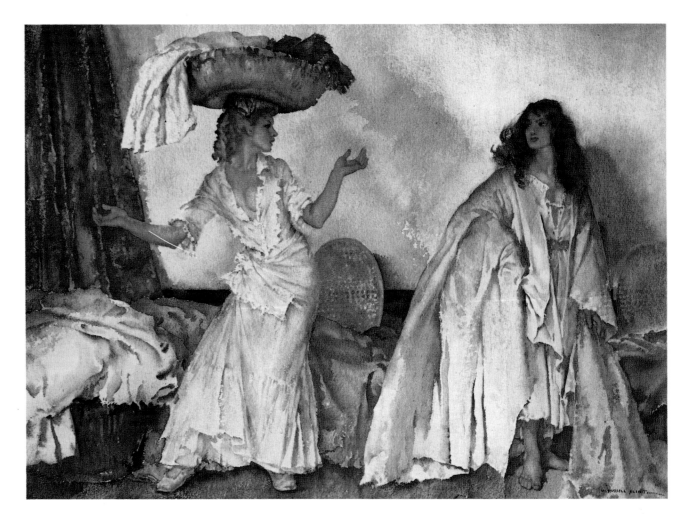

The Balance, 1964
Water-colour 15¼″ x 22¼″

their own echoing vaults and cloisters. The Russell Flints, discovering Italy for the first time, were earnest students and happily learnt the language in the tranquil atmosphere of the convent. Together, they had Italian lessons from a nun with a squeaky, high-pitched voice. 'Questo regolo è molto semplice', she shrilled at them repeatedly. She might have thought the couple slow learners, but she enjoyed instructing them and loved the interruption to her orderly existence.

'I believe that, towards the end, she came to dread the clang of the tyrannical bell which tore her away to austerer exercises', Russell Flint said.

At the monastery of Il Sagro Speco, perched high above the gorge of the Anio, he and his wife were surprised to see three British priests fall to their knees before the Abbot when he was walking in his small terraced rose garden. He wore a conspicuous ruby ring as a sign of his authority.

That moment seemed to Russell Flint to belong

W.R.F. with the original 'Balance'. The observant will note that by the time it was published he had removed one of the baskets!

to a past age when the authority of the Roman Catholic Church was supreme and never questioned. At that moment he felt he was standing in the grotto of Saint Benedict set below the high cliffs which emerged from the mists of the Anio. He imagined the roses about him to be the thorns transformed to flowers by St Francis, while beyond him rose the distant Sabine hills unchanged.

There were times in Italy, in later years, when Russell Flint became restless, and tired of painting the endless silver-grey landscapes that he saw in the wilds of Tuscany. He decided to escape to Florence and, while there, was invited to visit Sir Oswald Sitwell's home, Montegufoni, with Moira Shearer, whose Scottish beauty and radiance he greatly admired. His water-colour painting of the ballet dancer, writing her first letter when she became engaged, was painted at Montegufoni as a gift for her mother.

Russell Flint found inspiration in Rome, despite its sophistications, but preferred the humble and austere farms, the peasants and farmers of the Tuscan hills. He had a preference for those places that seemed to be beyond civilisation, where the harsh desert of stones and shrubs was enlivened by wine served on tin trays and coarse, home-baked bread. In those simple settings, he found serenity and dignity which he believed had come from some splendid ancestry. His paintings of those subjects endeavoured to express that belief.

By contrast, in the spring of 1913, the Russell Flints visited Paestum, at that time a distant and forlorn place. They were received by two courteous old men, who were guardians of the temples. The sky was overcast and heavy with the hint of thunder. The sombre magnificence of the temples in that light impressed Russell Flint, but before he was able to start painting a motor-car drew up and four German travellers emerged from it. They unpacked food and ate it with noisy comments. When they finished eating, they set up cardboard targets against the ancient Doric columns, produced pistols and began shooting at the targets. The antique stone was badly chipped but it was not possible to stop the vandalism. Russell Flint, sensitive to the destruction of beauty, recalled that experience of 'apostles of *Kultur*' as a distasteful interruption that could occur and ruin the moment when a place and conditions were ideal for painting.

In the tranquil atmosphere of Venice, the Russell Flints walked together through the narrow *sottoportico* leading to San Zaccaria, stopping to admire the fourteen big scallop-shells on the church's façade. The taverns, fruit-stalls and shops filled with glittering trash and tortured glass did not lure them

from their objective. At the Ponte Sorto, a group of gondoliers were quarrelling. They walked on past the Calle Bono de l'Arco into a narrow passageway which led towards what Russell Flint called 'the Courtyard of all the Muses'. It was a Venetian Valhalla, crammed with a varied collection of gods and goddesses in marble and stone. There were pavilions and dainty temples with cold curved benches, strangely reminiscent of those upon which classically-minded Victorian painters loved to paint London models reclining in Liberty silks. The seasons were there in sets of four, life-size and half life-size, showing pretty legs. Cupids were everywhere, plump infants turning somersaults, sitting on shells and waving sickles, astride dolphins and blowing trumpets. A stone goat was balancing on a globe. Bearded prophets or saints in wind-blown draperies worthy of Bernini struck attitudes indicative of ecstatic piety. Splendid lions in granite ignored well-trained dogs in stone, every one of which carried a basket of flowers in its mouth. A brawny Hercules stood high between a Psyche and a Persephone, and a grim Odin barred the way into the dark archway where men worked with hammers and saws among heaps of sawdust and shavings. Beyond, in a canal, a barge awaited goddesses crated and addressed to all the formal gardens of the earth. The artist and his wife saw both paradise lost and gained.

If one studies the paintings which Russell Flint made of *High Water on the Zattere* and *Ca' Mosta on the Grand Canal* one can see how he related the setting to the people, who were painted in afterwards. The gondoliers in the latter painting are arguing, watched by the woman on the balcony above them. *High Water* depicts the time of flooding, the figures in the painting are walking carefully to avoid getting their feet wet. Venice has always provided a rich feast of subjects for painters. But, at the height of the summer season, there is not sufficient opportunity for a painter to sit peacefully and concentrate on the view he has selected without interruption by onlookers. When painters work in public view, they are the same magnet for idlers as men digging a hole in the road. Even Russell Flint preferred complete seclusion with nothing to interrupt his energetic concentration. He gave sound advice on painting in Venice:

'At the year's end, Venice forgets her glittering infidelities. When she no longer teems with babbling multitudes, she reveals, to an artist or a poet, her gentler, more compassionate beauty, wistfully perhaps, but truthfully. Like wet pebbles by the sea-shore her marble palaces take on subtler shades. Then is the time to paint.'

3

Before 1914, Gala and First Nights at Covent Garden were memorable occasions. All the glitter and glory of a rich and carefree society were displayed in public. The occasions were not stiff and formal. The atmosphere was friendly and gay at the musical functions which the youthful Russell Flint attended. He was there to draw, not to listen, although, as he told people, his pencil often jogged to the lilt of the music.

During the last years of peace, from the time of King George the Fifth and Queen Mary's Coronation in June 1911, the Diaghilev Ballet visited London. The dancers from the east set a new standard for ballet and created legends that included Nijinsky's leap across the stage in *Le Spectre de la Rose*, and their Coronation Gala at Covent Garden in 1911. The programme also included the major stars of opera at that time: Melba, Tetrazzini, John McCormack and Destinn. Russell Flint's reputation for fine illustrating was already established and he enjoyed working in the theatre. His excellent likeness of Melba, who behaved like a fractious child, earned him an extra eight guineas. He admitted, modestly, that he was seldom good at portraits, but his portrait of Melba was exceptional and *The Illustrated London News* made the single-page illustration into a double-page one, much to his delight.

The skill of the Royal Ballet is taken for granted today but, in the years before the First World War, the artistic standards of ballet were not great. Pavlova was dropped by her partner Mordkin when they were dancing at the Palace Theatre and, forgetting the audience, she leapt up and smacked him across the face. Anna Pavlova, Tamara Karsavina and Adeline Genée, from whom the theatre at East Grinstead takes its name, were prima ballerinas at that time. The influencing colour of the time for decorators and designers was Bakst blue, introduced by the designer of the Diaghilev Ballet.

Russell Flint was sent to Covent Garden to make drawings of costumes for a new ballet. The designer, Herr Wilhelm, showed Russell Flint, and a female artistic rival from a fashion magazine, dainty pieces of cloth from which sketches were to be made for the costumes. The young woman made slick and ingenious sketches for the designs three times quicker than Russell Flint did. The humiliation that he felt rankled him. He believed, however, that emotion must always be allowed to take charge because it was the *raison d'être* of an artist's existence. He felt that emotion, or sentiment, had been the inspiration of man's loveliest creations. During his long and successful life, he looked on beauty many times and,

when he recorded it, he did so 'with love, faith and gratitude'. He also loved poetry all his life.

He was commissioned to depict the Kaiser and Kaiserin when it was announced that they would be visiting Waring and Gillow's new store in Oxford Street. His best overcoat was at the cleaners, but wearing his second-best, with a silk topper, he set out for the store. But the Kaiser had changed his mind and did not appear, while the Kaiserin arrived and departed before Russell Flint reached the store. Important events in Russell Flint's life often came about quite simply, but important commissions could be complicated by circumstances over which he had no control.

At Kiel Yachting week, only six weeks before the First World War started, two squadrons of the British Navy lay at their moorings with the German Fleet surrounding them. The Kaiser wore the uniform of a British Admiral of the Fleet when he visited the British flag-ship. When the war started, on 4 August 1914, Sir Edward Grey said: 'The lamps are going out all over Europe.' The words were an epitaph for a world that was to be subjected to violent changes, changes that would be reflected eventually in art and social life. The gold sovereigns disappeared and paper money, Bradburys, replaced them. There was the Royal Navy to rely on but Zeppelins, a new weapon of power, were introduced, even though they did not come until 1915. Britain entered the war with sixty-three aircraft in the Royal Flying Corps and, when the war ended in 1918, there were 3,300 aircraft in the Royal Air Force. Technology was forced ahead by wartime demands.

During the First World War, Russell Flint served as a Lieutenant in the R.N.V.R. and later as a Captain in the R.A.F. His brother-in-law, Murray Sueter, was Director of the Air Department at the Admiralty and intended that Russell Flint should be trained for work connected with the rigid airships then being designed, while other men were being called up under the Derby Scheme. Russell Flint tried hard to master the elementary mathematics that were required for his wartime work. His instructor told him, despairingly, that he had a completely non-mathematical brain. But he did master the general principles of aerostatics after many hours spent poring over the Naval Air Service Training Manual.

Mathematics, however, did not affect his first morning on duty. He reported to the White City and was promptly ordered to climb up the criss-cross supports to the roof girders of an enormous shed, and to drop from the highest point upon the smooth round surface of an inflated non-rigid airship below.

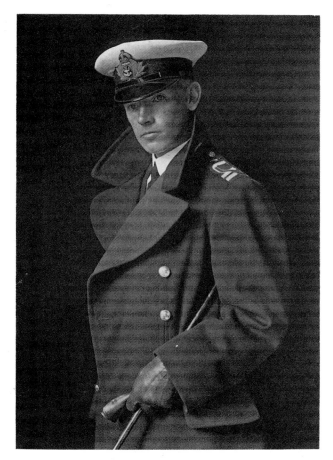

Russell Flint in naval uniform

'That gigantic sausage was the colour of unpolished pewter,' he said. He felt he would slip off and crash upon the concrete floor still further below. 'As in duty bound, I dropped and found the surface soft and yielding. I was resting in an air-cushioned valley of doped aluminium fabric.'

So Russell Flint spent much of the war years working on the development of rigid airships. Ironically, the politicians and Sea Lords, who knew the usefulness of the German airships for aerial observation over the North Sea, delayed and any decision on that aspect of warfare until it was too late to build sufficient rigid airships for wartime use. Many non-rigid, and a few rigid, airships did escort convoys eventually and not a single merchantman was attacked by a submarine while being escorted by them.

Russell Flint had a keen eye for spectacle when it occurred. On a bright and breezy day during the summer of 1916, he was enjoying a voyage down the Clyde. He had designed, with the warship's engineer officer, a V-class destroyer's crests and boat badges. He was on leave from his airship job and was a guest on the destroyer during her steaming and gunnery trials.

With his two gold R.N.V.R. stripes, prematurely grey hair and suntanned complexion, with second-hand tufts of cotton wool, given to him by a thoughtful rating, stuffed in his ears to protect them from the gun blast, he walked the decks feeling splendidly self-sufficient.

Below, makeshift luncheons were being served in relays to a crowd of naval and dockyard personalities. The waiters were harassed by the large number of people they were expected to serve and reacted by being rude and ill-tempered. They did not enjoy the destroyer's plunges and twists. Russell Flint managed to scrounge a quick meal, and then climbed to the bridge in time to watch rapid fire from the forward 4-inch gun.

The sight was poetry of movement for him: the rhythm with which the gun's crew worked against the deep blue background of the sea, white foam overside and green water streaming past the narrow gun platform before breaking on deck. The group of trained men swiftly loading and firing produced a perfect harmony, pleasing to the artist's eye because of the combination of movement, colour and viewpoint.

It was a sight he remembered fondly all his life. He wondered how the slim vanity crests he had designed would survive their baptism by water on the port bow and rear starboard of the vessel. They were slight and had not been tested before.

When he was granted leave during his wartime duty on the Clyde, he went to Shandon on the Gareloch to paint. Sketching on the tangled shore opposite the naval 'measured mile' was forbidden because of the secret trials of new submarines. Russell Flint was aware of the risk he was taking of being arrested. Warships were also built at Dalmuir just up the river, but the artist was never arrested despite his conspicuous display of sheets of cardboard in full view of any observers. But one wet summer evening, when he was working on a small water-colour, he noticed that he was being watched as he sat on his stool under an old black umbrella. He remained crouched over the easel upon which his water-colour was clipped until the observer, a policeman, approached on his bicycle. The man dismounted and watched him before taking off his peaked cap and walking up to where the painter sat.

The artist was not surprised when the policeman, in rich Scottish tones, proceeded to question him.

Russell Flint graciously shook his head when gravely asked if he was not contravening the Defence of the Realm Act. He grandly announced that not only had he the permission of the Chief Constable, but also that of the Lords of the Admiralty!

The policeman replied that he was greatly relieved and went on his way.

Russell Flint had a wry sense of humour and secretly hoped that the authorities would find him an object of suspicion when he sketched and painted during the war.

When he came out of uniform in 1919, he found a demand for his water-colours. He ceased to be an illustrator and became a painter.

4

The first Labour Government, with Ramsay MacDonald as Prime Minister, took office in 1924. The women whom Russell Flint loved to paint at that time were becoming emancipated. Short skirts and short hair were fashionable and so was the 'schoolboy shape'. There was an open, self-indulgence in drinking, smoking and cosmetics which was paraded at cocktail parties and in the night-clubs where jazz was played. The brittle wildness was an expression of the changes in social manners and morals that had occurred since the end of the First World War. The changes were also reflected in painting, psychology and philosophy. It was as though the years of strain, deprivation and hardship had brought people's repressions to the surface and then made them abandon self-restraint. Technology, rather than science, affected people in the forms of the motor-car, the aeroplane, the cinema and the radio.

As mentioned, during the First World War, Russell Flint had painted at Shandon on the Gareloch when he had been granted leave. And it was there, during the Spring of 1924, that he painted once again. That time, however, no policeman approached him—but instead a friend came to tell him that he had heard on the wireless news of the painter's election as an Associate of the Royal Academy. It was the first time that the election of an A.R.A. had been announced on the radio.

A year earlier, Sir David Murray, who was a member of the Royal Academy, had told Russell Flint that if he could repeat that year's R.A. performance his works would never again suffer the ignominy of having white chalk Xs or Ds on their backs. Russell Flint understood the endeavours and principles of the Academy, and having become an A.R.A. in 1924, was made a full Academician in 1933. The R.A. is, and was then, one of the centres of English social life. Those who sneer at the function of the Academy, and prefer to ignore it, remain ignorant of one of the great aspects of established

In My Campden Hill Studio, 1934
Water-colour 13″ x 20″
[*Courtesy Harris Art Gallery, Preston*]

English customs. The Academy has been held in affectionate esteem by a large section of the public, and many of its works, by painters who have exhibited in the galleries regularly, have had durable qualities. Sir Alfred Munnings and Sir William Russell Flint were two Academicians whose paintings attracted collectors during their lifetimes and whose work was sought out, after their deaths, at high prices.

Painters of water-colours, in any century, have often been imitative and uninspired, dangers which are inherent in a long-established form of painting. But Russell Flint managed to express a personal vision in his work without deserting long-tried methods. He had a remarkable command of water-colour, and achieved deep and strong effects when he used browns and purples. His works at the

Academy were often large and impressive but he could display the same mastery of technique in his smaller water-colours. His drawings and sketches showed that his draughtsmanship and sense of perspective were accurate and distinctive. His illustrations of *The Odyssey*, for the Medici Society, had been completed in 1914 but were not published until 1924 after being held up in Germany throughout the First World War.

Russell Flint served under nine Presidents of the Royal Academy. The first was an architect, Sir Aston Webb, who was small, friendly and a live-wire. He designed the Victoria and Albert Museum in South Kensington and also the Admiralty Arch.

The second President was Sir Frank Dicksee, a dignified and handsome man who painted with great technical skill, although his paintings had a quality that was reminiscent of the Victorian's mood of simulated holiness. He was a kind man, who lacked authority and used his presidential mallet at a General Assembly to strengthen his quiet voice. The effect was similar to that of a man who attempts to reinforce his arguments by shouting. Russell

Flint's home, Peel Cottage off Campden Hill, Kensington, had once belonged to Dicksee for a short time. Peel Cottage was built in 1872 by a gardener named Henry Evans. Matthew Ridley Corbet, A.R.A., lived in it from 1877 to 1886 and it was occupied subsequently by Dicksee. The studio had been a makeshift affair which had served the occupiers adequately but, after the improvements made by Russell Flint, it became an ideally practical workroom that had a look of luxury.

The third President that Russell Flint served was Sir William Llewellyn, a man who believed in expressing the dignity of the Royal Academy. He was strict and formal, possessing the aloof bearing of a courtier, conscious of the Academy's link with the reigning monarch, King George V. When the President and the members of the Assembly attended a levée at St James's Palace they dressed in the court fashion of that time, a fashion that required gold-buckled shoes and swords with gold hilts. Even black arm-bands were expected to be worn by visitors when the Court was in official mourning. King George V and Queen Mary maintained nineteenth-century standards of etiquette and protocol during their reign. When the Royal Academy invited reporters and photographers from the press to record the internal activities for publicity purposes the resulting photographs of members of the Hanging Committee at work so incensed King George V that he expressed his displeasure with a fine display of temper and royal reproof for Llewellyn. One of the photographs which roused royal wrath was a photograph of Russell Flint in his shirt sleeves with a six-foot rule leaning on his shoulder. He was sipping a bowl of turtle soup while one of the uniformed staff, in flawless academic livery, stood by. The King considered that Academicians should not be shown as labourers, even though there were times when they had to labour in the Academy.

Sir Edwin Lutyens followed Sir William Llewellyn, and it would be hard to imagine a greater contrast between Presidents. Lutyens was an imaginative and respected architect, with a simple and unassuming manner which concealed a wicked sense of humour and a high degree of cunning in avoiding the more unpleasant duties of a P.R.A. Russell Flint admitted that he was hypnotised into doing work that Lutyens did not wish to do. During the Second World War, Russell Flint agreed to appeal for funds for the R.A.F. by visiting the bombed area of Lewisham. He turned a difficult duty to good purpose by suggesting that the Civil Defence workers and bombed inhabitants start their own art society to bring a fresh interest into their strained lives. The idea resulted in a successful society that catered for those people who needed a panacea for their wartime hardships.

Russell Flint was not impressed by Lutyens and found the senseless flow of witticisms exhausting for those who had to listen. Lutyens was attracted to people of wealth and title but had no time for the person who was reverent. The fact annoyed Russell Flint, who had a good moral sense and was certainly not lacking a sense of humour.

In 1941, three years before Lutyens died, he and a committee of the R.A. prepared a new plan for London, which had suffered considerable damage from bombing. The plan covered one entire wall of one of the Academy's private rooms and although the proposals for the post-war city combined skill and imagination they were never adopted. The grandiose plan for London might have restored to the city the coherent unity that it lacks today. Lutyens had been helped in his career by the gardener, Gertrude Jekyll, with whom he had designed Munstead Wood in 1896. His success was established by the excellence of the country houses he designed between 1899 and 1912. He expressed the spirit of the Edwardian years and was responsible for some of the finest English houses built between 1903 and 1910. In 1913 he designed Viceregal Lodge and other government buildings for New Delhi, as well as a spectacular plan for the city, which was largely carried out. His decline, from 1920 onwards, was due to the neo-Georgian style he adopted and the commercial buildings of his later years did not possess the originality of his early work. His plan for London, during the period that he was P.R.A. and Russell Flint was P.R.W.S., was a swan-song that never reached the right ears.

Sir Alfred Munnings was the first animal painter to become P.R.A. His moods were so variable that members of the committee, including Russell Flint, were never sure how he would react. He could be rude or genial according to his temper, but he was concerned with fine painting and with serving the interests of the R.A. to the best of his ability.

Russell Flint considered him an excellent painter and a thoroughly English character, quite genuine and uninhibited.

Sir Alfred Munnings lost an eye when he was young, but that did not embitter or prevent him from painting. He became a master of colour and of recording the subtleties of light and shade. His rough works, impressionist in style, were painted while he was waiting for finished works to dry and were just as pleasing as his more detailed paintings. He exhibited *Pytchley Hounds Feeding* at the R.A. in 1944 and was delighted by the praise it received.

His Fresian bull, an essay in greens, and paintings of the Belvoir hounds pleased both sportsmen and critics. When he spoke of the English countryside his conversations were refreshing and delightful. When he was happy he would recite a breezy ballad of his own creation, in a manner that was as strong and spirited as the horses he painted. He had style, like Russell Flint and other painters whose work had a durable quality.

Winston Churchill liked Munnings and admired his work. It was Adrian Bury who suggested to Munnings that the Royal Academy should make Churchill an Honorary Member. The proposal received Royal approval and Churchill became Royal Academician Extraordinary. He enjoyed emphasising the last word when referring to the honour he had been given.

When Sir Alfred Munnings was President, dinner parties were lively events at the Royal Academy. A dinner party was given during the Summer Exhibition of 1947 when Winston Churchill, then in his seventies, was present. He looked tired and ill. The problems of post-war Britain were similar to those which had been prevalent after the First World War. He was suffering from political fatigue and the tragic consequences of the major powers being unwilling to collaborate in building peace and aiding recovery. His interest in painting seemed to increase as international security deteriorated and this was reflected in his own words: 'Painting is a complete distraction. I know of nothing which, without the body, more entirely absorbs the mind.'

At the Royal Academy in 1947, Russell Flint saw at first hand the onset of the sickness that was to affect Britain's great statesman in the spring of 1953 when Churchill had a serious stroke. Russell Flint arranged to have the Academy's invalid chair ready outside the dining-room door on that summer evening in 1947. When dinner ended, Churchill eased himself into the invalid chair and allowed himself to be wheeled round the Summer Exhibition by Russell Flint, who was given orders to push Churchill nearer or further back from the paintings. Churchill's criticisms were forthright and shrewd. When the two men stopped in front of Russell Flint's oil painting, *End of an Operetta*, Churchill said: 'I like that.' It was a sincere compliment and it is probable that he recalled his earlier thoughts on the work of accomplished painters: 'Leave to the masters of art trained by a lifetime of devotion the wonderful process of picture-building and picture creation. The painter wanders and loiters from place to place, always on the look out for some brilliant butterfly of a picture which can be caught and set up and carried home safely.'

Russell Flint found himself facing Churchill across the Academy dinner table when Sir Gerald Kelly was P.R.A. and the Queen was the guest of honour. Churchill had just returned from a holiday in Jamaica where he had been painting in oils and was disgruntled because of the behaviour of an onlooker whom he claimed had spoilt one of his works.

'You will never realise the full rigour of painting until you try your hand at water-colour', Russell Flint remarked without caution.

Churchill looked up with a scowl: 'I don't intend to try!' he retorted. He was aware that painters like himself could not aspire to masterpieces.

Most of Russell Flint's meetings with Churchill had an element of comedy in them. Churchill's Naval A.D.C., during his first visit to the Normandy assault area after D-Day, had been Francis Russell Flint, the painter's only son, who had crossed the Channel on board the destroyer *Kelvin*. After the war, Russell Flint asked Churchill if he remembered his A.D.C.

'Yes,' replied Churchill with a smile, 'I remember him. He was in charge of my spare bottle of whisky and was sketching most of the time instead of looking after me.'

Churchill enjoyed being in the company of painters, and painting for him was a travelling-companion for a not inconsiderable part of his life's journey. 'When I get to heaven,' he wrote, 'I mean to spend a considerable portion of my first million years in painting, and so get to the bottom of the subject.'

Sir Gerald Kelly succeeded Sir Alfred Munnings as P.R.A. and was noted for his completely fearless attitude to persons and propriety. When Churchill submitted a poor painting for the first Summer Exhibition after Kelly took office, it was not displayed prominently. The following year, Churchill in a fit of pique did not submit a painting. Sir Gerald told Churchill that, although he might be our greatest Englishman, he was just a troublesome old gentleman to those in the Royal Academy.

Churchill, unabashed, looked the President straight in the eye and said: 'Kelly, you know perfectly well that the Royal Academy only uses me as an advertisement.'

Russell Flint's first love among art societies was the R.W.S. (next in seniority to the Royal Academy), which he originally visited in 1904. It was a Society he admired and of which he wanted to be a member. The Royal Society of Painters in Water-Colours, founded in 1804, is old and famous. The gallery was originally at 5A Pall Mall East when Russell Flint first visited it and it was there,

after seeking membership for a number of years, that he was finally elected an A.R.W.S. in 1914, and a full member in 1917. In 1936 he was elected President, fully aware of the waves of prosperity and hard times that the Society had experienced in the past and would continue to experience in the future. As President of the R.W.S. he lost his battle to retain the existing premises in which the Society had been housed for over a hundred years, and was therefore forced to search the West End of London for new and suitable premises. During the five months that Russell Flint toured London with Harry Philp, the Society's new secretary, he did not paint or draw until eventually new premises at 26 Conduit Street were found and adapted. Russell Flint remained President of the R.W.S. for twenty years.

He also became an Honorary Member of the Royal Institute of Painters in Water-Colours, the R.I., a splinter group that broke away from the R.W.S. in 1831. When Lord Moynihan made after-dinner speeches at the R.W.S. and the R.I. on two consecutive evenings he made identical speeches assuming, wrongly, that as the two Societies were rivals no member would attend both functions. It was a calculated risk and only Russell Flint, a member of both Societies, was present on both occasions. On the second he found that a repeat of the eloquent speech failed to uplift his emotions.

Russell Flint's pleasure in being a member of the Societies he loved is admirably expressed by Rupert Brooke, a poet whom the painter admired, in his lines:

And laughter, learnt of friends;
and gentleness,
In hearts at peace.

5

After the economic crisis at the start of the thirties, which in Britain took the form of unemployment with almost two million people out of work (a figure which was to rise to a peak of three million in the winter of 1932), the economy did not start to recover until 1933. New industries were growing: chemicals, cars, radio and rayon. Those people who were fortunate enough to stay in continuous employment were better off when the cost of living fell. The dole, state pay for the unemployed, prevented destitution. Increased building of houses and flats, commercial and industrial projects, contributed to the country's industrial recovery.

The locust years between 1931 and 1935, when Stanley Baldwin was in office, were years of lost opportunities. Baldwin and MacDonald, who shared office simultaneously in the thirties, carried the responsibility for Britain's failure to resist effectively the future aggressions of Germany and Italy.

Churchill was out of office, but was a clear-sighted commentator on the events of that time. Hitler became Chancellor of Germany in 1933 and became a dictator with the National Socialist Party. It was not an easy time to earn a living as a painter although Russell Flint found an increasing demand for his work. Nor was it a peaceful time despite the enthusiastic meetings held by the muddled thinkers of Societies for Peace. The Oxford Union Society passed a motion that 'this House will in no circumstances fight for its King and Country'. This sentiment was greatly resented by Russell Flint, whose patriotism was much in evidence in both World Wars.

The Popular Front Government, in the Spanish Civil War fought in the thirties, was opposed by Germany and Italy whose dictators established General Franco in his position of power. The British and French Governments were two of a major group that agreed to non-intervention. The Fascist rebels had taken possession of most of the north and west of the country by 1936. Madrid, however, was not held and the International Brigade, composed mainly of left-wing opponents of Fascism, delayed Franco's victory until the spring of 1939. The Spanish Civil War, apart from stirring those men who sought an opportunity for action, was responsible for halting the helplessness of British politics at that time and ended the inertia that existed in the country.

Russell Flint understood the moods and dignity of the Spanish people. He was also aware that Spain had made money during the First World War and had used it to destroy, like vandals, many of the country's architectural treasures. He said that the cloisters of the church at Orio, which he first visited in 1921 when he sketched a Spanish christening, provided him with one of the finest subjects he had ever seen. But, on his return to Orio in 1931, they had been destroyed.

He never attended a bullfight in Spain although he went to one in Provence where, despite reservations, he found the spectacle exciting. One incident impressed him during his visit and that was when one of the matadors was tossed by a bull. The matador was a little man, brave but not young, who returned to face the bull after he had gargled and been brushed down. Russell Flint was not proud of the savagery he had depicted in the poster

background of *The Programme Seller*, a painting which showed a Spanish girl selling posters outside a bull-ring.

Artists were incomprehensible to Spaniards, despite their hero, Goya. There were subjects galore in Spain for Russell Flint, particularly inland among the strange mountain peaks of Alicante and Murcia, where the southern colours were ochre, sienna, red or purple. His first landscape in Spain, of the Guadarrama Mountains, had been painted in spring 1921 and he had been attracted by the russet and blue-black débris at the base of the cliffs. Humble communities lived in dwellings sheltered by the débris and goats wandered untethered among the large rocks. He enjoyed painting the poor inhabitants and their families as much as he enjoyed painting gipsies, who were colourful and cheerful models. He painted gipsies at the Salamanca bull market, dancers in various stages of dress from the chorus at Albaicin, Granada, and guitarists from Valencia.

Russell Flint travelled across Spain between the two World Wars, that period of time when the old customs and courtesies still existed. Some of the best views of the country could be obtained from the seat beside the drivers of the stage-coaches, which travelled along set routes and which were pulled by mules. The muleteers were rugged characters and Russell Flint sketched those whose faces interested him. There was also a British-built locomotive of 1868, highly polished and in working order, which could be boarded at Logrono. Policemen were strangely shy of newcomers and Russell Flint was watched suspiciously from the secrecy of doorways at Catalayud, a town that pleased him. He said of it:

'If you survey this Spanish scene from the dominating Moorish Castello de Ayud more subjects are before your eyes than you are ever likely to be able to paint. Choose one. Take yourself in summertime to the high winnowing platforms and there you may see one of the loveliest sights on earth, the separating of the wheat from the chaff.'

Russell Flint regretted not being able to make a really worthwhile drawing of a village harvest hiring because the police, at that time, would not allow more than three of the dignified and picturesque people to stand together.

Russell Flint's visit to Spain in 1931 was the one which he said proved to be the most exciting for him. King Alfonso no longer ruled the country and the population believed that a new life was beginning for them. The painter was accompanied by his wife and together they travelled long distances across the dusty tracks in a motor-car. Russell Flint was not mechanically minded and there was a considerable risk of hardship for the couple if the vehicle broke down. He sketched more than he painted. There were so many subjects from which he could select in southern Spain. In the cave dwellings, tiered above each other, the old people were grave and courteous; the young ones were primitive and picturesque.

He spent a great deal of time in the Ebro Valley, although the accommodation available was rough, mosquito-infested and insanitary. Hotels did not exist in the wilder parts of the country and habitable dwellings were barely adequate for the local people. The coastal plain had good stretches of road for travellers at that time, however, although roads in general across Spain were bad. Russell Flint's old Sunbeam was tested to the limits of its ability and, through luck, avoided accidents on two occasions. When he stopped to paint he still worked at tremendous speed for what he described as 'four-fifths of the way'. 'But', he would add, with a twinkle in his eye, 'in the last fifth I hit all sorts of snags.' Whenever a painting had to be left unfinished, it was placed along the wall of his studio. When one, in particular, caught his eye, he would go over it and try to improve the work. One painting, *Casual Assembly*, took him over twenty years to complete.

Despite the pleasures and subjects that Spain had to offer, he was happiest touring France in a hired motor-car, combing the Alpes-Maritimes and elsewhere in his search for new, and suitable, landscapes to paint.

'Every young artist should succumb to the fascination of continental market scenes', he said. 'I have no recollection of being disturbed by the bustle all round though on one occasion the girl turning the big wheel of a knife-grinder's contraption grinned at me, and now and then put me off my stroke.'

In France, which he loved, there were unpleasant moments. During the industrial strikes, when he had been advised not to travel, women linked arms to prevent his motor-car travelling down a road, a large part of which had been blocked with lumps of stone as an added deterrent. His wife, crippled with arthritis, was with him and had to suffer the nerve-straining experience of being hemmed in by angry strikers, who would have overturned the vehicle given provocation and who shouted and jeered along the roadside. Riots occurred in Arles and black-skinned troops, insensitive to the inhabitants and the tourists, commanded the town and robbed it of any artistic content for the Russell Flints.

The artist recalls an occasion when he travelled with Adrian Bury through wooded valleys of France and through desiccated ivory and grey villages. Then across the plateaux, where the skies always seemed to be overcast and depressing. The silvery Loire was a compensation, with blue skies by day and, by evening, enhanced by the large clouds which gathered over it. On the giant sandbanks, summer flowers grew profusely. They stayed at a small inn, 'Les Trois Rois Mages', and each day Russell Flint went out to paint along the banks of the river. He painted there at a later period in his life with his son Francis, during what he described as 'soul-soothing hours'.

During the thirties, St Malo was the Russell Flints' regular resort during school holidays. St Servan and Dinard were nearby but at St Malo, as Russell Flint pointed out, there were innumerable subjects to paint: fortresses, islands, ships, the old granite town's tremendous ramparts and bastions, and a series of delightful beaches where the immense tides of that part of the Breton coast hid or revealed with endless variations of aspect. The changing effects on those crowded sands kept him busy and

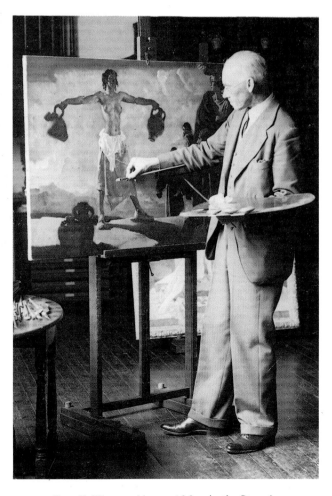

Russell Flint working on 'Maruja the Strong'

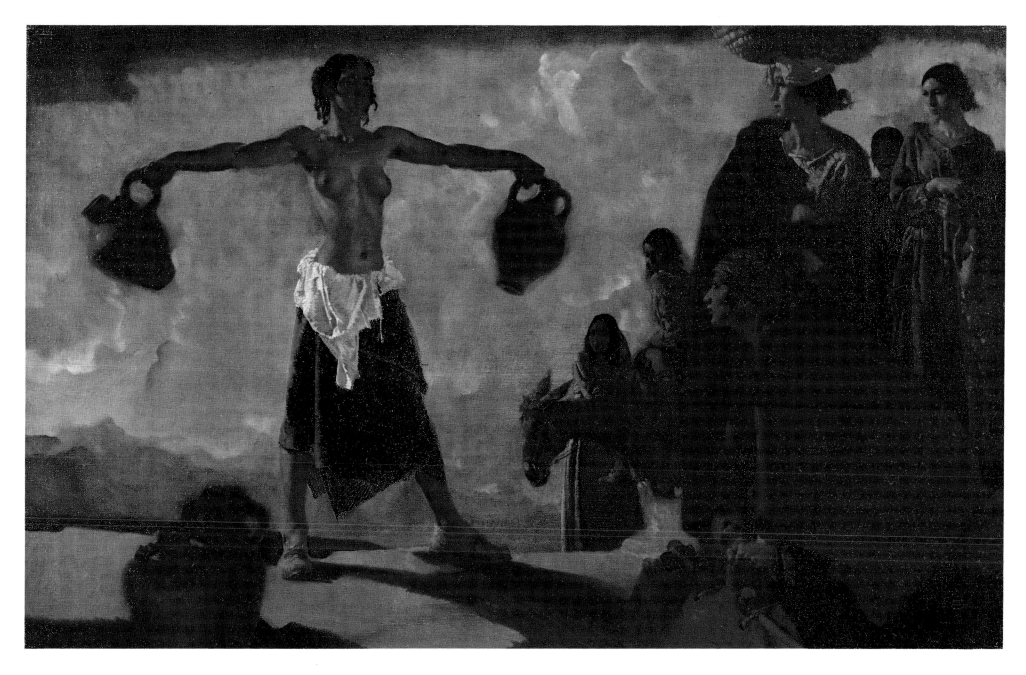

Maruja the Strong, 1935
Oil 34" x 55"
[*Courtesy Rochdale Municipal Art Gallery*]

he spent many days painting what he saw there. He selected a vantage point on top of a rocky headland which jutted out into the Bon Secours bay. He found subjects to paint all about him.

Although routine worship had little appeal for Russell Flint, he seldom entered any ancient church without being reminded that within its walls, all through the centuries, countless souls had prayed, prayed in anxiety and hope, in grief and thanks-giving, perhaps in desperate appeal for guidance. The churches he particularly loved were the sturdy old edifices in the small hill-towns of France. One old church at Senlis, near Paris, had fallen from spiritual to materialistic use and served as a market-hall once a week. The fine tracery of the damaged windows had been restored carefully and skilfully, however, by masons from the Ministry of Fine Arts. Russell Flint was given permission to paint in the market-hall on any week-day provided he left by five o'clock. Unfortunately, the masons departed one evening while he was pre-occupied with his painting and he found himself locked up within the solid structure of the medieval church. He felt that escape was impossible until, when exploring the base of the outer walls, he found a hinged door of rusty iron which, when his weight was exerted upon it, opened sufficiently to allow him to squeeze through. When he revisited the place in later years there was no door, only a solid wall of masonry.

In the Norman town of Louviers, where there were many picturesque timber-framed houses characteristic of the area, Russell Flint found no subject matter in the architecture for a painting. At Le Castellat, on the French Riviera, the vast seignor-ial manor or citadel was in a ruinous state but, for him, was full of paintable interiors. He wandered through it and saw subject after subject which he

wanted to record. He felt that his discovery was a rich one. The French Riviera, Cordes, Crest, St Gemme, Petit Anderly, Périgord, Ostend, Normandy, Paris and Versailles were all places where he discovered subjects that interested him and which he felt were paintable. When he found a new subject that appealed to him, he would clip a half-double-elephant sheet of unblemished water-colour paper to his piece of plywood. Then he would set it up on his easel, which dated from 1906, and open his paintbox (he had one specially made for him in 1927) which contained, in addition to the paints, a grubby bit of sponge to wash it out. He took pride in his collection of brushes of ancient sable and modern hog. He seldom sat on his three-legged stool and started work with his assortment of new, half-squeezed-out or almost entirely squeezed-out tubes of paint. He filled his tin water-cup from an aluminium half-litre water bottle, which was practical and virtually indestructible. The French passers-by would sometimes watch him, noticing his familiarity with his materials and the scrap of blotting-paper, the hedgehog of drawing pins stuck in a cork, the sketching bag containing his reserve quarter-imperials of '300 lb rough', the little bottle of anti-mosquito lotion and the metal box which held his curiously strong peppermints. A length of cord was tied round the easel's legs to prevent them straddling too wide on a marble floor. He worked swiftly and with a clear idea of what he wanted to achieve on the paper.

On Pont St Esprit, Russell Flint found good use for the anti-mosquito lotion, for the air was full of the pests. They did not deter him, however, when he set out to paint, full of excitement and zeal.

'The seven hundred years old bridge—which I love to revisit—is long, undulating and crooked. Viewed from it, the town's river front is, for an artist with an eye for architecture, one of the best sights in France.

Cordes, the town built as a fortress in 1222, had many walls and was a generous town with subjects for Russell Flint despite the fact that he found access to paintable interiors difficult. He often trespassed, therefore, and it was in Cordes that he was again accidentally locked up inside a building that he was painting. But again he was fortunate in finding a small escape door with an inside latch.

St Gemme was a pleasant discovery for the painter and was situated in a region of France which had proved rather disappointing for suitable subjects. The Ancienne Halle aux Grains at Mauvezin, where he stayed, had many good architectural features. The massive columns made the interior an exciting problem for perspective. The beams, king-posts,

corbels, brackets and supports for the tiled roof were intricate in detail and a challenge to an artist.

But it was at Périgord that Russell Flint found great happiness and peace. There he discovered the Château Bonaguil, a medieval stronghold that recalled, for him, his illustrations for Sir Thomas Malory's *Morte d'Arthur*.

'I painted that château with the devotion of a class of amateurs under inspired direction,' he said, 'and did not particularly notice a woman who, unlike the château, had not been especially designed for my benefit. She dragged a length of wire across the top of the muddy slope of the field in which I was painting and went to a green box, unlocked it, clicked something inside and locked it again.'

The woman had had a mischievous look on her face. Two hours later, a friend shouted a warning to Russell Flint who, without knowing, had been enclosed by an electrified fence. He crawled up the muddy slope without delay and managed to find sufficient space to squeeze underneath the electrified wires. He admitted that he looked, and acted, like a nervous cat.

But in Périgord there were happier moments, and golden days of October sunshine, peace and hard work. Russell Flint painted and tackled difficult subjects.

'Trees especially, though swift streams, ancient enclosures and arcaded streets with cunning vistas refused to be ignored. It was an unblemished eight-day feast which numbed, but did not kill, the memory of my carelessness.'

The painter would sit by the open window of his bedroom, with his breakfast of coffee and bread on a table, watching for the moment when the sun would touch the dovecote on the red-roofed chapel just beyond the meadow, full of white-stemmed apple trees, below him. The grass was lush and green, and there were tall elms and beeches, rich in October colours. He watched an old man hauling a trolley laden with dangling tobacco leaves and a sturdy girl, with a mass of dark hair, follow with a barrow-load of washing. Her blouse was emerald, her apron was pink and her skirt was the colour of good red wine. She became, for Russell Flint, the centre of a picture that he knew he ought to paint. On the landing of the outside backstair, the hotel's brisk young mistress had her own table, chair and huge red parasol. Beside her were baskets of vegetables, darning, cosmetics and empty snail shells. It was an iridescent morning, full of promise for the day ahead. The weather was set fair for painting after breakfast in Périgord. Nothing, not even the coffee which had become cold, could have spoiled a day like that for Russell Flint in France.

6

Chance enters into everything and it was chance that led to Russell Flint's first commission, by Philip Lee Warner, for water-colours inspired by *The Song of Solomon*. That commission inspired Russell Flint to continue his career as a water-colour painter. During his long and successful progress, he always endeavoured to record faithfully, and with love, the beauty which he saw so many times. He believed that, in many respects, his work was misunderstood and he stressed that he never painted as he did in order to be popular. For fifty years he painted only to please himself, and still was never quite content with the results. He believed that it was just by luck that people liked his work, with some exceptions.

He was fully aware that a wise man should be conscious of his own worth, although he should seldom blow his own trumpet. In 1907 he had drawn for two days without a break in order to deliver a double-page feature for *The Illustrated London News*. It was one of the hardest tasks he had ever tackled, and was intended to show the great buildings of the time, and of the future, in London. It required a considerable effort to complete the work by the time it was required by the editor. Ironically, the feature was not used until a year after it had been completed. A less arduous commission for Russell Flint was the design of decorative headings for the same magazine. He had been given a free hand and therefore selected art, music and drama to illustrate since the subjects gave him a wide artistic range. His choice of subjects might have been prophetic because forty years later, in 1947, he was knighted for his services to art by King George VI at Buckingham Palace. His companions on that occasion were Malcolm Sargent, who was knighted for services to music and Laurence Olivier, who was knighted for his services to drama. The honours were well deserved and had been earned by men whose distinguished careers had been spent serving the country and the public with humility and with professional integrity.

'There is a pleasure in comparing past trials with present peace,' Russell Flint said, 'and old strivings with present rewards.'

There was ample opportunity for him to make the comparison when a retrospective exhibition of his work was held at the Royal Academy on 20 October 1962. Russell Flint's first sale at the R.A. had been in 1907 when he was notified officially while painting at the Île de Château, Petit Andely, accompanied by his wife who delighted in his success. Fifty-five years later, in 1962, Russell Flint

was one of the nine members of the Royal Academy to have his work exhibited in the Diploma Gallery during his lifetime. The other members accorded the honour were Sir Frank Brangwyn (1952), Augustus John (1954), Sir Alfred Munnings (1956), Sir Gerald Kelly (1957), Sir Winston Churchill (1959), Dunoyer de Segonzac, Honorary R.A. (1959), Dame Laura Knight (1965) and John Nash (1967). Selecting and collecting the exhibits for Sir William Russell Flint's exhibition was a heavy task but lenders, from her Majesty the Queen downwards, were helpful. The exhibition of 350 paintings and drawings included a great variety of subject matter and the range of the painter's work was as representative as it could be, including book illustrations, etchings, drawings, oils and water-colours. Despite his prodigious output, there was no lack of vigour and freshness of outlook in whatever he tackled. His painting was direct and his ideals and enthusiasm never wavered. In the exhibition of his life's work, the pleasure that creation gave him was evident and although his water-colours showed his control of the medium, his keen eye and merry spirit had captured a variety of subjects without deviating from the traditions of the medium.

The retrospective exhibition was open to the public from 20 October to 21 December 1962. He had been described as the doyen of English water-colour painting. His wooded landscapes, in subtle tones of brown and green, and his figure drawings, with their classical sense of form, had previously hung in galleries at home and abroad. It was, for the painter, an opportunity to reassess the work he had done in the earlier years of his life. He explained his reactions in the Royal Academy catalogue of his exhibition:

'Anxiety, surprise, disappointment, even an occasional, very agreeable, feeling of satisfaction have all been evident. The variety of subjects is, I suppose, the natural result of a temperament emotionally responsive to many sorts of beauty but not all. Some of the exhibits, even to myself, reappear as relics of a bygone age. To the analytical mind many may seem simple and unsophisticated, but virtue (or humble merit) may lie in technical completeness. Each has had, for me, its own enthralling interest.'

Sir William had spent four years of his life illustrating events for *The Illustrated London News*. He had been President of the Royal Society of Painters in Water-colours from 1936 to 1956. His paintings, just as he planned parts of his life, revealed that he could see a whole scene as an entity, a composition affected by light and shade, and of diverse interest that never lost unity. France, not Spain, was his painting country. The carefully studied compositions which he painted in France appeared to be casual, although each had been accurately observed before he started work. One of the paintings in his retrospective exhibition was *Façade at Montreuil*, which he had painted in 1948. In it he had accurately picked out the features of decaying grandeur of a fading French mansion, painting them as truthfully as he would have painted the features of a woman whose beauty was no longer at its peak. The painting showed his skill in recording detail without losing the impression of spontaneous application of the water-colours.

Another painting in the exhibition was *Castanets*, the diploma work which Russell Flint deposited on his election to full membership of the Royal Academy in 1933. It was inevitable that at the moment of high reward in the R.A. his thoughts should return to the event, twenty-nine years earlier, when the painting had been submitted. Later, when the Royal Academy decided to publish colour prints of *Castanets*, copies were ready for Russell Flint to sign after the printers had completed their work to his satisfaction. It was a formal occasion, and the proofs were set out neatly in fifteen sets of fifty each in the Reynolds Room. Two pretty girls waited on the artist, ready to remove each print as it was signed. On a black lacquer tray there were a dozen new 2B pencils, with their points machine-sharpened. Russell Flint was pleased with the stateliness of the occasion but was not concerned with the ceremonial trimmings. He produced the stump of a 4B pencil from his waistcoat pocket and began singing in silence. Tea, cake and biscuits were served on a silver tray, by the senior porter in livery, at 4 o'clock with quiet precision. The girls disappeared to their own office while Russell Flint signed on, lifting away each print himself without bothering to record the number signed. The junior porter removed the tea-tray, observing Academy protocol, while Russell Flint kept on signing in solitary style. He put his signature on the 750 prints without stopping to resharpen his scrap of 4B pencil. As he put it back in his waistcoat pocket, he glanced at the dozen specially sharpened pencils, untouched on their tray, and smiled to himself.

A total of 21,340 people visited Russell Flint's exhibition and yielded a handsome profit from the event for the Academy. Sir Charles Wheeler, the President, said of the exhibition in his introduction to the catalogue:

' "A good wine needs no bush", nor do these works of Russell Flint require any abstruse explanation. The pictures speak for themselves in pattern, form and colour, and that, I am sure, is how it should be.'

The exhibition had been the ultimate compliment for Russell Flint, a Royal Academician who was

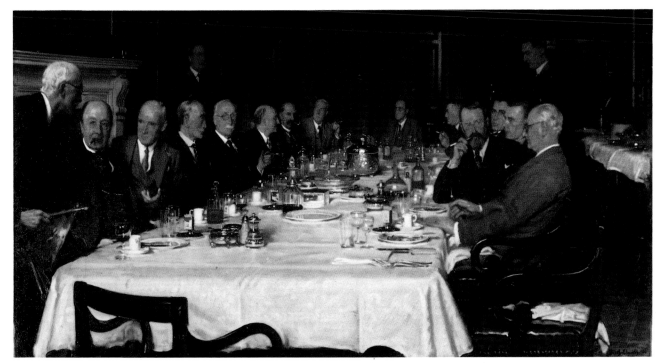

The R.A. Selection and Hanging Committee at dinner, 1938, by F.W. Elwell, R.A. Russell Flint is third from the left.
(Courtesy Royal Academy)

proud to serve the best interests of his profession. Five months earlier, in May 1962, Russell Flint had been painting a tiny water-colour of the little walled town of Beaufort. The breached and crumbling bastions of the medieval town were alive with blossoms, yellow, mauve and pink. The chirping of cicadas and the splash of water from the old spouts were sounds that broke the silence. The artist drove up to Montclar and looked once again at its sad war memorial, an inscribed column with the names of dead young men. There were only three remaining inhabitants, very old, and a long-legged, friendly dog that barked a welcome.

'There are rare moments when the whole of nature seems to sing a song of praise,' he said of that occasion, 'moments which move one to an ecstasy of appreciation. Everything is lovable in the glory of this early summer day and everything seems to urge me with gentle, but unrelenting, appeal to paint, or to write with heart and soul's devotion. I sit in my car, limp with a surfeit of beauty, blissfully grateful, blissfully content.'

Russell Flint was eighty-two years of age, and neither his talent nor his health had deserted him. He was world-famous as a painter of elegant nudes, picturesque gipsies and stormy landscapes but he was still a profoundly grateful man who considered that he had been extremely fortunate throughout his life. Despite the changes in fashions of art, he retained the friendship and admiration of the public who enjoyed his work. His journey to France, in 1962, had enabled him to discover fresh landscapes to paint. 'I bagged two or three good ones', he said. In his eighties, despite his slight build, he was still sprightly, keen-eyed and full of humour. His grey tweed jacket, trousers, waistcoat and stout brown shoes were outward expressions of the simplicity and dependability that he revealed in his paintings. He never abandoned his natural style to adopt a fashionable one.

'I have never known it to work,' he said, 'however good the intentions. I have seen several fine careers spoilt because of it. I admit there have been times when I myself have felt like changing, but I've always recoiled at the last moment, and I think I've been right to do so.'

The prices for his paintings, in salerooms, at the time of his exhibition at the Royal Academy in October 1962, ranged from £400 to £2,000. In 1972, three years after his death, one of his large water-colours fetched £6,000 at auction. And certain of his signed proofs were sold at over £300 each. During his lifetime, he calculated he had sold several hundred of his paintings although the figure was never specific. His signed proofs, in 1962, realised

£100 each and of those there were thousands. Some people assume that when a painter sells a picture the buyer of it automatically gets the copyright. This is not so. Only those people who commission work from a painter retain the copyright.

Russell Flint never found painting easy. When he painted landscapes he believed that, if a painter suffered a measure of discomfort, the pictorial result was better. He painted Snowdon in Wales and the lochs of Scotland in fierce storm conditions and the results were impressive. He encountered, as other painters have done, difficult conditions when working out-of-doors. He had encountered, and survived, riots in France and fights between rival gangs in Spain. He had been chased by a Dutchman armed with a pitchfork on the island of Marken and had been locked inside medieval buildings he painted on more than one occasion. He had been trapped in a field when the owner of it electrified the fencing in Perigord, as mentioned earlier, and he had survived two World Wars.

The exhibition of his work at the Royal Academy had been his first large one-man show, though his first small one-man exhibition was mounted as long ago as 1908. On that occasion, with great daring, he had hung his paintings in the New Dudley Gallery in Piccadilly. Being honest, Russell Flint later admitted that his exhibition had been an expensive failure. The exhibits included numerous Scottish landscapes, lightened by bright pastels in the fashionable Parisian style.

But for the 1962 exhibition of his work collectors loaned paintings at their own expense and, when Sir William Russell Flint saw them again on their return to him, he remarked: 'I wish I had never parted with some of them.'

He always replied to letters from admirers. His mail was large, for he had many friends all over the world who wrote to him enquiring about the histories of reproductions they had purchased. He seldom bought paintings himself, although he was alert and interested in changes of fashion in the world of art. Abstract paintings gave him great pleasure and he expressed sympathy for younger painters, believing however that art students were frequently misled by the cult of over-valuing modern abstraction and under-valuing traditional painting. 'It must be painfully puzzling to know what to do', he explained, 'as regards the "isms".' He had seen, through the years, fashionable styles boosted and tradition decried, but he never found that painting was puzzling for him.

'I have always painted for fun', he pointed out. 'If it ceased to be fun, I would stop painting.'

The present age is certainly more generous and

friendlier to *students*, which may account for the production of so much nonsense in art schools. As far as painters, who have to live by their work, are concerned, patronage is more fragmented than in past ages and that applies to State, Church and industry. It is still hard to earn your living as a painter, even harder to aspire to greatness and hard work every time brush touches paper or canvas. That is why it is wonderful. What is easy is seldom excellent and neither fame nor success is permanent or important.

7

Russell Flint never painted figures without models in his studio at Peel Cottage, his house in Kensington set back from the road behind a high wall encrusted with broken bottles. He did not often paint the models he used as he saw them, and when he worked on any figure subject, even a small one, he required a girl to strike various poses for him while he painted.

Even the attention given to small figures in his paintings necessitated the use of a model. Russell Flint realised that there was no end to the attitudes a willing model could assume without intellectual strain. Physical strain was another matter.

He knew well how necessary it was for friendly collaboration to exist between a painter and his model. The enthusiasm that both had to have stemmed from their mutual interest in the work to be done. A model needed patience and a certain amount of vanity, while the painter had to work hard and have pride in his ability to capture her likeness and express her character.

He still found pretty women difficult to draw. Men he did not find difficult and therefore seldom bothered about them. He considered that the laziest male models he met were the Romans. They complained that it hurt to adopt the simplest pose and they worked to the clock, stopping work immediately they heard the sound of the noonday gun fired from the Castel San Angelo. By comparison, Russell Flint found that male models in London were good and willing workers. Although he was unable to work without models even for little figures, or impressions of them in movement, circumstances were different and even more exacting when he was required to paint or draw a larger figure. In these situations only the sustained patience of his models and his own ability to concentrate on the job in hand could result in the finished work almost satis-

fying him. He admitted that he would never be content with a production at the time, though somehow the passing years would seem to improve it.

He was able to distinguish, and explain the difference which he saw, between a pretty woman and a beautiful one. He had considered, in his young days, that a girl who travelled regularly on the same train as he did in Edinburgh was lovely. But when his mother travelled with him one day on the same train he was aware of her beauty in contrast with the young girl's prettiness and the initial attraction he had felt faded. He always sought good models when painting figures, realising that they were blessings. He also said that the more attractive the model the oftener she must be painted or drawn. There were snags to this point of view, however.

'We mustn't have any one girl too often', he was warned.

'But', he objected, 'one girl can appear in different guises.'

'People are very observant', came the reply. 'They will say "Here's that girl again".'

He once painted a large water-colour of five girls ski-ing on the practice slopes of Flims in the Engadine. Only one girl posed for all five figures. Several years later, when the model had married a physician, her brother saw the painting in her house. After looking at it carefully, he pointed to one of the figures and said to his sister, rather accusingly,

'That's you.'

'Yes,' she replied, 'that's me. They're all me.'

'Don't be a fool,' he retorted, 'how could they be?'

Russell Flint had hoped to write a romantic book at some time about the models of great artists throughout the centuries. The idea delighted him, and he visualised writing about Praxiteles and his model Phryne, Botticelli and Simonetta, Raphael and the baker's daughter and Tiepolo with his gondolier's girl. He would have included the delicate nudes of Pisanello, better known as a medallist, but, unfortunately, the idea never became reality. He believed that the most appealing of all great pictures of women throughout the centuries had tales of affection and love contained within them. There needed to be an atmosphere of mutual trust and helpful companionship. Russell Flint knew this for himself and so, he knew too, had his predecessors.

One of his favourite models, Cecilia Green, appeared in many of his paintings. She was the model depicted in *Barefoot Girl in a Gold Coat*, which was one of the paintings in Russell Flint's retrospec-

tive exhibition at the Royal Academy in 1962. Cecilia was also the model for the girl in *The Secret Retreat* and the foreground figure in *Casual Assembly*. The coat of gold appeared in several paintings, including *Variations III*, and, as the artist pointed out, most figure painters have studio garments and oddments which can be detected over and over again in the pictures of which they form part. Russell Flint invited criticism of his work from the models he used and considered that, by seeking their opinions, an artist received comments which were invariably sensible and shrewd. On occasions, however, their response could be shattering and their criticisms were never inhibited by ignorance.

He had painted and drawn Consuelito Carmona, the dancer, many times. Pictures of her by Russell Flint were included in Arnold Palmer's book *More than Shadows*. Carmen Amaya, another supremely graceful Spanish dancer, was a beauty whom Russell Flint admired. He had painted several behind-the-scenes pictures of theatres during his later years and those he painted of the Spanish dancers captured, with glints of variegated colour, their vanity and restlessness as well as their other gipsy characteristics. Russell Flint enjoyed working with colourful and amusing models, particularly those who took an interest in his paintings of them.

He commented that kindred spirits will delight in talking shop in even the most commonplace of surroundings but that the pleasure is so much the greater when the surroundings are excitingly uncommon and romantic.

When the Spanish dancers visited London, Russell Flint enjoyed the opportunity and fun of sketching them from the wings of the theatre. It was an echo back to his early days in the theatre when he had sketched events and first nights for *The Illustrated London News*. There was always an untidy domestic atmosphere where the Spanish dancers settled. 'Squalid would be a shade too harsh a word', according to the artist. The dancers' families followed them, fathers, mothers, uncles and aunts, and usually a number of small children. The law did not permit children of their ages to appear on stage but nevertheless they did, and appeared in their finery for the grand finale. When they were not on stage they squabbled noisily among themselves. The men were seldom in sight. Russell Flint found the ostentatious religion, paraded before the start of a show, embarrassing. The dancers crossed themselves time and time again while waiting for the curtain to rise and worked themselves up into frenzies of agitation. Carmen Amaya's dressing room had been set up with an altar, a crucifix, candles and flowers. Her flounced dresses

were strewn casually about the room among dressing gowns and other oddments. Her glittering trinkets cascaded across the dressing table. In the midst of the chaos, Russell Flint saw an idea for a painting, using the dancer and the two swarthy women who attended her, massaging her ankles and dressing her hair. But when another girl came into the dressing room, carrying more candles, bags of sweets and a thermos flask, the romantic mood was shattered. Russell Flint abandoned his idea and went back to the wings.

He seldom painted figures in the landscapes he painted out-of-doors, preferring to add any figures that were necessary at his leisure in the studio. There were occasions, however, when a group of people posed naturally in a setting he had decided to paint. One summer, he had driven from Châtillon-sur-Loire to the village of Ousson, where the river had a wide sandy shore that encouraged bathers. He set up his easel to start work on the up-river view, because he found that water flowing towards him was less difficult to paint than water flowing away. The skyline, with a distant hamlet, had just the character he liked. He sheltered under a leafy embankment, using the shade to make painting easier. There were bathers in the distance, laughing and splashing, to complete the picture and they were the only objects to disturb the calm of the day. Suddenly the bathers, three women, caught sight of the painter working and began walking towards him along the sandy bank. While Russell Flint tried to work, they formed a polite and interested audience, chattering among themselves about his ability to record the scene in front of them all, of which they had once been part. The artist was embarrassed because he considered that his water-colours always appeared to him to be ineffective until, usually long after, they were completed in his studio.

'Never for me,' he said, 'though at least once for my son, a bystander's complimentary "*Ah! Il a du talent.*" Too often, many times too often, it is a contemptuous "*Ça ne marche pas.*"'

But the shapely and unselfconscious bystanders on that summer afternoon were most enthusiastic about Russell Flint's talent. They had come from Les Loups, the village he was painting on the skyline, and had changed from figures in his painting to living models at his side. They complimented him, their lovely faces examining the painting to make sure that he had painted their village correctly. Eventually they waved goodbye, the river water still gleaming on their backs, satisfied by the painter's convincing demonstration of his skill.

The models portrayed in Russell Flint's paintings

ranged from the statuesque Diana, with bow and quiver, in *The Smiling Amazon*, an oil painting of 1908, to the tempera painting of *Marguerite-Pauline*, a supple lady seated unconcerned, and unclothed, on a gilt settee. That particular painting was taken away to be reproduced in colour just after it had been completed. When it came back, Russell Flint did not like it and re-painted the figure from another model as well as altering the shadows and the background. It was then taken to the U.S.A., still with the original title. The collector in America, who eventually saw the colour reproduction, was surprised to find a different woman on the gilt settee although the name was the same. The lady who had lent the artist the gilt couch for the composition was also taken aback because he had painted a nude sitting on it. And, if the picture had been returned from America, Russell Flint was quite certain that he would have altered it again. He said: 'The moral is that a painter should keep his work for some time before sending it out into the world and particularly before thousands of people see a reproduction of it.'

The famous British artists of the eighteenth and nineteenth century were, in the main, either portrait painters or painters who used figures as their subjects as well as landscapes. There were not many painters of nudes, and it was from the France of David and his followers that painting the naked human form was inherited in Britain. The Victorians disguised their nudes in a conventional style, using biblical scenes or ancient settings. It was a bogus form of classicism. Manet, Degas and the Impressionists broke down the convention and paved the way for painters to portray nudes in styles which revealed their personal vision and conception. Russell Flint portrayed his naked human figures with grace and delicacy. They were supple creatures and part of a carefully considered design. Everything was 'placed' with great discretion and in *Reclining Nude*, painted in 1956, tempera was used to strengthen the drapery and background leaving the figure untouched. In *Reclining Nude*, painted in 1961, the medium was water-colour and although both paintings were designed for ornate frames, the delicacy of each nude shows how Russell Flint could express tenderness as well as a tough, lithe quality that prevented their becoming essays in fragile prettiness.

His preference for working with Cecilia as a model resulted in her being the subject of many of his paintings although she was depicted in various disguises to make her less liable to recognition. Both she and the painter were genuinely interested in the subjects of his paintings and how the final work was accomplished. She was a patient and beautiful companion, whose enthusiasm and understanding of a painter's temperament encouraged him to paint with pride and diligence.

Some of the paintings which Russell Flint made of women, in particular *Rococo Aphrodite*, have the quality of dreams. But he did not stop to consider the vanity of his dreams and consequently was able to translate them into reality by the actions of painting, in which accuracy and beauty, as he saw it, were always evident. He was not a person to be deflected from his purpose by criticism of no value. Those models who worked with him, and understood him, preferred to wear a Giacondo smile, and little else, when no words were needed.

8

Landscape painting in Britain has been an outstanding and proud tradition. Richard Wilson, Turner, Constable, Cox, Cotman, Sandby, Gainsborough, Girtin, John Varley, De Wint, Bonington, Samuel Palmer and Russell Flint, as well as many less familiar names, gained their inspiration from the study of nature and the countryside through which they travelled. Each endeavoured to express through the vehicle of their technical skill their own response to their surroundings. This basic principle in the approach to landscape painting is still as valid today—in spite of changes in techniques and attitudes—as it was in past centuries. The ability to learn from the traditional methods of painting with water-colour is not easy to acquire. In the past three hundred years painters of distinction have known that it was essential to be able to draw first in order to create a foundation from which to start painting.

Russell Flint was aware that paintings dealt with facts, with forms seen, recorded by hand and reported by the eye. A painting was made like a model ship, a map or a piece of furniture. The appeal of the finished work is mainly to the senses and its conception has virtually nothing to do with ideas. The language of speculation and association of ideas are created from words and not painting. In Russell Flint's paintings objects are brought together; the abstract qualities of line, pattern and colour are related to material objects to give meaning and coherence to the pictures he made. His personal statement of facts which he observed is the true subject of his pictures.

He never gave lessons in water-colour painting, but risked being considered selfish for he felt he could not teach. He pointed out that he did not have enough time to paint his own pictures. He said he had no ability for teaching and that if he attempted to do it he would be impatient and vary his instructions, causing people to call him inconsistent.

The problems which he had to solve were those that face any painter—the problems of representation, of likeness, of truth and of realism. When Russell Flint worked, and finished working to his own satisfaction, for us he added another quality not obvious even if we had stood working at his same viewpoint. This was the physical quality of the medium he used. This medium was made to retain its character whatever he chose to represent with it. He explained quite clearly his reasons for making a painting in the first place, reasons which were topographical, decorative, illustrative, romantic and personal.

The way in which he used his materials, the calculated quality, remained to justify his paintings despite loss of topical interest in the subjects which he chose or the changes of fashion. His best pictures continue to satisfy, and can be looked at over and over again without of loss of interest even when the contents have been learnt by heart. Russell Flint knew that the illusion of painting was achieved through two-dimensional means, from three-dimensional subjects. The beauty of water-colour as a medium is in its transparency. The freshness and freedom it gives a painter can best be appreciated when it is spread in thin washes combined with blobs of luminous colour. An understanding of the nature of the paper to which it is applied is necessary and the rich accents which Russell Flint used—his shorthand of dots, strokes and dashes—are distributed across his paintings like guide lines to lead the eye through his designs. Water is the most important ingredient, not the strength of the paints.

Russell Flint executed his works in the medium rapidly, appreciating the thinness and using it for small-scale works when necessary as well as for the elaboration of surface in his larger works. Water-colour is a more graphic medium than oil paint and Russell Flint's interest in writing, with which there is a similarity of personal expression, enabled him to paint accurately and precisely with what has been described as 'the in-between art' of water-colour.

The impetus for landscape painting in water-colours was the pursuit and record of the picturesque. Drawing is thought out in three parts, foreground, middle distance and distance. Each of these has to be planned and conceived in colour by

a painter. The sequence of colouring is personal to each painter. When the pencil outline is complete you can make all the shadows and middle tints with Prussian blue and brown ink, thinking only of light and shade in monochrome. Alternatively, you can colour it all over, making light and shade and middle tint, using the method of of oil painting. The lights have to be preserved and the ground coloured over, with regard only to colour.

The paper has a decisive influence over the quality of the wash, the colour being the lightest tone to which all other colour has to be related. The texture of the paper surface imposes a discipline and can make thin tints glare. The range of textures with which painters have experimented to reduce this glare is legion. You can use an absorbent paper, impregnate it with colour and keep a matt surface. Alterations are then difficult. Russell Flint sometimes used a unifying underwash of a pale warm colour which he ran over the whole work in preference to using a mechanically toned paper. He also burnished the grain in parts to vary the texture to keep certain areas flat. The paper was roughened for parts which were to be accentuated.

The surface of drawings can be the subject of great trickery: wiping out, abrasing, leaving drawings to soak in water to achieve mistiness and greater refinement. Stippling, using the fine point of the brush to make a series of dots, allows the painter to use pure colour. This can be a trick which can rebound on the painter and develop into a vice. Water-colour, as a medium, allows for tricks. The limitations have to be assessed carefully and then exploited. Decisions have to be swift. Calculations must be made for the contrast of light and dark masses as well as linear patterns which are ruled by the surface of the paper used. Calculations must be made for the flow of water, for the depth and penetration of the paint. Russell Flint had mastery of this virtuoso medium, achieving swift and luminous effects to please the eye.

Water-colours are light and compact to carry on journeys. The medium allows a painter, like Russell Flint, to capture—with the minimum of preparation—the changing atmosphere and scenery out-of-doors. Water-colours dry more quickly than oils, and the cleaning-up process after completing a painting is negligible. Pure water-colour, when pure colour is used, is a difficult medium. The term 'water-colour' embraces paintings for which the materials used include body colour and gouache, supplemented by ink, charcoal, crayon and pastel. Water is the main unifying element. Two factors which influence pure water-colour painting are the paper and the colours. Subject matter, composition,

perspective and a knowledge of anatomy are other factors. Each factor, as Russell Flint proved, has to be mastered. He was a painter whose care and observation, when choosing a subject, was meticulous. His honesty in seeing a subject as it really was distinguished his work from the work of others less honest. When he painted out-of-doors, he was fully aware of the hazards of the weather. Drops of rain can ruin a water-colour, leaving circular marks which are impossible to remove effectively.

'Coping with bad weather is a commonplace for any landscape painter,' he said. 'I get a strange satisfaction out of crouching on my three-legged stool under an old umbrella (I usually stand while painting) while the rain drums on the back of my upturned water-colour. By a wonderful Providence a damp water-colour automatically presents a convex surface to the sky.'

The umbrella, 'Old Faithful', used by Russell Flint had a long life, even though some of the spokes fell by the wayside. It saved many of his paintings from the elements.

The choice of paper influenced the results he achieved in his paintings. The grand views he painted and the grand washes he used needed stout paper, not less than 300 lb imperial, to give them full effect. Many of the smaller water-colour sketches which Russell Flint made, when dying light had to be captured and time was limited, were still painted on fine quality paper. He understood the potential, and the limitations, of all types of hand-made papers, selecting only those of good quality and weight. A New York supplier of artists' materials whom he once met thought him a paper-maker as he had sold Russell Flint paper for years.

Take a good water-colour paper, wet it, drop a brushful of colour on it and study the surface changes. The weight of such paper ranges from 60 lb to 300 lb (400 lb is rare, but can be obtained), with varying surfaces and finishes. Papers less than 140 lb in weight can be strengthened by stretching them before use. Papers of 300 lb can take a good soaking and can be painted on effectively while damp. You can study the water-colour washes which Russell Flint applied to rough surface paper and realise how skilfully he made use of 'breaks' in the colour. He explained how to achieve an easy gradation of an over-all wash by lifting up the paper when the wash had been applied and tipping it, in reverse, to make the pale colour run into the strong colour. The movement of the paper made the water run evenly over the surface and any surplus could be removed with a sponge. The surfaces of all good papers have a stiffening of size to toughen them. A painter washes off a certain amount of the finish by

sponging over the paper before use.

The colours which Russell Flint used took into account the luminous quality of the papers he used and there are certain studies made by him on the absorbent type of papers that were produced in France for engravers. But the finest paper and a quiescent model did not always enable him to achieve the result he wanted.

'Water-colour is a very difficult medium', he would repeat. 'Oil is a still more difficult medium; tempera is an atrociously difficult medium; drawing is an infernal sort of fun. I spoil more drawings than anything else.'

A painter can be tempted to use a large selection of colours indiscriminately. Yet taking generous amounts of colours from tubes or pans before you start is worthwhile. They can always be used again. When Russell Flint painted out-of-doors his palette contained the minimum number of colours that he considered necessary. The colours included cobalt blue, French ultramarine, light red, yellow ochre, burnt sienna, rose madder, Hooker's green No. 1, vermilion, sepia, cerulean and Prussian blue. Greens made from chrome yellows, viridian and Hooker's green are not suitable for capturing the colours of nature. An ideal water-colour mix for natural green is yellow ochre and cobalt, but sienna and Prussian blue, when mixed together, also produce a warm, deep green. The skilful mixes which Russell Flint achieved may have seemed deceptively easy to copy. They were not, as many painters who tried to copy his colours of sand and sea (basically cobalt blue and yellow ochre) discovered. When he painted his model Cecilia in a gold coat he wrote:

'Gold, I once boasted, is easy to paint—it's just sepia and yellow ochre! For that foolish flash of pride I have paid the traditional penalty; gold is now difficult to paint! My simple recipe of sepia and yellow ochre no longer works. Perhaps after a period of contrition I may again be cunning enough to make them glitter.'

Russell Flint was cunning enough, however, to know the exact areas where the white of the paper should be left to show in his compositions and he was adept at toning paper to suit a particular subject.

'We have all seen countless sheets of studies in chalk, pen and wash and all sorts of media, but seldom, if ever, in water-colour,' he said of *Variations*. 'On paper toned by myself it has been interesting to build up groups unhurriedly and carefully.'

Variations I appeared in the Royal Academy in 1961 and *Variations II* and *IV* in the Royal Academy in 1962. The white paper background was put to

good use in *Caprice in White (Two Idlers and a Saint)*.

'It may be that there are still artists who design their compositions down to the last detail, who never make a rash start and who are never in any doubt about the intellectual integrity of their productions,' Russell Flint remarked. 'Not having any desire for such chilly perfection I like to take a carefree plunge now and then and just puzzle a way out.'

In his painting of *Two Idlers and a Saint* he had only one intention: to stick to white and call it a caprice.

At Les Cabannes, Russell Flint decided to paint the interior of a farm building, which had a twisting stair that interested him and subtle lighting. The owner, who enquired if the water he was using for painting was too alkaline showed an uncanny understanding of an element which could affect the control of the medium which the artist possessed. Water creates a problem when there is no adequate supply available. For this reason, a light aluminium flask, with a screw top, holding about a pint of water was a valuable part of the painter's equipment and was used to fill the tin container fixed to the broad arm of his easel. The contents also provided refreshment on a hot day. The stock in trade necessary for a water-colour painter working out-of-doors should include paper, paints, sketching bag, easel and stool, water-colour box, brushes, an assortment of pencils, charcoal, rubber, knife, water flask and container. Other useful accessories, sometimes forgotten, are clips, blotting paper and a sea sponge. A fine sponge is an asset in emergencies, essential for removing part of a painting, for stopping colours running and for taking off excess water. It also cleans a paintbox swiftly and efficiently. A pocket looking-glass can also be an asset. By looking through it, from time to time, a painter can see new angles of his subject and the way he is painting it. The looking-glass is merciless in showing faults and errors.

Russell Flint, when he painted out-of-doors, knew where his colours were positioned, had everything to hand and ignored anybody who chose to watch him. His umbrella protected his painting in bad weather and a warm pullover was available when needed. He had equipment to dry his paper when necessary and when there was not time for the paper to dry naturally. A simple method of drying washes is to light Meta fuel in a tin and then move the wet paper horizontally over the heat taking care to avoid burning. Although Russell Flint's method of drying his washes was more sophisticated, his brushes were rather worn and were treated as old friends. All brushes, sables or hoghair, have to be

cleaned after use if they are to retain their efficiency. Out-of-doors, brushes and easels are easily lost and damaged.

Russell Flint was painting in the bay of Arisaig on a June evening in 1929, catching the reflections of the mountains of Skye in the waters of the Sound of Sleat. He was happy until, after a supper of kippers, oatcakes, jam and tea in the gamekeeper's lodge where he was staying, he found that his big water-colour brush was missing. He later lovingly described this favourite brush as 'plump, blunt-pointed', made of 'lyons' hair and with a brass ferrule overlaid with tin. The wooden shaft was yellow and although it was a good-looking brush it was not expensive even by the standards that existed before the First World War.

Russell Flint was distressed by the loss of the brush. The following evening, when he was painting on the shores of a loch a mile away, the brush returned on the tide and he picked it out of the water near him. He was highly delighted by the unexpected good luck of finding it again. The brush was still in his studio in March 1969 when he had been using it for sixty years—even after it became worn and had lost numerous hairs.

The best easels are small, compact ones with strong legs, and not too light in weight. Russell Flint's well-worn sketching easel survived many a mishap until, finally, one of its lower legs had to be replaced. The original king-pin was lost on the island of Mull, where the blacksmith at the time fitted and rivetted a massive bolt for sixpence. In Majorca, despite the riveting, the bolt went again and a garage hand did a neat job in brass for a few pesetas. In Venice, a baby dropped out of a window a few feet above him and landed on the picture Russell Flint was painting of San Barnaba. His easel was flattened to the ground, scattering his paintbox, water-can and brushes. It was a trying interlude for him, with his precious brushes blowing about the narrow fondamenta close to the edge of the canal. The baby was unhurt. Later, when the water-colour was completed and exhibited, nobody remarked on its exceptional surface quality.

The majority of landscapes which Russell Flint painted out-of-doors were considered from the point of view of light at the outset. In the mornings, he stood with his back to the rising sun looking westwards, where he could assess the colours at their best as well as the strength of the shadows. By the middle of the day, when the sun was overhead, the landscape was at its least interesting because the tones in it were flat. But by evening, when he looked eastwards, he was able to enjoy painting at the best time of day for light. He stood, when

painting out-of-doors, because the horizon viewed from a standing position is lower than it is when viewed from an easel stool. In a painting, a low horizon is easier to manage than a high one. This aspect of composition Russell Flint mastered, as skilfully as he mastered perspective. His guide lines were sketched in with a stick of vine charcoal. The lines were wiped out with a clean cloth so that only the lightest traces remained before he started painting. He knew, also, that there are few perfect subjects although many subjects he tackled were made into well composed paintings by use of artistic licence. The centre of interest was never in the middle of his paintings and light and shade balanced each other.

When he painted at Versailles with his son, Francis, he preferred the end of September when the hordes of visitors had gone. *The Forgotten Fountain* was painted in September and he said of it:

'While my son and I were painting, not a soul wandered down the embowered, chestnut alley to inspect the fountain. The guardians were friendly and kept grandfatherly eyes on us. The weather was moist and still but every now and then a "conker" landed with a plop. One hit me and spluttered my paint water over my picture. Rectifications forced me to take extra trouble with the foliage.'

Composition has always concerned the intelligent painter. The compositions of past masters provide a rewarding study, as do their treatments of colour and tone. The proportions of sky and land were not designed by nature to fit a ready shaped piece of paper. Part has to be taken from the whole. Viewfinders—a mount from a water-colour—have often given the final key to the best composition when the eye is not fully experienced to segregate a suitable area. Russell Flint wrote of Santa Maria Dei Jesuiti, Venice:

'During April, 1929, I tried to paint this delightful subject from my friend Henry Trier's sandalo but it wobbled too much. I made a careful pencil drawing instead and, long after, did the painting from it, and from memory.'

Colour, tone and light were dictated by the conditions under which Russell Flint painted. But freshness, transparency and clearness, those essential ingredients of a pure water-colour, were always present in his work. The transparency was never lost by working over a colour that had dried out. The wet colour was always put on at the right strength or the painting abandoned when it was not correct. Speed was achieved by electrical drying of parts of an area of painting and irregular shapes were filled with practised accuracy.

'Great painters did not scorn labour-saving devices', Russell Flint pointed out. 'For instance, they were not above using vapour trails or clouds as space fillers, or as substitutes for thrones or couches. Clouds were easy. Even Raphael seated one of his divinities on a ridiculous little puff, a perilously inadequate prop for a well-developed female.'

Colour, often a repetition of colour achieved by earlier masters, was dictated by nature. But there were moments, like the occasion in 1924 by the bridges at Pierre-Pertuis, when a painter receives a bonus that enlivens the existing colours of nature and architecture.

'A coach drew up and a dark multitude of National Gendarmerie seemed to explode from its interior. The gentlemen courteously assisted their ladies off the low parapet and together in merry bunches they slithered down the steep banks with entertaining unconcern for decorum. In a few minutes the river margin was dotted with confetti-like blobs of colour. There, before my delighted eyes, was a modern *Fête Champêtre*.'

Colour has a composition of its own and therefore by mixing up plenty of the main colours that a painter sees in his subject provision can be made for changes that occur unexpectedly in cloud formations and changing light. When the largest areas are painted in then the true colours and tones of the far distance, so accurately captured in Russell Flint's landscapes, can be judged. Distance is deceptive.

He added additional details when necessary, strengthening those that already existed. These gave life to the scenes painted, and added touches of interest. The splash of red or orange roofs in the Spanish paintings, the linking shadows and the authentic little figures were carefully thought out and then placed. In the painting *A Fine October Sunday, Ostend*, you can see what makes the work enjoyable for a spectator. The painting was completed during a freak summer spell late in the year and the crowded beach at Ostend, described by Russell Flint as 'a dreadful resort for an artist though some of the fishing boats are interesting enough', has been authentically recorded. An illusion of air and space exists round the groups of figures. The fishing boats and the calm sea, the figures and the linking shadows seen from above, were viewed and painted from an hotel window.

Few subjects defeated Russell Flint, for whom time was precious. When he painted *Souvenir of Egypt* in March 1961, the weather was cool and grey. 'New or not, I liked the bit where the road turned a corner of Cheop's Pyramid. The variety of figures streaming past was perfectly delightful, all sorts with a vengeance. What a procession! Yet in spite of such visual distractions and without, as I believe, conscious effort I became aware of the serenity and inevitable melancholy of vast antiquity and wondered how on earth I could suggest such intangibles in water-colours.' But the painting does succeed in capturing those intangibles in the fresh washes of colour handled by a painter in complete control of his medium. Russell Flint was able to paint swiftly out-of-doors when necessary. He also sketched everything that was of interest to him when it came his way, knowing that sketches have a value of their own.

Figures added realism, life and interest to a large number of his paintings. How did he put figures in a landscape or seascape like *Sinking Sands*? The answer, according to his son Francis, was years of experience over the handling of water-colours and the temperament of each colour as well as his choice of papers. Russell Flint's constant observation and perfect knowledge of anatomy are evident in all his paintings where figures are included. He needed complete seclusion with nothing to interrupt his energetic concentration when he set about capturing the rhythm and colouration of the human figure. He was especially gifted in the art of composition and use of colours, which gave such lustre and artistry to all his work. He also knew exactly when to stop his paintings and where to add a highlight, by lifting out the colour—when wet—with a small, hard hoghair brush.

Poses are second nature to models but a standing pose is difficult for those who are not used to it. The eyes, nose and fingers of a Russell Flint figure always had enough detail to convey what the painter wanted in his composition. When you study his work you are aware that there is not too much detail, but sufficient detail that is accurate and perfect. There was the peak of artistry where, as a mature draughtsman, he could express everything with almost nothing. Focus allows a painter the opportunity of showing what can be seen. The folds and shapes of material of different character played a large part in paintings by Russell Flint when they complimented a woman or group of women. He successfully captured the brightness of satins and silks, the softness of velvet and the rough quality of corduroy and leather. Perfection of draughtmanship reveals itself in his method of softening the edges of a dress and the manner in which materials were gathered together to form folds of light and shade. The largest patches of colour were applied first. The patterns of folds and creases were simplified to avoid fussiness in the completed water-colour. The

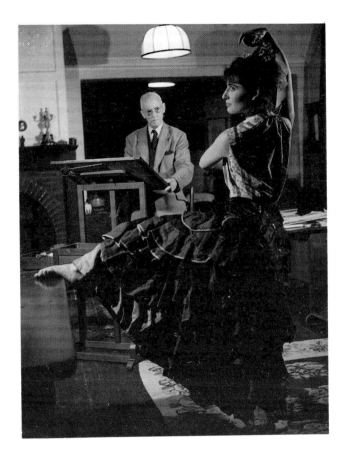

W.R.F. with Cecilia Green in classic pose

highlights raised on the faces, arms and shoulders of the figures conveyed the softness and luminosity of human skin like the bloom on a pale peach.

The figures were always considered in relation to their surroundings. The model was never painted in isolation, unrelated to the finished work. In Russell Flint's paintings, where the figures are either sitting or standing, study the shadows that link them to the setting. This is not always obvious at first glance, but the soft shadows are there when you look for them. Those shadows provide substance for the figures.

In the nineteenth century, Europe provided a rich field of architectural subjects for landscape painters. The craze for recording the riches of Italy in water-colour or crayon was a fashionable one, and not a stone of Venice was left unturned or unrecorded. Today, the camera provides a record for our generation with restless interests and limited time. There is no great artistic value in a colour slide or photograph but they make splendid momentos and provide a pleasurable pastime for amateur photographers. Recording architecture requires great skill when painting and the closer the painter is to the detail the more carefully it has to

be recorded without vagueness. This is a failing in some paintings by amateurs. In Malta during February 1966, Russell Flint was button-holed by an amateur artist who was determined to show him every one of the seventy sketches of architectural subjects which he had drawn with a ball-point pen. Russell Flint glanced at three or four, aware that they were bad with the badness of the complacent amateur. He was also aware of the man's scorn for the little aquarelle which he was completing. Like two academic architects they heartily despised each other's productions.

'My compliments', said Russell Flint ironically. 'Your perspective is highly original.'

'You yourself are not above taking liberties with your subject', came the amateur's tart reply. 'Accuracy is my ideal. Obviously, Sir, it is not yours.'

The foreshortening that can make perspective difficult to set down has to be overcome and this entails an understanding of vanishing points, height lines and the painter's relationship to his viewpoint. Interiors are often more rewarding than exteriors because of the soft shadows and the subtle tones of light. The treatment of interiors by Russell Flint was notable for the scale of his brushwork and the structural elements he selected to compose his painting. On many occasions he had the good fortune of finding an interesting interior subject quite unexpectedly. At Chaffens, a farm near Crest, an outer door opened as he was driving past. He stopped and painted a water-colour of the interior. 'Within an hour the (to me) essential figure motive offered itself, that of two girls renewing the pink wash on the columns,' he said, 'though the figures themselves were not painted in until long after, and then at home.' One problem which interested Russell Flint was the number of figures which artists used in their pictorial groupings. Odds, not evens, win easily. Three, five, seven or eleven seem to balance naturally, but two, four or eight are nearly always troublesome for no apparent reason. He summed up the problem in these words: 'For centuries the trio has been an attraction; thrice three Muses, three Goddesses or three Graces. Now, I have my own three washerwomen, three gipsies, three bathers, or, more simply, three models, obedient—in theory at least—to my slightest caprice.' Most people interpret pictures literally. A group is a group: those figures in that picture must have been like that, all together, when the artist painted them. This is seldom true.

Outhouses are good subject matter for a painter. Quarries, wharves, dockyards and ports are also a rich field from which to select painting matter. The pleasure that Russell Flint derived from painting out-of-doors was reflected in his paintings. It was the same peace and enjoyment that anyone could find working on a river bank or by the wooded shores of the lochs, with a paintbox at their side and, with luck, a clear blue sky overhead. *The Secret Retreat* was one interior which he considered possessed an enduring quality. Labourers were unloading bags of cement from which the clouds of dust solidified the painter's wet washes. Repair work on the terrace overhead resulted in pails of sludge, broken tiles and rubble being thrown within three feet of the doorway where Russell Flint was working. Why attempt such a difficult task at such a time is the obvious question? The reason, according to the painter, was that the interior he wanted to record was authentic thirteenth century and at other times the place was locked up. Sir William was a tenacious man when a subject interested him and, although not all of his interiors were notable for their architectural merit, he invariably found elements which resulted in an interesting composition. The twisting stair and intriguing lighting of the farmhouse at Les Cabannes is a good example of a subject lacking antiquity but possessing atmosphere. The Market Hall at Cordes, on the other hand, provided a powerful subject of great antiquity—the fortress town was built in 1222—as did the medieval interior of the Bishop's Palace at Chichester, which Russell Flint painted just after the Second World War when the Palace had become a young ladies' school. The painting, with its grand piano on the right hand side and a young woman reading in a recess, suggests an impromptu music room. It was the shadows, the details of windows, doors and roof trusses, that gave Russell Flint's interiors their atmosphere. They may be small in scale, or large, but the technique used to record them on paper is precise, accurate in tone of the materials used in the building's construction and deceptive in its simplicity. The simplicity was achieved by constant practice.

Control of the medium of water-colour enabled the artist to achieve the effects he required. His fine draughtsmanship and understanding of light, form and colour were always evident. Many of his paintings without figures were equally satisfying to the eye and in his painting of *The Statue On The Stair* at Crest, in 1954, you can assess the extent of his skill in conveying to the viewer the architectural qualities of the buildings in which he saw merit. When he painted *Casual Assembly* in 1942 he wrote: 'A gale had uprooted a noble beech. The prostrate giant bridged a moat and flattened a fence. A pleasant domain was revealed and into it I trespassed. Later, when painting, I was challenged and ordered to withdraw. My name was taken. I was, however, allowed two hours' grace but in less than half that time the Agent returned—with his hat in his hand! The owner had several of my pictures and wished to make me welcome. The scene was Pains Hill, one of Capability Brown's masterpieces, the year 1942. The first figure was painted then. Others have been added through the years, the last "only the other day".' The last figure was Cecilia, the model who appears in many of his paintings.

Russell Flint's paintings have a flowing, refreshing and spontaneous quality. He possessed a natural flair for choosing colours and textures as well as a deep regard for subject matter. There was variety in his landscapes and an understanding of anatomy and human personality in his figure studies. He expressed buildings and figures in his paintings under the conditions in which he saw them, detailing only that which was necessary for the compositions. His interpretation of subject matter was inspired by enthusiasm, affection and a high degree of sensitivity. He was a master of his craft. He was conscientious with his brush strokes in the same way as he was with words in his much smaller amount of literary work.

He was well aware that assertions were made that his method of using water-colours was full of tricks and although he knew the accusations to be nonsensical they sometimes amused but more likely irritated him. He had too great a respect for the medium in which he worked to resort to any type of trickery, indeed the idea of doing so was repulsive to him. A painter's respect for technique was comparable to a writer's respect for grammar to him. He was able to give an explanation of what puzzled the experienced as well as the inexperienced, and it was control of the medium. He had practised that control for seventy-five years.

Many of the compliments Russell Flint received were for his technique, not for the truth which technique enabled him to portray. Even practice, he admitted, did not seem to make painting one whit easier for him.

Incidentally, Adrian Bury, who sketched often with Sir William, discusses his friend's methods in his own autobiography, *Just a Moment, Time*. He says, 'having been with Flint on sketching occasions in England, France, Italy and North Africa, I can describe his routine. I choose the one that we shared together at Châteauneuf-sur-Loire during a week in the summer of 1963. . . .

'Coffee and rolls prompt at 8 a.m. Sketching materials included a 27″ × 20″ drawing-board and a sheet of heavy drawing paper. A quick march to

the Château and gardens. R.F. soon makes up his mind as to the subject, noting the dominant interest, and what to select and simplify from the profusion of nature. The tripod-easel is fixed with the drawing board horizontal. The artist always stands up to his work and draws with the brush after faintly indicating with charcoal the salient features of the design. On this occasion it is the Château framed by tall trees, the bridge across the moat in the middle-distance, a stretch of water, and the steep ramparts rising on the right—a complicated subject.

'Flint's technical power is superb, and he interprets the subject much as a great pianist will interpret a piece of music. Eyes, hand, heart, and brain are synchronised to depict a unity of design, tone, and colour. After about an hour the paper is covered; architectural interest, trees, water, and sky and any available figure interest—all placed where they should be to give the maximum of effect. Everything is under control, awaiting an accent here, some more detail there; but the artist is careful not to superimpose tints if such passages as water and sky fully express themselves in the first spontaneous wash of colour.

'Water-colour painters know how perilous it is to convert the *premier coup* into the finished picture. Many a brilliant sketch is ruined in carrying the work farther. But precisely because R.F. knows exactly what he wants to do and has the power of doing it he continues in the same mood that has inspired the picture in the first place. Two and a half to three and a half hours' intensive concentration and the work from nature is complete. He never returns for a second session on a landscape subject. If he feels that some large figure interest is necessary in the foreground he will introduce this in the studio in such a way that it looks as if painted on the spot. The artist has already visualised where it should come while working out of doors, and usually leaves a part of the paper clean to contain the figures. Only his perfect knowledge of the figure in relation to any background makes this possible.

'With almost startling celerity his interpretation of the scene—for interpretation it always is—appears on his paper. Three brushes serve him: a large flat one, a medium-sized round one, and a ridiculously small one. Usually his big brush is fully charged, but for foliage or crumbling old walls in may be dragged half-dry across the paper.

'R.F. has tried to give me a clear account of his technique but finds it impossible as every subject requires its own. He says he would be a very poor fish if after three-quarters of a century's continual practice he hadn't subjected his chosen medium to obedience. One sees him flick and twirl his brushes, now one, now another. He changes them over with a sort of legerdemain. His swivelled board is sometimes flat, sometimes tilted and he seems to be perpetually sponging his old paint-box and changing his paint water.

'In contrast to what I have written about his speed in painting out of doors, "finishing up" in the studio is a slow and long-drawn-out process.

'The multiplicity of little bits which he thinks need modifying or emphasising is astonishing. The picture is in and out of its frame a dozen or more times. Incomplete works stand in full view on a long shelf in his studio, and, while working on other subjects, unsatisfactory spots catch his eye. Weeks, usually months, pass before any of his larger water-colours are allowed to leave the studio. And, completing a small landscape, he tells me, often occupies more time than a much larger figure subject.'

9

Early in the Second World War, Russell Flint and his wife spent a year on a turkey farm near Totnes, in Devon. Despite the pain of Sibylle's arthritis the antics of the turkeys provided a regular evening entertainment and the couple enjoyed watching the ungainly creatures roost on the horizontal branches of the Cedar of Lebanon which they could see from their sitting room. Their laughter, however, upset their landlady, who had scant humour and was extremely proud of her championship birds. She was eventually pacified by the Russell Flints' charm. In 1942, Russell Flint painted, in tempera, *Stormy Harvest, Dartmoor*. He also painted at that time a snowy landscape in greys and browns. The landlady, after looking at it, turned to Russell Flint's wife and remarked: 'It'll be nice when Mr Flint has greened in the grass.'

Sibylle Russell Flint was severely crippled by arthritis and a great deal of the money which Russell Flint earned went to hospitals and clinics. His devotion to his wife was steadfast and, when she died in 1960, his grief could not be lessened by the fame he had earned. A great deal of his success had been due to the understanding and encouragement given to him by his wife during their happy marriage.

William Russell Flint's own motto was: 'While I can, I must.' His autobiography, *In Pursuit*, ends with his search for a fitting conclusion. The book must not, he decreed, finish flippantly, and it must not close ponderously; it could not end with a prayer such as Chaucer or other ancients would have used. How then? Glancing around his studio in a search for inspiration he found none, but there came instead to him a realisation that time could be running short. 'Stop writing', he decided then, 'and arrange your pages.' And indeed that proved to be both a happy task and an appropriate decision.

His own life ended during the night of 27 December 1969. In a few days more he would have entered another decade, and in April 1970, he would have celebrated his 90th birthday, in characteristic style, with a family dinner party like many he had given at Peel Cottage.

There are few gifts greater than lasting friendship, honour, kindness and a respect for human beings, whatever their failings or good qualities may be. The price for refuting, or ignoring, the value of such gifts would seem to be loneliness and bitterness, those outward etchings on the human face. Tragedy exists for everybody and, in the short span of life, the moments of happiness and contentment have to be enjoyed if and when they occur. Some people have 'loved the stars too fondly to be fearful of the night', and death, when it comes, is a finishing touch to a living portrait.

Portraiture was born from the noble Renaissance dream of man. Russell Flint was a man of noble ideals. He took twenty years to put the finishing touch to a painting, and his own life, a full canvas, rich in colour and detail ended peacefully on that December night in 1969. But his spirit lived on tangibly in the paintings he left and in his only son, Francis, and his grandchildren. He had made valid the words of Joseph Conrad: 'A work that aspires, however humbly, to the condition of art should carry its justification in every line.'

There are strange, inexplicable moments in life which haunt the memory and defy explanation. When Francis Russell Flint held an exhibition of his paintings in Brighton during May 1972, Jeanie Anscombe, author of *My Native Sun*, expressed the spirit of Sir William Russell Flint, his father and his son in the form of three long-stemmed red roses set against three simple gilt frames. Every painting at that exhibition was sold, and many of the landscapes were of places where both Russell Flint and his son had painted together. The roses, strangely, did not wilt and die in the usual manner, but opened slightly and remained as symbols of a renaissance throughout the weeks of the exhibition. When the exhibition closed, the roses dropped their petals, as a painter sets aside his brushes when a painting has been completed. The sun had set and there was music at the close.

W.R.F. and Sibylle with the young Francis

Francis Russell Flint was born in 1915 and was educated at Stubbington, Cheltenham and H.M.S. Conway. He studied art at The Royal Academy Schools under Sir Thomas Monnington and also at the Beaux Arts, Paris. He was official War Artist in the Far East while serving with the R.N.V.R. at sea during the Second World War. Sketches, which he made when he served as a war-time aide-de-camp to Sir Winston Churchill, were the basis for his painting of the cruiser Belfast, during bombardment off the Normandy coast in 1944. The painting was commissioned by the H.M.S. Belfast Trust and was displayed aboard the ship in 1972.

Russell Flint believed that the trust that stems from true friendship comes close to holiness. Such friendship was also expressed in the mutual love between father and son. In Sir William's book *Drawings*, published in 1950, there is a summary of his son's varied duties during the Second World War. Russell Flint found it easy to make a personal choice of one of his son's war experiences and he included the incident in his autobiography.

H.M.S. Thanet was slowly sinking. When the distance between the water-line and the deck was only eighteen inches, Francis rallied the nineteen survivors, whom he found with the help of Petty Officer Fern, and then herded them into Carley floats with orders to paddle clear of Thanet. Miraculously the Japanese searchlights swung too high during the action and did not illuminate the survivors in the floats. Eventually Francis found himself alone with Petty Officer Fern and they stood together on the doomed quarterdeck. They finally checked, for punctures, the Mae Wests they wore and then jumped into the sea.

Francis Russell Flint painted *H.M.S. Thanet's Last Fight* and it was exhibited in the Royal Academy after the war. He was notified officially of the sale of the painting and enquired who had been the purchaser.

'Your father', he was informed.

When speaking of painting, Francis Russell Flint said: 'I do claim a feeling for the tenderness and delight of water-colour. This painting business must have been in the blood. My great-great-grandfather, grandfather, father and uncle have all been artists or craftsmen, and who knows, my own three sons and two daughters may yet follow on? In my

early days, the house was filled with frame-makers, painters and the smell of paint. I ran away from home, thinking that by going to sea I could escape from brushes and paints. My experience, after changing from a smart uniform of which I was proud, was to don dungarees and chip paint off the ship I was aboard as it crossed the Atlantic. Across the Pacific, I was given the largest brush I have ever handled and was told, with others, to paint the ship. Is it any wonder that I am now able to achieve surprising results with a genteel little water-colour brush?'

Francis was devoted to his father, one of the world's greatest water-colour artists, and said of him: 'My father was a religious Scot. He was a humble person, desperately humble. He did not deliberately strive for popularity. He was an individualist and his work made him happy.'

There is an affinity between the pattern of life and the pattern of water-colour painting. Both require enthusiasm and the realisation that anything worth doing means hard work and giving whole-heartedly of one's best. The disappointments that occur are best accepted as experience and used for the benefit of others. Father and son painted together, happy to enjoy each other's company and the pleasure of their work. Sir William Russell Flint described, in his book *Breakfast in Périgord*, a peaceful day that they had spent together:

'We had been painting, my son and I, by the shadeless Loire one July day. Our picnic lunch had, for once, been rather meagre, but, after a good spell of work, we had enjoyed our schoolboy game of "skiffers"—throwing flat stones and watching them skim across the water from ripple to ripple until they sank. Then we had a lazy spell on the wide sandbanks of the river in the late sunshine. Suddenly we were tired and hungry and drove to Briare in expectation of a good dinner at the Poste.'

The work of both painters encourages contemplation and expresses the union between life and peace. In the words of G. K. Chesterton lies one key to the universal appeal of a Russell Flint painting: 'Every work of art has one indispensable mark. The centre of it is simple however much the fulfilment may be complicated.' In 1972, when Francis Russell Flint held the exhibition of his paintings in Brighton at the same time as a posthumous exhibition of his father's work was showing in London, the public and the press acknowledged that both father and son had the same mastery of technique as well as the ability to record the personal statement of facts which they observed.

'He has succeeded', one art critic wrote, 'in following in father's footsteps.'

The Technique of William Russell Flint

PERCY V. BRADSHAW

1914

OUT OF THE HURLY-BURLY of Modern Illustration —a world in which many admirable artists are too often engaged in entirely uncongenial work—there occasionally emerges a man who gets an opportunity to use the best of his talent. Among the most prominent of such favoured mortals is W. Russell Flint—an artist who has triumphantly survived the rough-and-tumble of his earlier employment on "the common round and daily task."

Russell Flint is equally well known to his contemporaries and to the discerning public as Painter and Illustrator. It is impossible to believe that his dainty Water-Colours—so poetic in conception, and so remote and reticent in their colour schemes—can have resulted from early training as a "Trade Artist." It is almost as surprising to find that Illustrations—which especially appeal to the student and artist by reason of their scholarly distinction and leisurely refined atmosphere—have grown out of conventional and leisurely training and subsequent experience as a Pictorial Journalist.

Yet one discovers that Russell Flint has worked as Student, Lithographer, Scientific Draughtsman and general Illustrator, at such varied work as ordinary Commercial Drawing, Medical Diagrams and Pictorial Journalism of all kinds. Of this previous experience—and of the more obvious qualities essential to popularity as an Illustrator—the Artist's recent work bears not the slightest trace.

He is the eldest son of the late Thomas Wighton Flint, an Artist who was, at the same time, Captain of the High Constables of Edinburgh. Russell Flint's experience as a "Trade Artist" was preceded by some training in his father's studio and at the Edinburgh School of Art; and he came to London when he was twenty years of age, being appointed to the regular staff of the *Illustrated London News* three years later.

Though his early days taught him sureness of draughtsmanship, and gave him a fine elementary equipment, he has outgrown any suggestion that his work could have been used for anything but the subjects he has recently made so peculiarly his own. One looks in vain for the strong contrasts of colour, the undue insistence on prominent figures or details,

the forcing of values, and that melodramatic treatment of a scene which so often becomes characteristic of the work of every Illustrator who has to "tell his story" clearly to the public.

It seems a far cry indeed from the trade jobs of the young Lithographer, to the Illustration of Chaucer and other Classical authors upon which Russell Flint has worked exclusively during the last few years—work which shows not only brilliant technical skill, but scholarly feeling, appreciation of period, and sense of romance. Needing, as such commissions did, a love for the Classics, literary knowledge, and the greatest sympathy, it must have been difficult indeed to discover just the right Illustrator. Mr. Lee-Warner, of the Medici Society, and the Artist, are to be congratulated on the completely successful combination which has resulted.

When one turns over these beautifully produced volumes, and studies the Illustrations minutely, it is always with the feeling that the Artist is a born Poet or Painter turned Illustrator rather than the Illustrator turned Painter. There is something of the monkish Art which beautified the old missals here—a reverance for the author's outlook, and a love for the period when the work was produced, that makes us regret the necessarily exclusive nature of the public for whom these "Editions de Luxe" are designed.

One feels another regret, that the production of such drawings should have been interrupted. But, at the outbreak of War, Russell Flint volunteered for more serious work, and for the last two years he has held a commission in the Royal Naval Air Service, his duties leaving him no opportunity whatever for continuing his Art work. But, though his brushes remain idle, he is not likely to be forgotten by his brother-Artists.

He has, for some years, been quite as well known as a Landscape and Figure Painter, as an Illustrator, and he has happily been able to divide his time almost equally between his two enthusiasms. Water-Colour is his favourite medium, and it is interesting to note that, for his Illustrations in which a certain definite colour-scheme and a richness or depth of tone are necessary—in the representation of a gloomy interior, the blue of an Oriental night scene, or the green of a forest—he invariably uses a method which is very different, in its early stages, from that which he has found most satisfactory for pictures.

In dealing with an Illustration of this nature, he first covers the entire surface with a wash of tone composed of the pigments most suited to his prevailing colour-scheme. On this transparent ground the drawing is produced, any high lights

which were required being removed with a moistened brush, the other colours introduced being necessarily affected by prevailing tone. A similar method has already been illustrated in the last two stages of the subject which Heath Robinson produced for us.

For Russell Flint's pictures, pure Water-Colour on a white ground is almost always used, and it is in this method, which gives greater evidence of his skill, that he made—just before the War commenced—the drawing we are about to study.

First of all, it should be noted that he has used, for this subject, Unbleached Arnold Paper of the quality known as "140 lb., Not Imperial"; brushes of Fitch hair, very large in size, the smaller qualities being Nos. 3—7, and occasionally a Sable for smaller details.

The Arnold Paper used in this instance was something in the nature of an experiment, and has proved exceedingly satisfactory, but Russell Flint usually works on "O.W.", which, though not so brilliantly white, is on the whole rather better.

His colours are, in the early stages, restricted to Yellow Ochre, Light Red, French Ultramarine, Indian Yellow, Prussian Blue, and Hooker's Green No. I; and this is how the drawing proceeded:

STAGE I—A very slight preliminary pencil note (little more than a thumb-nail in size) has been made of the composition, a model has been obtained, and the figures very lightly and loosely sketched in charcoal. There is nothing in the nature of a carefully constructed pencil study here, the charcoal lines, still observable in the tree, showing quite clearly the lack of detail introduced into this preliminary stage.

The artist starts his drawing almost at once, with the brush, and proceeds by well-defined stages and by a method which is repeated in all his work. First of all, Yellow Ochre and Light Red are mixed very thinly on his palette, and a pure wash of these colours placed all over both the figures, from head to feet—in a tone approximating to the high light shown on the shoulder.

These washes are allowed to dry thoroughly, and it is an essential characteristic of Russell Flint's method that, though the successive washes are put on with all the freshness, sparkle and purity of which he is capable, they must be *absolutely dry*, stage by stage, before the drawing is proceeded with. So particular is he in this matter that he has often used a spirit lamp to dry a wash and enable him quickly to proceed to the next stage.

The first thin wash of Yellow Ochre and Light Red having been allowed to dry, he proceeds to

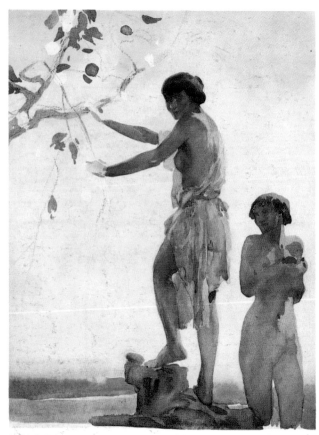

STAGE I

introduce a slightly stronger wash of the same colours, putting it on quite flatly, with no attempt yet at modelling or detail. This again is left to dry. Meanwhile, he has made a rough pencil sketch for the arrangement of drapery, and when the second wash is dry he has treated the drapery by a similar method, first introducing a light wash of Ultramarine and Light Red, and, later, placing on the shadow portions a darker tone of the same colours— a little less red being used. Finally, the high lights have been lifted up with a small brush. You will see that the drapery, as far as it has gone, has been kept quite fresh, and that ragged edges are left unsoftened.

Now with regard to the completion of this first stage of the drawing. For this, a stronger flat wash of the Light Red and Yellow Ochre (with the addition of a very little French Ultramarine) has been used to block in roughly the darker tones— such as the hair, suggestion of the features, the modelling beneath the armpits and on the legs, etc. Where edges have appeared, they have been washed away, and the nose has been tentatively modelled by lifting away the darker tones with a small moistened brush.

An exactly similar method has been adopted with regard to the lower figure, but this has not been taken quite so far. With regard to the rock, this is washed in freshly, first with Ultramarine and Indian Yellow, secondly with a darker wash of the same colours, thirdly with these colours and Light Red, each stage being thoroughly dry before the next is applied.

Then comes the background, a fresh wash, with a big brush, of Ultramarine, Indian Yellow, and Prussian Blue. The sea is indicated with Ultramarine, there is a little Indian Yellow for the sand, and the foliage is chiefly suggested by Hooker's Green, Indian Yellow, and Raw Sienna.

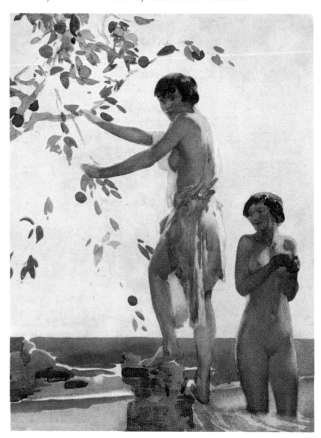

STAGE II

STAGE II—You will see, by the second reproduction that the drawing has reached a decidedly more finished condition. To achieve this the hair is darkened, a little Raw Sienna being introduced, the features being defined more carefully, with the previous colours, and a slight touch of Crimson Lake introduced on to the cheeks. Then the trunk and arms are modelled, by washing over the previous tones with pure water to remove rough-

ness, and when the water is dry, another wash of the colours used previously is taken over the surface, the shadows being further suggested with darker tints of the original colours.

Where lighter tones are to be noticed, such as on the left shoulder and on the outline of the trunk beneath the breast, the tone is obtained by washing away. Towards the ankles, after a similar general method has been adopted, touches of Crimson Lake are introduced, the drapery being washed down and simplified with pure water, and improved by the subsequent addition of one or two fresher tones.

The lower figure is similarly treated, except that the tones are kept slightly warmer throughout, and, in starting the second series of washes, the original high lights on the shoulder and breast are of course left. You will note the addition of a little Crimson Lake on the hands and towards the knees.

As to the background, the horizon line is very considerably raised, by a wash of Ultramarine and Prussian Blue; the rocks in the water are suggested with Raw Sienna, the blue showing underneath in the foreground. There is a suggestion of distance, introduced by Light Red and Crimson Lake, and the foreground rock is washed down, touches of Light Red being introduced. Finally, Hooker's Green, Raw Sienna and Indian Yellow were again used to strengthen the foliage.

STAGE III—In the third reproduction, you will realise that a good deal of scrubbing has taken place. If the paper is of satisfactory quality, this can easily be accomplished without detriment to the drawing. In this stage the artist has scrubbed down, with water and a rather large brush, the hair of the nearer girl, and proceeded to model the face more carefully.

To do this, a wash of Raw Sienna and a little Lake is taken over the entire face. When this is dry the lights are lifted out with a moist brush, and the features defined more carefully with Sienna and Lake. Exactly the same system is adopted with regard to the body and arms, the Crimson Lake being decidedly noticeable in the left forearm. Observe once again that the original high light is still on the shoulder and back.

The drapery has been very considerably improved, by reference to the previous pencil study, and by strengthening of the darker portions with a brush of French Ultramarine and Crimson Lake, the edges being softened when dry and the lights lifted with the moistened brush. The scrubbing of the legs, lower portion of the drapery and the sea should be noted. The rock in the foreground has been strengthened with Light Red and Ultra-

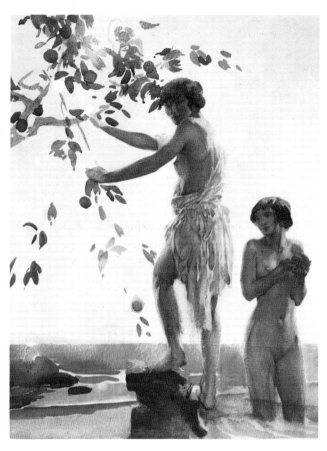

STAGE III

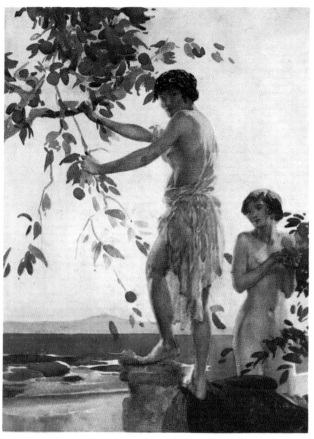

STAGE V

shadows of both the figures—especially on the legs—have been softened throughout, foliage has been introduced around the nude girl, and a useful mass of drapery (Crimson Lake and Light Red) has been introduced over the previous colour. Finally, the sea has been strengthened, a fresher green introduced into the rock on which the girl stands, and a touch of red in the sea.

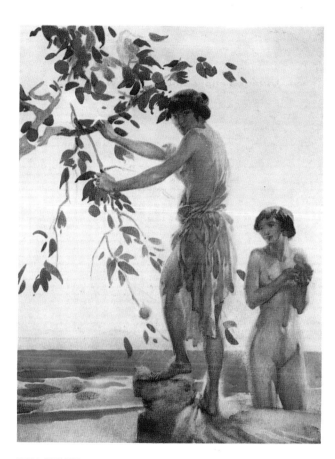

STAGE IV

marine, and the lower figure treated in exactly the same way as the draped girl, the tones being strengthened with Raw Sienna, Lake and a little French Ultramarine in the method just discussed.

STAGE IV—With regard to the fourth reproduction, you will see, at a glance, that it is altogether colder. Russell Flint felt that the figures in the previous stage were getting a little too warm in tone, so he has taken a very transparent wash of Prussian Blue, slightly touched with Chinese White, over the darker tones to cool the colour, and worked again on the features. The rocks in the sea have been taken out, and the foreground rock scrubbed away. There are also a few additional touches introduced for the foliage.

STAGE V—The fifth reproduction shows another very definite advance and improvement. Some of the previous coolness has been removed; the foliage has been strengthened with pure Hooker's Green, Indian Yellow (for the fruit) and Raw Sienna; and the draped girl has been given a scarf of French Ultramarine and Light Red, the pattern being picked out with a moist brush. The edges of the

STAGE VI—In the final stage it will be noted that the warm foreground has been strengthened with Light Red, Crimson Lake and French Ultramarine, the legs of the draped figure slightly warmed with a wash of Raw Sienna, and a little Lake at the heels. The hair of the nude figures has been slightly softened, the foliage made a little less obtrusive, and the horizon line washed down slightly. Lastly, a portion of the drapery has been scrubbed out with a Hog-Hair brush, and some oranges in a gold dish have added another touch of interest to an exceedingly interesting example of Russell Flint's technique.

STAGE VI

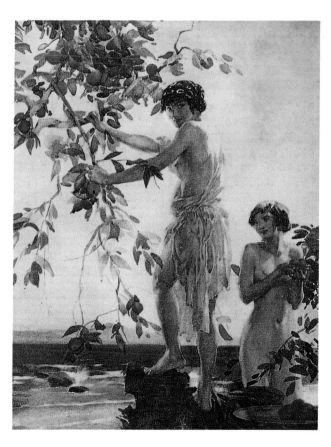

He used a model throughout, as he does in all his work. In the early stage it was only possible for him to proceed with the drawing when he could study the effect of sunshine on the model. He does not rely on memory for any such subtle details as this. The background is, of course, fictitious, but he has such experience of painting in Italy and on the shores of the Mediterranean, that the vivid colour of a little subject of this kind would present no difficulties.

The chief point to be noted about the whole drawing is that, though the method of drying each stage would appear to encourage dullness and dryness of effect, Russell Flint uses it so dexterously, and each successive wash is put on with such freshness, that the final result is as sparkling and unworried as one could possibly desire. The processes described in the production of this drawing are not always followed absolutely in every picture which Russell Flint produces. He has, for instance, no dogmatic views against the use of Body Colour, and occasionally carries through an entire drawing using Chinese White with this colour. But the quantity used in any one wash of colour would be small.

Like most artists, he has preference for special colours, and those mentioned may be considered among his favourites. Brown Madder, Burnt Sienna and Vandyke Brown are used only very occasionally, while Cerulean Blue is found useful only for definite spots of local colour, such as might be required for a pattern on drapery.

His artistic achievements, for a man of thirty-five, have been notable. He is an Associate of the Royal Water Colour Society, a member of the Royal Scottish Water Colour Society, Royal Institute of Oil Painters, the Art Workers' Guild, and other artistic Societies. In addition he was awarded a Silver Medal by the Paris Salon in 1913, for his Illustrations to the "Morte d'Arthur," he has exhibited in the Royal Academy and the galleries of Venice, Berlin, Munich, etc., and has works in the permanent collections of Liverpool, Cardiff, Udine, Italy and Japan, while his record as an Illustrator includes some brilliant work for special editions of Malory, Chaucer, Theocritus and other Classic authors.

From a student's point of view, the charming purity of his Water-Colour technique has an irresistible appeal. He paints the nude in sunlight with especial joy, and his most characteristic subjects have been pictures of Greek maidens idling on sunny shores, with a background of vivid Eastern Seas.

Such subjects can by very trite, "pretty," and commonplace, as we all know. But Russell Flint has a poet's temperament allied to a particularly accomplished technique, and his Water-Colours painted around the Mediterranean Coast—his visions of Capri in afternoon sunlight, and of Sorrento or Amalfi bathed in sunshine—are enchanting examples of his Art, while, in some romantic adaptations and uses of Italian backgrounds, he has produced works which must be a joy to their fortunate possessors.

His studio just before the War was the happiest of hunting-grounds for the student of Water-Colour. I have an exceeding fondness for the medium, and the sketches and pictures which Russell Flint showed me—the result of an Italian pilgrimage—left me almost incoherent with admiration and envy. They were so absolutely masterly in their natural purity of colour, so certain in their composition and analysis of essentials. There was no obvious exhibition of facility, no superficial trickiness, no obtrusive cleverness. Distinguished craftsmanship and a perfect sense of colour—the beauty of Nature recorded by a romantic temperament and poetic vision. That summarises, very briefly and ineffectively, the Art of Russell Flint.

THE PLATES

Keith S. Gardner

The foregoing stage-by-stage analysis by Percy Bradshaw was written in about 1918, and referred, of course, to one water-colour painting specially executed in dry technique for Bradshaw's study in 1914.

In retrospect we know that W.R.F. had a further fifty-five years ahead of him in which to develop almost every medium and technique, from oil on canvas to dry-point engraving. In particular, he was not always to be bound by the restrictions of the dry technique, but emulated his old mentors in the Glasgow School by mastering the difficult application of wet water-colour upon wet water-colour, particularly in the portrayal of dense foliage. This wide range of skills in oil, chalk, pencil, water-colour or burin will, it is hoped, be self-evident in the following illustrated section.

Each picture is a statement in itself, each picture worth the proverbial thousand words. The narrative accompanying the illustrations, therefore, is intended to supplement the main biography by, in general, linking the picture to that biography by means of a more detailed vignette about either the man or the background to the work. It is hoped to dispel the Spanish gypsy myth or at least reduce it to its proper perspective; to reveal to a wider public the vast range of Russell Flint's techniques and subject matter; and ultimately to understand the man better. One interpretation of art is that it is that peculiar skill which lies in communicating the artist's feelings to as wide a public as possible. Russell Flint's feelings were, basically, those of a Victorian Romantic—having seen reality, he often shied away from it and created an Arcadian world of his own. Faced, for example, with imminent death in a crippled airship over the cold and fog-bound North Sea, he returned to its shores in peacetime and painted it, calm and serene, bathed in warm sunlight, the sands peopled with children or nubile young girls—symbols of life and hope after the years of war.

The public enthusiastically acclaimed his work as, indeed, did the critics of the day. They praised 'its freshness and joyousness of impulse, its delicacy, its charm, its air of being done for the pure fun and pleasure of the doing'. They sympathised with the fact that 'he feels no incentive to follow the lead of any exotic schools of abstract art hustled into being by the so-called "advanced movements".'—*Studio*, 1920.

For the next forty years he could do no wrong. Academic honours were bestowed upon him, he was knighted by his sovereign, and the critics and public alike adored him.

'His intention is manifestly to create a "vision of loveliness", an illusion of reality pleasurable to both eye and intellect...His drawing is truly remarkable for its unlimiting discipline and painstaking detail finish, coupled with an ever-present idealising conception.'—*Apollo*, 1930.

'... one of the few academicians who remain faithful to the classical past, and continue to provide the exhibition with pictures of a true spectacular character, is W. Russell Flint.'—*Strand Magazine*, 1935.

'He is in the great tradition, both as a landscape and as a figure artist, and very few water-colour painters have been able to handle so many diverse and difficult subjects with such unerring skill.'—*The Connoisseur*, 1936.

'Unlike the exponents of modernism, the artist has the greatest respect for the beauty of the human form, and remains true to Hellenic principles in an age of aesthetic chaos. Let us not be deluded by art sophistry. These principles never can be out of date, nor is it easy as some would pretend to express them. Sir William is a consummate draughtsman in this way, and his best drawings lose nothing by comparison with earlier masters of the subject... In Sir William Russell Flint we have the example of an artist who has kept faithful to certain irrevocable standards of vision and technique, and he has therefore deservedly won the applause of discerning people all over the world.'—*The Artist*, 1958.

'At a time when some forms of art would appear to have abandoned interest in life, it is both consoling and inspiring to be reminded by this exhibition [Royal Academy Diploma Gallery Exhibition 1962] of an artist who has remained optimistically true of his ideal throughout a long and arduous career. Who would think, looking at the vigour of Sir William's latest work done within the last few weeks, that he is in his eighty-third year? From the earliest drawings of his 'teens to those dated 1962 there is an inflexible resolution to express truth by the best available means. Having won his freedom very early, he had the great good fortune to win countless admirers simply by working hard to please himself.'—*The Connoisseur*, 1962.

However, few critics reviewing his R.A. exhibition in 1962 were as kind as *The Connoisseur*. *The Apollo* had changed its tune: 'Russell Flint's art seldom rises above a level of incidental triviality. He has rarely, it would seem, produced a picture that meant anything more than the evocation of an imaginary landscape where olive-skinned gypsies or English maidens disport themselves.' *The Times* complained that 'he has always succumbed, in landscape, to the easiest charms of the picturesque, and in figure-subjects to a mixture of coyness and chic fitter for the calendar-trade.'

What happened? Russell Flint had changed only in the degree of increased confidence with which he tackled even the most complex subject, and was forgivably even more of a hopeful romantic in his eighties than he had been in his twenties. It was fashion in the art establishment that had moved on. Romanticism was dead and deeply significant truths were looked for in every brush-stroke and under every stone. Art appreciation as an intellectual pursuit has developed to a degree where some may feel that deep truths may well be recognised and proclaimed where none were ever intended. Whatever the arguments, art appreciation is largely subjective, and Russell Flint is more popular now than ever, with a world-wide following. The sad thing is that new generations of art students, of dealers, of auctioneers are being told to disregard him. The Spanish gypsy image is now so well believed that even his beloved R.W.S. could write in 1985, 'he painted extensively in Europe, *particularly Spain*, where he found his most well-known subject-matter—gypsy girls.' Perhaps the saddest reflection on the shallowness of the modern critic's knowledge is the offhand and patronising entry in *The Directory of British Water-colour Artists*, 'He also produced a number of landscapes whose merits are often overlooked in the contemplation of the banal if technically brilliant breastscapes which filled his later years.' The selection of 'breastscapes' in this volume are, by any standards, magnificent works and yet one looks in vain for the inclusion of Russell Flint in any academic treatise on the nude.

The following pages, then, display, for the reader's approbation, a representative selection; a selection of harbours and hills, of buildings and boats, of beaches and book plates, of gardens and trees and rivers, of churches and shipyards, of female figures clad and unclad, and just one or two Spanish gypsy dancers.

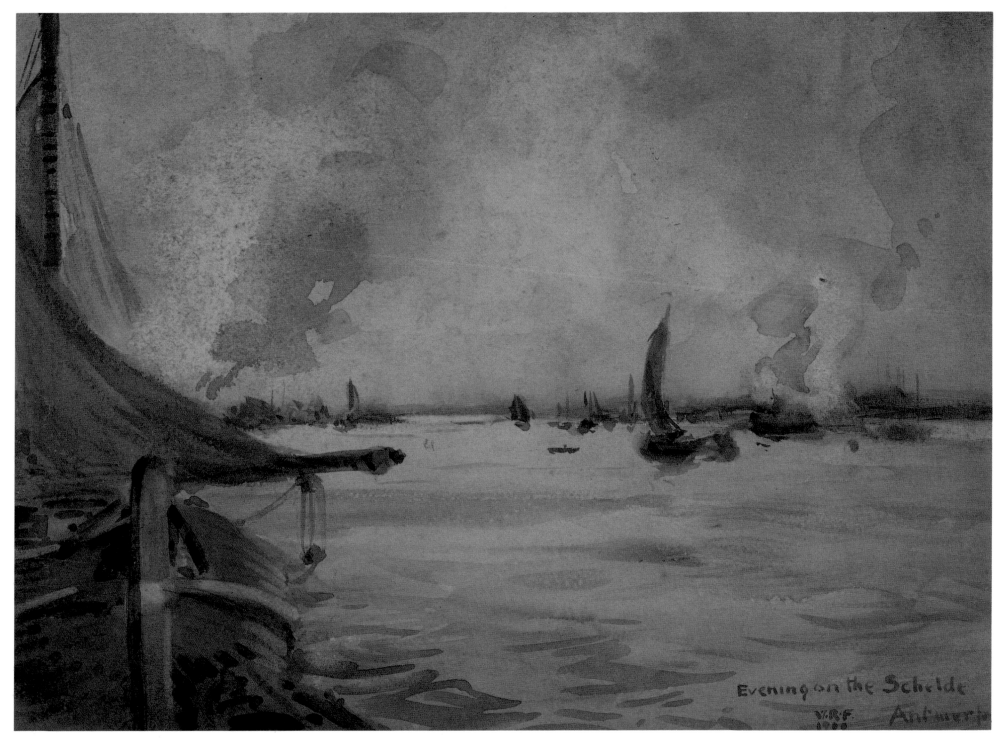

Evening on the Schelde, Antwerp, 1900
Water-colour 6¾″ x 9¾″
[*Courtesy Alan Gardiner*]

When the 'six long years of damnable purgatory' (as an apprentice at Banks) were over, Willie and his younger brother, Robert Purves Flint [R.W.S. 1937], set off on a great adventure. They took passage from the port of Leith to London and thence via Dieppe to Paris and the Low Countries. It was the first of many such visits for Willie, and was doubtless inspired by the close affinity of his mentors in the Glasgow School with the Dutch painters of the closing decades of the nineteenth century. He much admired the work of the Hague School artist James Maris, whilst the influence of Glasgow techniques, particularly of Arthur Melville [R.W.S. 1899], is apparent in this simple example from the 1900 tour.

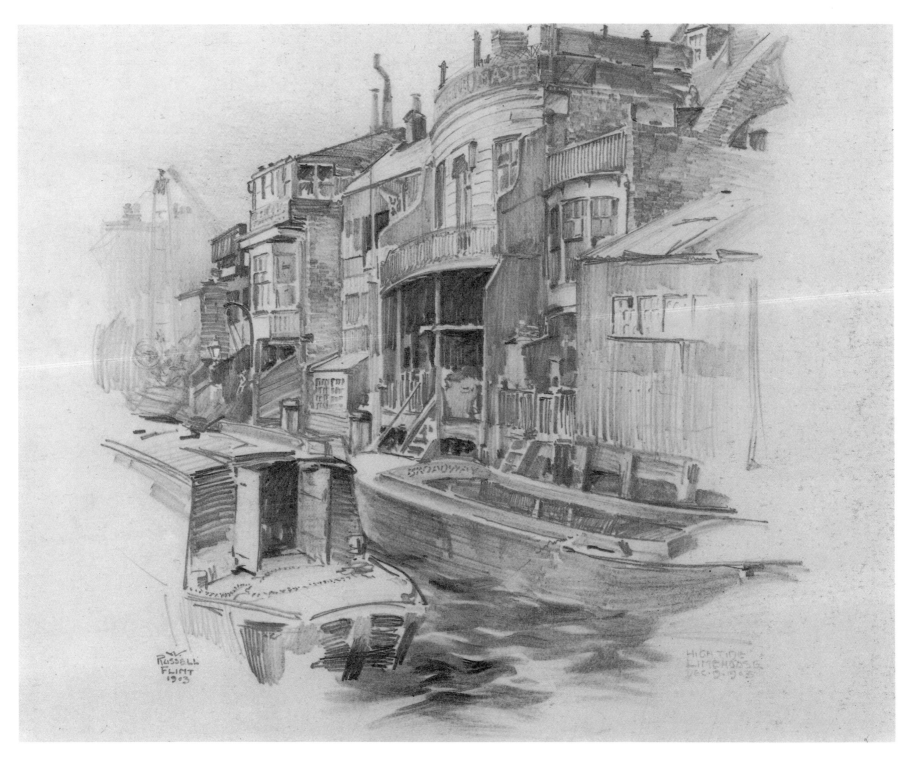

High Tide at Limehouse, 1903
Pencil 6½″ x 8″

Schooled in the tradition of black and white line-drawing
and encouraged by the demand for draughtsmen by the
magazines of the day, the young W.R.F. enrolled at
Heatherley's School of Fine Art. By 1903 he was hawking
his sample drawings up and down Fleet Street, until in
December of that year he was successfully engaged by
the *Illustrated London News*. It may well be that this
pencilled study of Limehouse formed part of his porto-
folio.

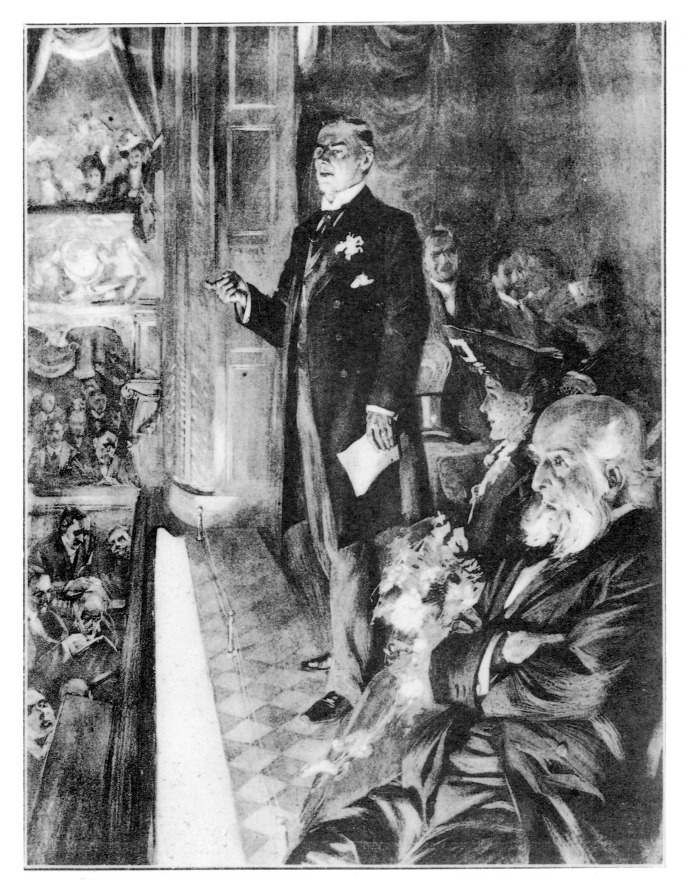

During the years 1904-7, W.R.F. worked as a staff illustrator for the *Illustrated London News*, covering live events with sketch pad in hand and using his lively imagination to construct plausible views of action abroad. Eventually, 'the camera already having begun its damnable work', he turned more and more to private commission work. He continued to supply the *I.L.N.* with two drawings per week, but the days of the news artist were numbered.

In 1905, having married Sibylle Seuter whom he met through Heatherley's, he was commissioned by Cassells to illustrate a new edition of *King Solomon's Mines*, with thirty-three new black and white drawings. The honeymoon was curtailed, the drawings produced and Rider Haggard having expressed his approval, the book was published. It was Russell Flint's first book.

Russell Flint's involvement in water-colour painting had, of necessity, to take something of a back seat, although from 1906 he regularly exhibited at the R.A. Now, inspired by the coloured book illustrations of Arthur Rackham [*Rip Van Winkle*, *Grimm's Fairy Tales* etc], he began to experiment in coloured illustration. His first commission came from Philip Lee Warner. The year 1406 had first seen the publication in Latin of Thomas à Kempis's *Imitatio Christi*. As 'an admonition useful for a spiritual life', it had been translated into English in 1503, and now Warner, on behalf of Chatto and Windus, planned a special edition illustrated with eleven colour plates to be designed and executed by W.R.F.
Of his father, Russell Flint had said that 'he had the medieval miniaturist's skill', a skill which was obviously passed on to the son. There emerges an almost Pre-Raphaelite feeling for romance and precision in his work; but in this first of his coloured illustrations there is also a sense of tentative experiment, his Glasgow School roots are successfully suppressed and the discipline of the draughtsman rules.

Illustrated London News, 1905/7
Engraving
[*Courtesy Illustrated London News*]

'Our great Englishman…hit at him with all his force'
Pencil 5″ x 3″
King Solomon's Mines 1905 (*Book*)

'My son…struggleth for what he desireth'
Water-colour 5½″ x 4″
Imitatio Christi, 1908 (*Book*)

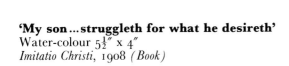

My son, oftentimes a man, vehemently struggleth for somewhat he desireth, but when he hath arrived at it, he beginneth to be of another mind; for the affections do not long remain on one object, but rather urge us from one thing to another.

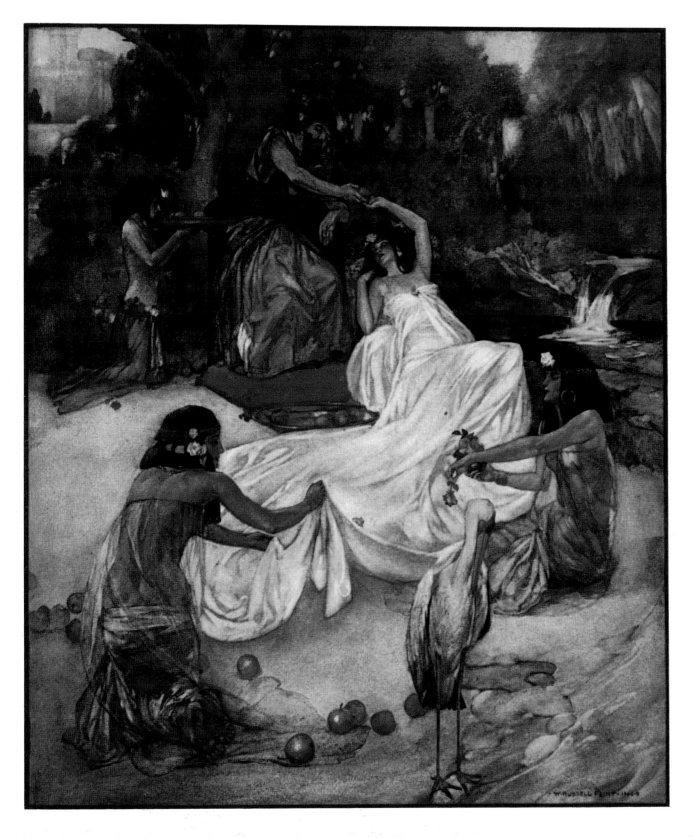

In 1908 he decided to hold a one-man exhibition and so rented the New Dudley Gallery in Piccadilly. The basis of the show was a collection of water-colour landscapes with a few pastels, and alas for the future president of the Royal Water-colour Society, it was not a success—in fact he lost £92!Fortunately, he had included a set of six uncommissioned drawings, illustrative of the biblical 'Song of Solomon'. Philip Lee Warner, now with Medici Society, secured them and published them, with the text, as the first deluxe edition of the Medici's Riccardi Press.

I am the rose of Sharon,
And the lily of the valleys.

As the lily among thorns,
So is my love among the daughters.

As the apple tree among the trees of the wood,
So is my beloved among the sons.

I sat down under his shadow
With great delight,
And his fruit was sweet to my taste.
He brought me to the banqueting house,
And his banner over me was love.

Stay me with flagons, comfort me with apples:
For I am sick of love.
His left hand is under my head,
And his right hand doth embrace me.

I charge you, O ye daughters of Jerusalem,
By the roes, and by the hinds of the field,
That ye stir not up, nor awake my love,
Till he please.

'I sat down under his shadow with great delight'
Water-colour 6″ x 5¼″
Song of Songs, 1908 *(Book)*

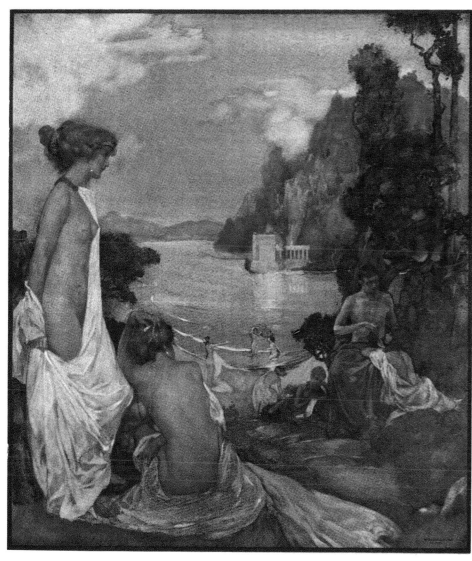

'Certain islands of the Happy'
Water-colour 4½″ x 4″
Marcus Aurelius, 1909 *(Book)*

With Philip Lee Warner, friend and patron, now well entrenched in charge of the Riccardi Press, a series of commissions kept Russell Flint busy. The classical *Thoughts of Marcus Aurelius* (1909) and Kingsley's *Heroes* (1914) brought him much acclaim and still stand as prime examples of the illustrator's interpretive art. *Marcus Aurelius* was again a philosophical work translated from the Latin, and brought him some adverse comment from the more prudish critics.

Heroes, however, was a free interpretation by Charles Kingsley, sub-titled *Greek Fairy Tales for my Children*, and included the mythical Jason and the Argonauts, Perseus and Theseus, who is illustrated here. After killing Periphetes, Theseus had taken up the ogre's club and bearskin, when the Arcadian nymphs and shepherds, mistaking him for their late tormentor, fled. Having learnt Theseus's true identity they 'leapt across the pool and came to him'.

'Then they leapt across the pool and came to him'
Water-colour 4″ x 5″
Heroes, 1912 *(Book)*

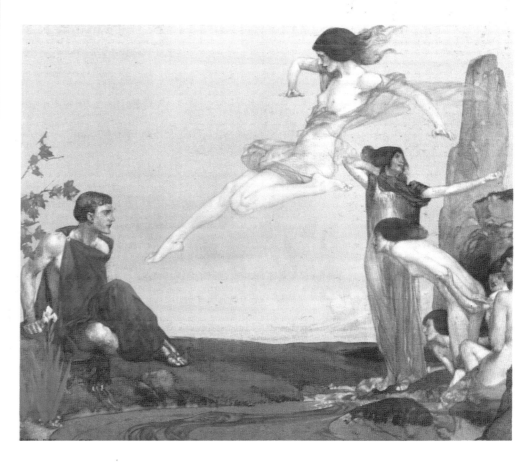

'And they put on their helms and departed'
Water-colour 4″ x 5⅛″
Le Morte d'Arthur, 1910/11 *(Book)*

In 1407 Malory, having collected together the medieval romances of Arthur, folk hero of the Celtic west, issued them in manuscript form. It was subsequently Caxton, with his newly developed printing press, who first published them in book form in 1485. Since that time they have been edited and re-written, most impressively by Tennyson as the high Victorian poem, 'The Idylls of the King'. Philip Lee Warner obviously saw this as a great challenge for the Riccardi Press. W.R.F. accepted the commission with equal enthusiasm. It kept him busy for two years, and when the forty-eight plates were finally completed, he could, he said, have done another forty-eight. The four volumes published by Warner through 1910 and 1911 were in a limited edition of five hundred on paper, bound in vellum and tape, plus twelve actually printed on vellum. After the Great War a two-volume edition was released, and a combined single volume followed in 1927.

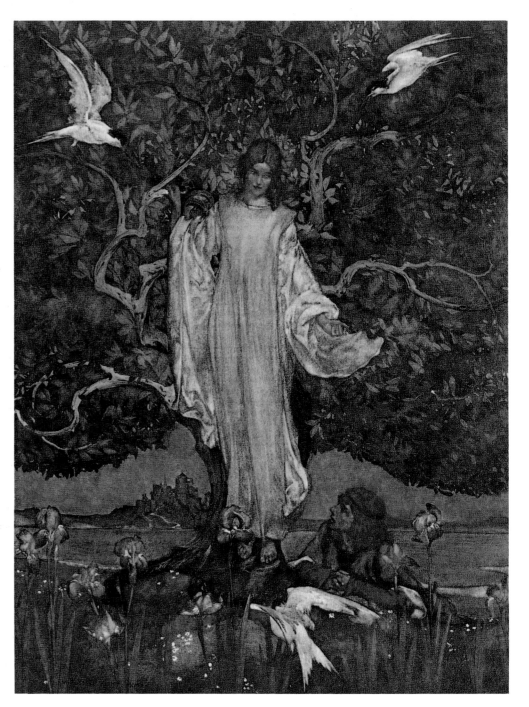

'Sir Pelleas and the Damosel of the Lake'
Water-colour 6½″ x 5″
Le Morte d'Arthur, 1910/11 *(Book)*

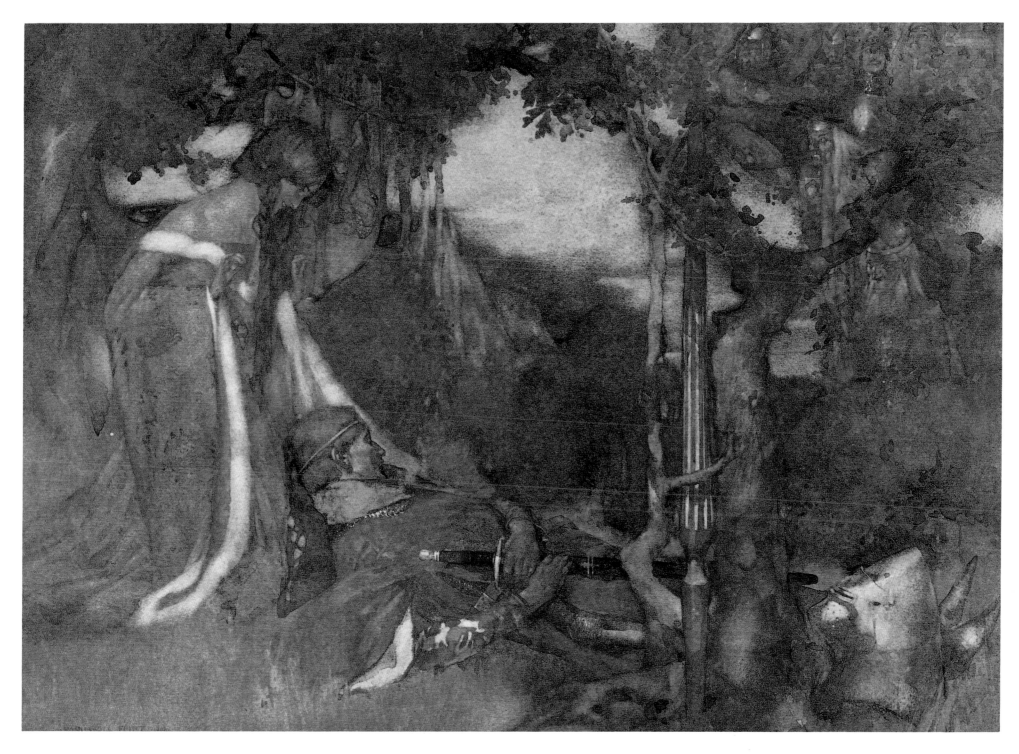

'La Belle Dame sans Merci', 1908
(The Enchanted Forest)
Water-colour 17½″ x 25″
[*Courtesy Walker Art Gallery, Liverpool*]

The pleasure he derived from such material as *Le Morte d'Arthur* and *Imitatio Christi* is perhaps crystallised in this example, known in print form as *The Enchanted Forest*. There is a Rackham-inspired grotesqueness about the trees and the fairy faces amid the leaves, but there is a softness and dedication which makes this much more than just an illustration. Here we see a combination of all that his fourteen years of training had given him; technique and poetry come together in this romantic fairy tale.

In 1909, George Bell published the first collection of the Gilbert and Sullivan operas to be illustrated by W.R.F. Called *The Savoy Operas*, it contained *The Pirates of Penzance, Patience, Princess Ida* and *Yeoman of the Guard*. It was quickly followed in 1910 by a twin volume entitled *Iolanthe and other Operas*, the others being *The Mikado, Ruddigore* and *The Gondoliers*. In 1911 and 1912, each of the operas was republished as a separate title for 3/6d, each containing eight illustrations by Russell Flint. Macmillan published them again in 1928.

The opera series, however, involved the artist in late nights and tiresome journeys travelling to provincial theatres, and he was somewhat relieved to return to Warner who needed illustrations for a new edition of Chaucer. W.R.F.'s love of classics, religion and medieval romance was obvious in his usual choice of commission, and it is perhaps revealing that his illustrations of the full-blooded and often bawdy tales of the Canterbury pilgrims seem somewhat to lack enthusiasm.

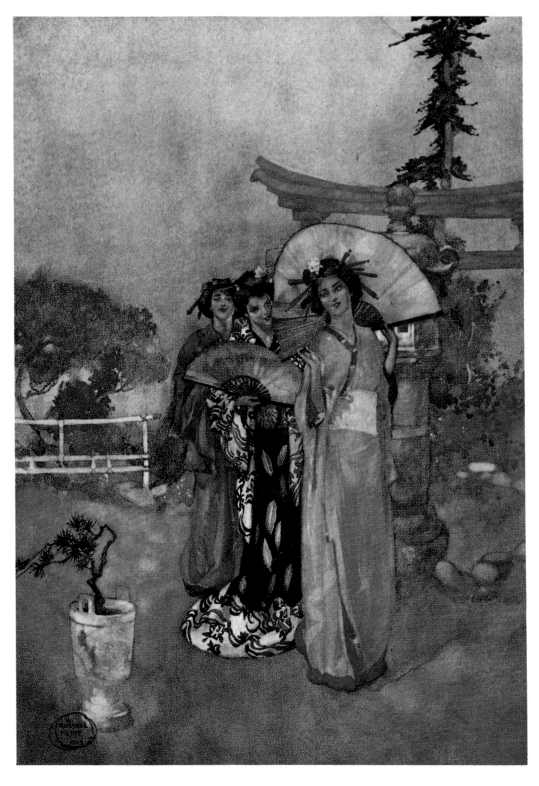

'Three little maids from school'
Water-colour 6¼″ x 4½″
Savoy Operas, 1909 *(Book)*

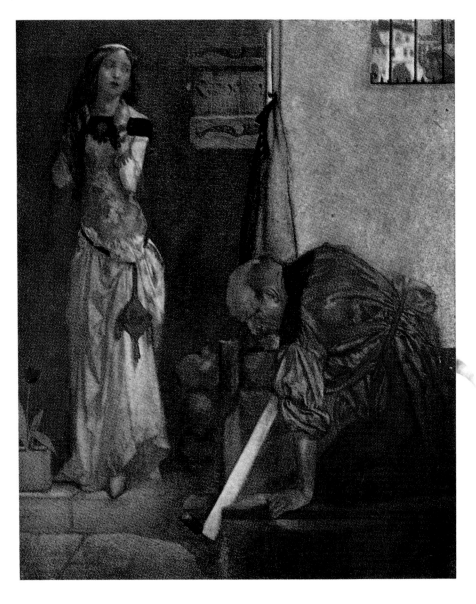

'The Carpenter had a wife of 18 years old'
Water-colour 5¼″ x 4¼″
Canterbury Tales, 1913 *(Book)*

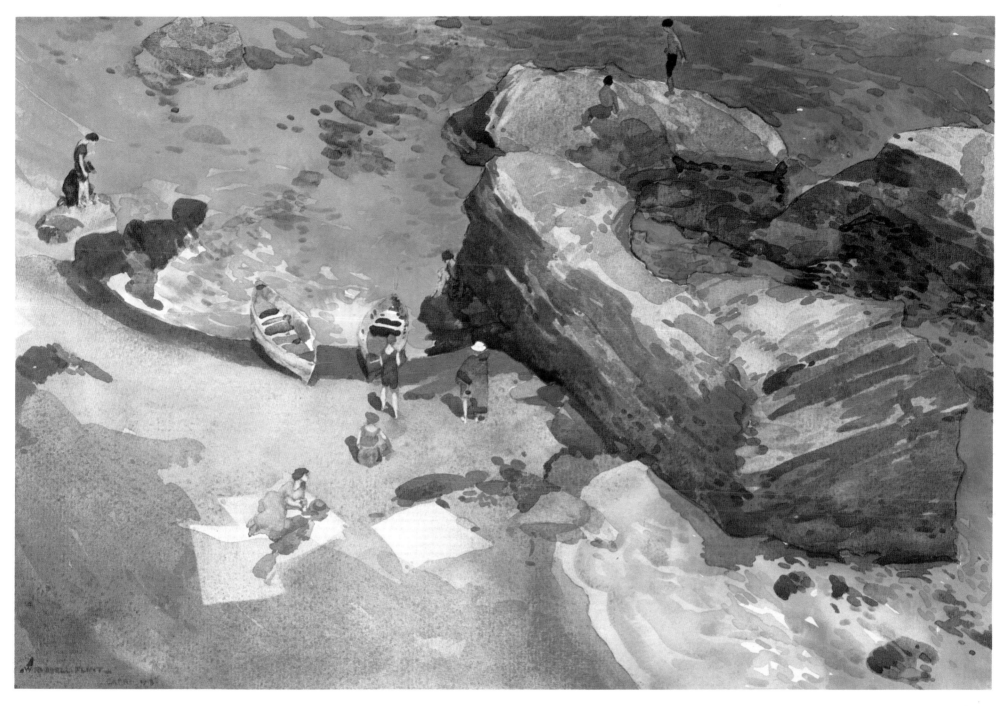

The eve of the 'war to end all wars' saw the end of this particular phase of W.R.F.'s long working life as an artist. However, before Europe was plunged into chaos he had the foresight to take a holiday, and in 1912, with his wife, he departed for an extended visit to Italy. Having stayed for the first few weeks in the Sabine hills, much of their time was spent at a rented studio in an artists' colony near Rome, in the grounds of the Villa Strohl Fern. When winter ended they toured, in the balmy spring of 1913, through Naples, Capri and Sicily, back to Florence and Venice, and home. Although these were happy days for the Flints, and he was to return to Italy again many times, he was disappointed in the

pallid, sun-bleached colour of landscape and building alike, and significantly (in view of a later critic's comments on his work) he complained of the 'utter picturesqueness of everything'. But the opportunity to escape from the disciplined life of a commercial artist, with only one break between the ages of fourteen and thirty-two, had broadened his attitude and had allowed his instincts as a painter to develop free and unfettered. *From a Capri Cliff* shows so clearly his background fifteen years before in the Glasgow School of Arthur Melville and others, with their use of the 'blottesque' technique, pattern-making 'blobs' of colour, which together give a delightfully loose and impressionistic effect.

From a Capri Cliff, 1913
Water-colour 9″ x 13¾″
[*Courtesy Richard Green Gallery*]

47

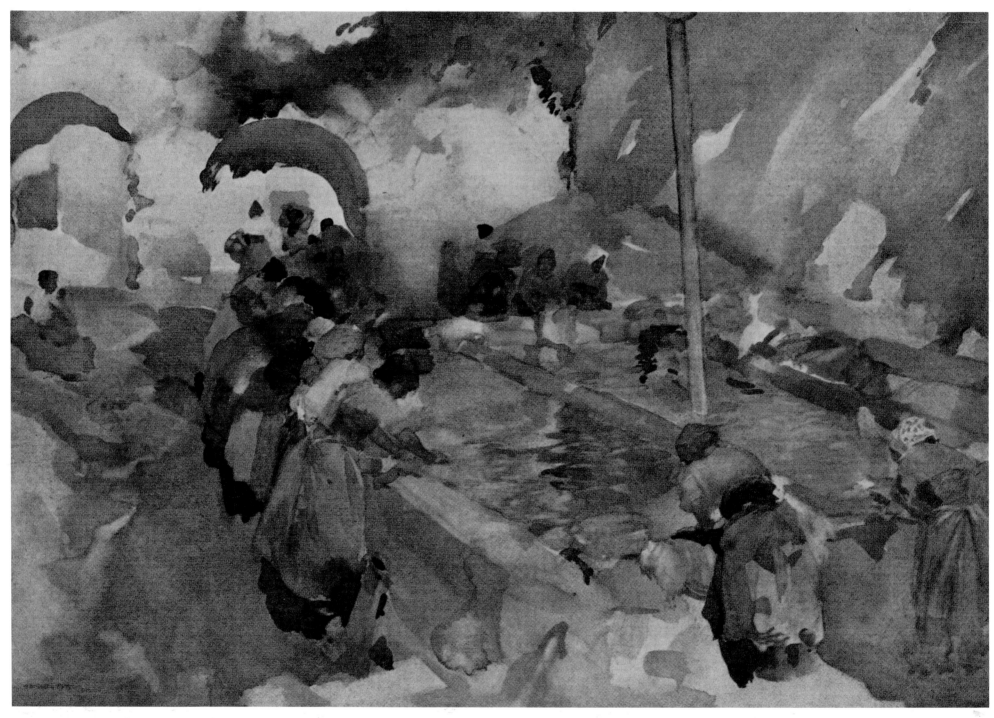

Sabine Washerwomen, Subiaco, 1912
Water-colour 14″ x 20½″

Before settling in Rome, W.R.F. and his wife stayed in
Orvieto and Subiaco, in the Sabine hills, and we now
see one of the first of the genre which he was to pursue
so avidly in France in later years, that of the peasant
lavoir—the public washing-place where the womenfolk
toiled at their daily chores.

Simonetta and Her Companions, 1963
Water-colour $26\frac{1}{2}''$ x $19\frac{1}{2}''$

Fifty years on he returned yet again to Italy—to Venice, this time with his artist/sailor companion, Admiral John Moore. In his notebook, he recorded painting 'R [] Campiello—chimneys'. The basic work, as was his habit (and who can blame him at eighty-three?), was taken back to London and through the winter months embellished with different poses by Ray Fuller and Cecilia Green, to produce his final study of Italian peasant women at work—but these are not peasants. The difference between these two pictures is much more than a mere fifty years of time. The discipline of tight commercial illustration was relaxed in the Sabine hills, and he painted loosely and freely what he saw—his peasants were peasants. The world was real and beautiful. But fifty years later we see the experience of a lifetime, and not merely in his technique, which is now his own— no trace of Glaswegian accent here. Supremely confident, faultless in composition and in colour, in figure and in architecture, this picture represents W.R.F. at his technical peak. But he has lost touch with that reality; the romantic rules again—the romance of *Morte d'Arthur*, of *Solomon* and of *Heroes*. His peasant girls, like Theseus's nymphs, are heroines indeed.

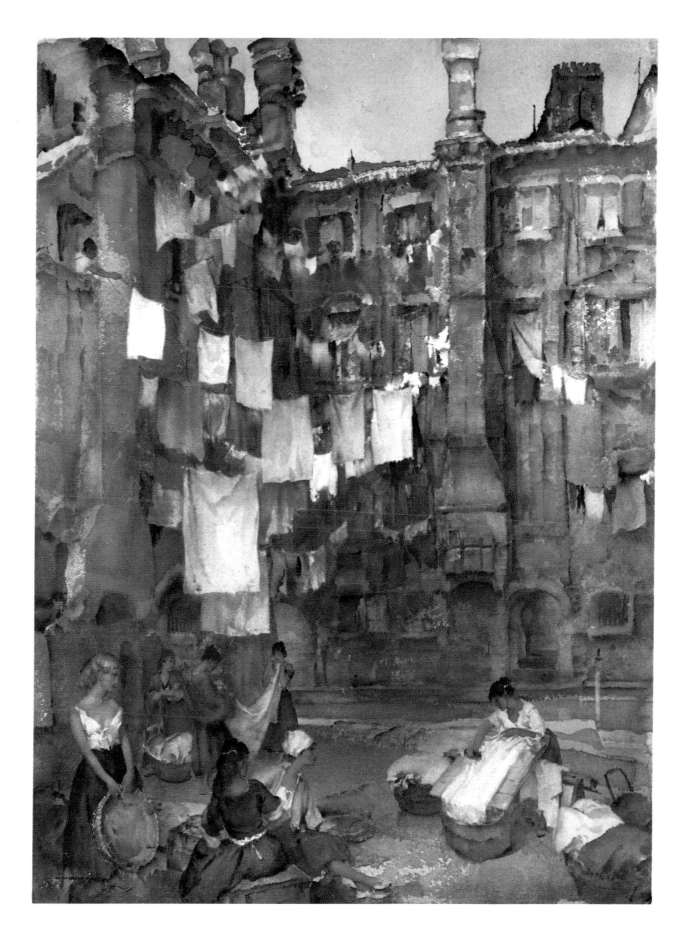

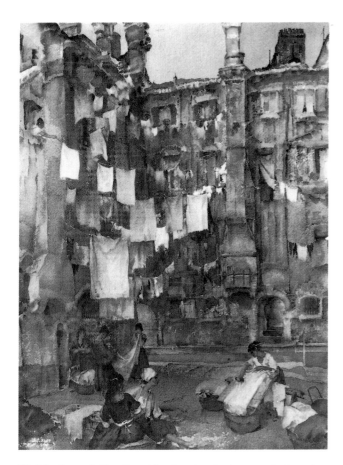

Finished as *A Venetian Monday*, he had second thoughts and inserted the blonde Ray Fuller as Simonetta.

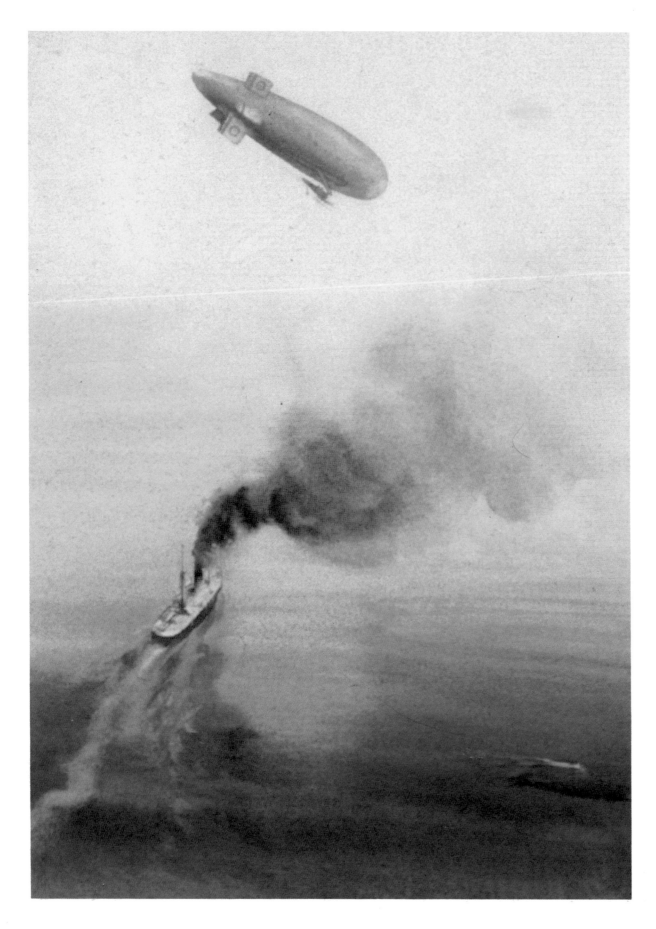

S. S. Airship Warning a Food Vessel of a Submarine, 1918
Water-colour 13″ x 9½″
[*Courtesy Royal Air Force Museum, Hendon*]

Suddenly, in 1914, almost by accident, Europe found itself embroiled in a long and bitter war. W.R.F. had had the luck to marry into a naval family. His father-in-law was Fleet Paymaster and his brother-in-law, later to become Admiral Sir Murray Seuter, was appointed Director of the Naval Air Department. Fate had cast its dice and the horror of Passchendaele was not for him. After suitable training as a lieutenant in the Royal Naval Volunteer Reserve, he was posted to his native Scotland, to Inchinnan on the Clyde, as Admiralty Overseer of Airships. Later, with the conversion of the Royal Naval Air Service and the Royal Flying Corps into the Royal Air Force, he was transferred to the latter with the rank of captain. The 'Blimp' patrol's responsibility was to escort merchant fleets and it was their proud boast that they never lost a ship in their care to the marauding U-boats. The duty is well illustrated here.

Warneford V.C. 1915
Autolithograph 15″ x 20½″

In August 1915, the Medici Society published a limited edition autolithograph, illustrating Sub-Flight Lieutenant R. Warneford's action in destroying a Zeppelin, for which he was awarded the V.C. Two hundred copies were produced to sell at one guinea each.

The Doomed Battleship and the *S.S. Airship* were illustrations for his brother-in-law's autobiography, *Airmen and Noahs*, and now reside in the R.A.F. Museum at Hendon.

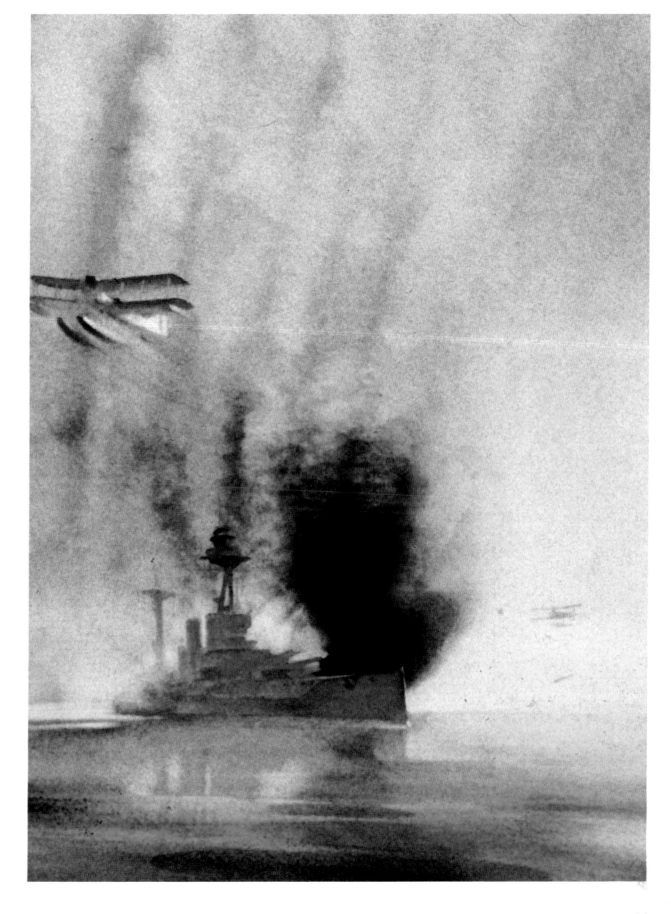

The Doomed Battleship, 1918
Water-colour 12½″ x 9″
[*Courtesy Royal Air Force Museum, Hendon*]

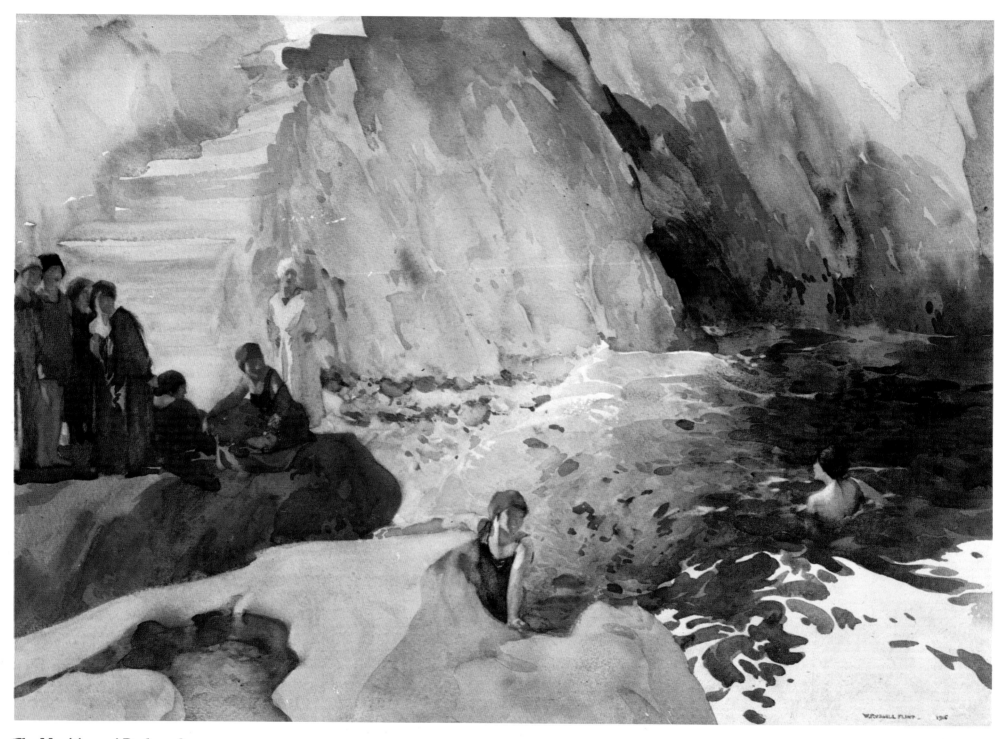

The Munitioners' Pool, 1916
Water-colour 14″ x 20¼″
[*Courtesy Christie's*]

Whenever his duties at Inchinnan permitted, he escaped
to Oakbank, a quiet country house at Shandon, on the
Gareloch, and relaxed with brush and palette. In *The
Munitioners' Pool*, a picture depicting a group of women
war-workers relaxing in 1916, he has retained much of
the blottesque technique used at Capri three years before.

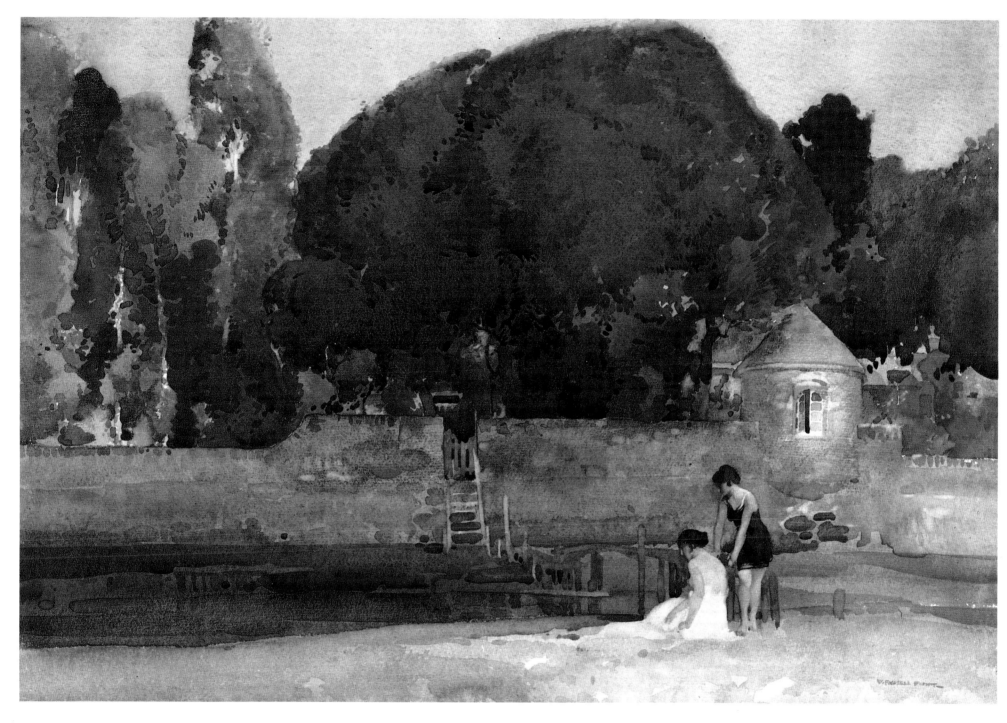

The Turret Pool, 1917
Water-colour 15″ x 22″
[*Courtesy Sotheby's*]

In *The Turret Pool*, painted in the garden of Oakbank itself in 1917, we see a development. The whole work is tighter and more confident, and the use of wet-on-wet in the portrayal of foliage in the trees is a technique which he continued to use with increasing pleasure and skill for the next fifty years.

It may not be insignificant that it was in this year, 1917, that he was raised to the full status of an R.W.S., having been elected Associate in the year following his return from Italy. Russell Flint the illustrator and draughtsman was developing into Russell Flint the painter. On his discharge from the R.A.F. he made the great decision. He would not return to commercial illustration; he would not accept commissions. At the age of forty he would become a painter of landscapes and figures. He prepared for an exhibition at the Fine Art Society in London, an exhibition which, unlike its predecessor, was an absolute sell-out. William Russell Flint had arrived.

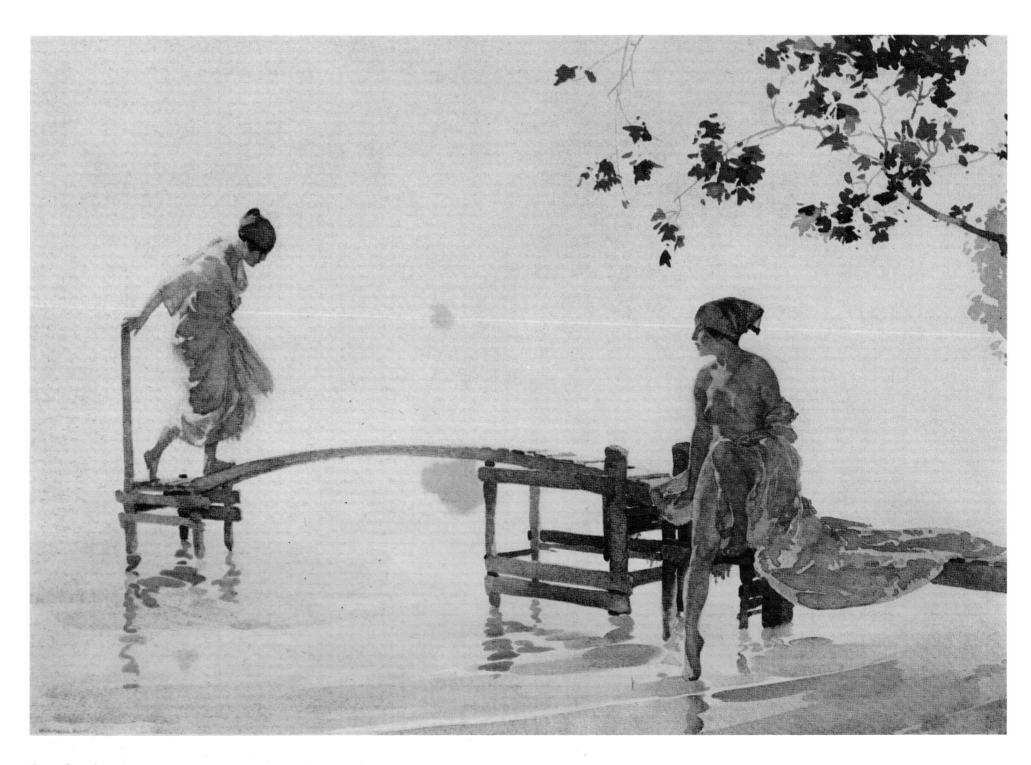

June Caprice, c. 1920
Water-colour 15″ x 21½″

Many of his subjects were light and frivolous, and were enthusiastically taken up by the war-weary public to whom tranquillity and beauty were pleasures long denied. In *June Caprice* we see the new Russell Flint. A still morning on the Gareloch is the setting for the graceful composition of curved arch linking the two barefoot girls, with just a hint of Japan in the introduction of the leafy bough, a theme repeated in *Phillida—The Girl with the Cloche Hat*.

Also painted on the banks of the Gareloch, this was the first to be reproduced by W.J. Stacey as a coloured limited edition print, signed by the artist and stamped by the Fine Art Trade Guild. Well over a hundred more were to follow over the next forty-five years, and it was this particular form of exposure to the public that made him a household name. During his airship days, testing flights over the North Sea often took him over the Northumberland coast, over St. Aidan's Dunes running south from Bamburgh Castle to Seahouses. He promised himself that when the war ended he would return there and paint the peace and beauty of the place, the intense blue of the North Sea in the evening light, the brightness of the sunlit sands.

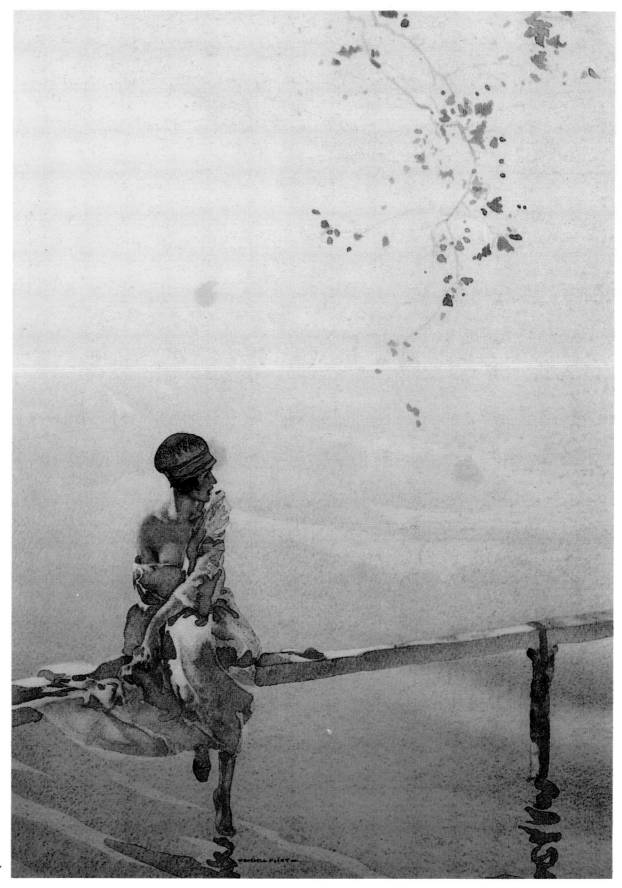

Phillida, c. 1920
Water-colour 12¼″ x 9″

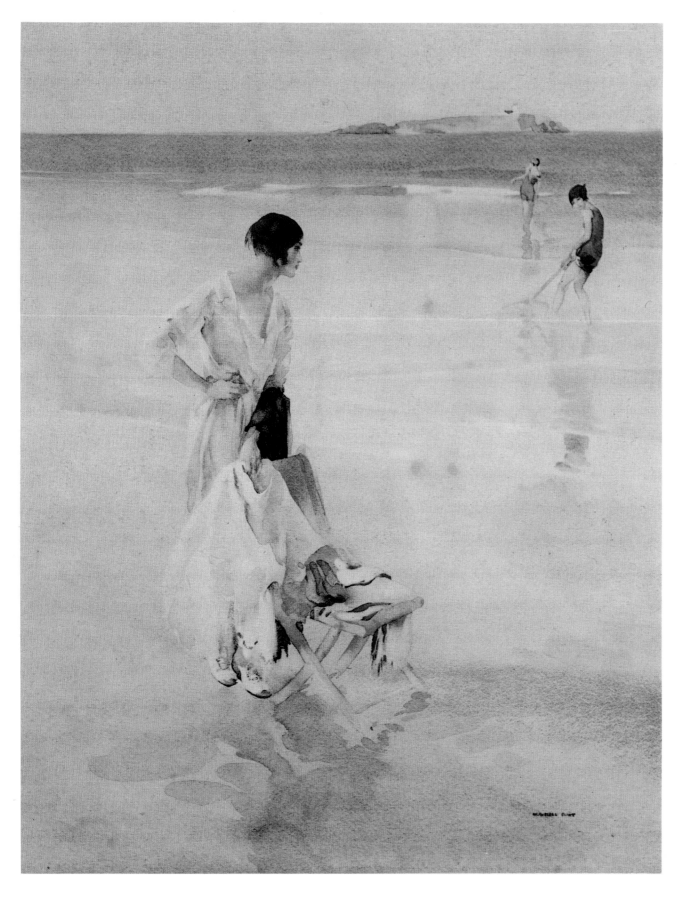

The Guardian, c. 1923
Water-colour 12¼″ x 9½″

The Guardian is very much a family picture, with Farne Island and its lighthouse recognisable in the background. With the arrival of his only child Francis in 1915, trips to the seaside became working affairs, staying, in the early twenties, in the Ship Hotel, Seahouses. His note book for 1920 lists no less than forty-six paintings under the heading 'Begun at Bamburgh'.

By contrast, *Gitanas à la Galera* was the very last limited edition publication to be signed by him, actually being released in 1970 after his death. It is the work of a master in his ninetieth year, and again almost fifty years separate the two pictures.

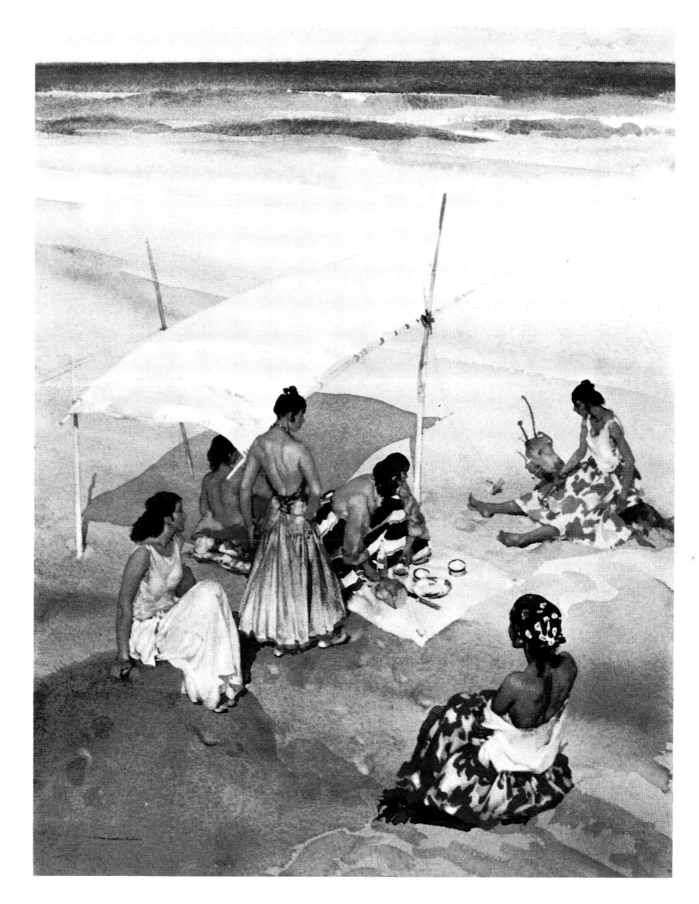

Gitanas à la Galera, 1968
Water-colour 26½″ x 19½″

Les Petits Sables, Concarneau, 1922
Water-colour 9½″ x 13″
[*Courtesy Richard Green Gallery*]

Between the wars, with his wife and young son, many of his working trips were perforce of a holiday nature—to the beaches of Brittany, to St Malo, Concarneau and Dinard. Here, once again, the early technique is clearly seen.

Paddling in the Shallows, 1927
Water-colour $9\frac{3}{4}''$ x $13\frac{1}{2}''$

Before his elevation to full status as a Royal Academician and in relaxed and anachronistic style, he produced this exquisite gem *Paddling in the Shallows*. Note the use of wet-on-wet to build up the impression of distance on the left, and the effect of the jumble of impressionistic 'blobs' to create figures and objects in the centre and right. As a subject it may be of little importance, but the sheer pleasure he felt in its execution is abundantly apparent.

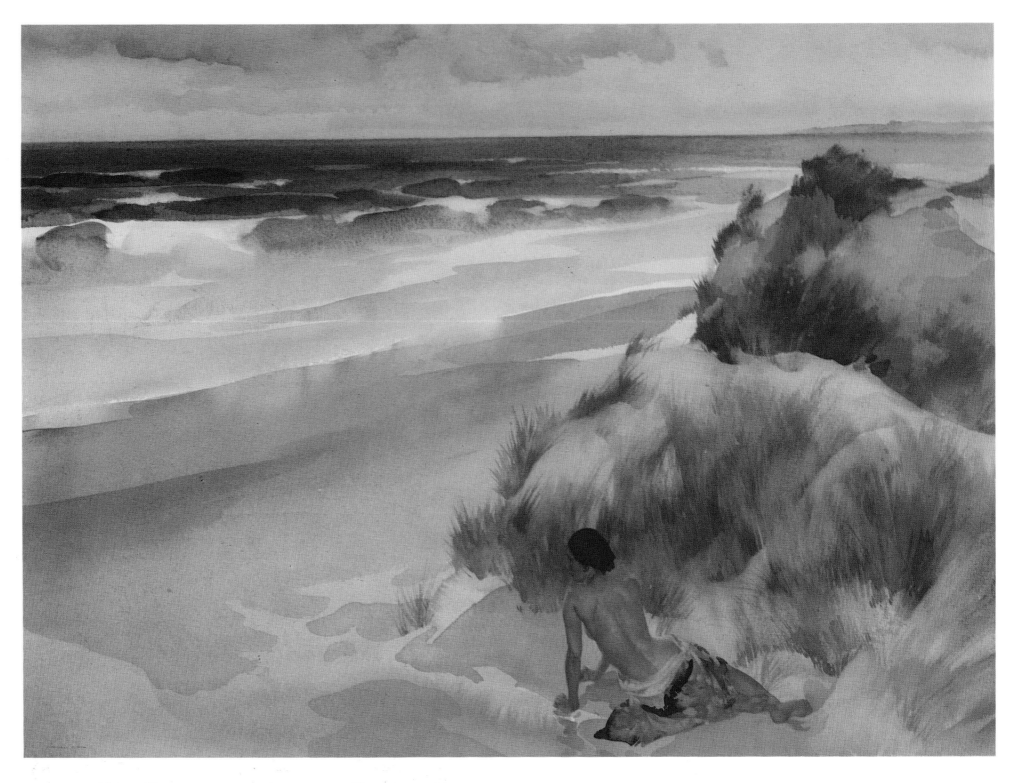

Model for a Mermaid, 1932
Water-colour 19½″ x 27″

Throughout the thirties, he found a ready market for his more popular beach girls, a number of which were published as signed limited editions. Bamburgh sands remained a favourite locale but as he was now living in London, the Breton beach at Pararmé near St Malo was almost as convenient (and probably warmer).

Of his beach paintings he wrote that they were 'In my opinion, technically the most difficult of all forms of water-colour painting and the purest. I might be asked why and the answer would be that these subjects are essentially the most delicate, direct and subtle of all. Any heaviness, any fumbling, any muddiness of colour would ruin them. I claim that there is far more in them than meets even the most professional eyes, and I unashamedly confess to amusement at imitators' efforts. I never "make them up." '

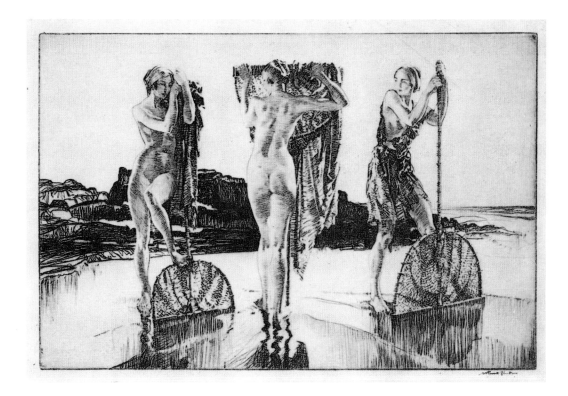

For a short span of seven years (1928-35), before eye-strain caused him to give it up, he practised the art of dry-point engraving. With hardened steel or diamond burin every line was carefully cut into the soft copper plate before, on his own printing press, a copy was pulled on antique paper for his own critical approbation. Of the sixty-six plates, only half reached the public eye in the form of a limited signed state, usually seventy-five in each edition. Of the others, only proofs would be pulled for himself before the plate was destroyed or, as here, irrevocably altered. Originally there were three girls on the beach but, said W.R.F., 'they did not swing together', so he cut the plate right and left and developed the centre portion only. Of the first state (three girls) only one print is known to exist. Of the final state (with the single girl), only seventy-five plus the artist's six were printed. Dry-points are very collectable items.

'Trying to model a nude figure in water-colour is difficult enough but it is child's play compared to dry-point. At first, this plate contained three figures of about equal size, all with big shrimp nets bought at St Malo. After moiling and toiling for ages I chopped two of them off and developed the central figure only.'

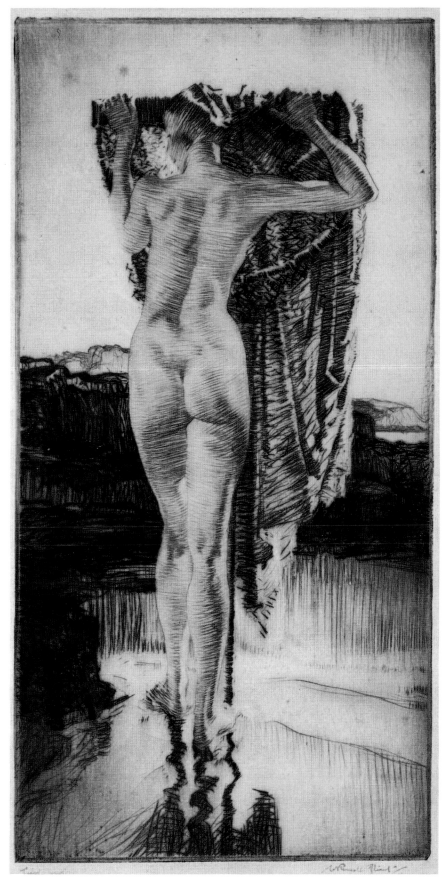

The Shrimper, 1931
Dry-point $9\frac{7}{16}''$ x $4\frac{15}{16}''$

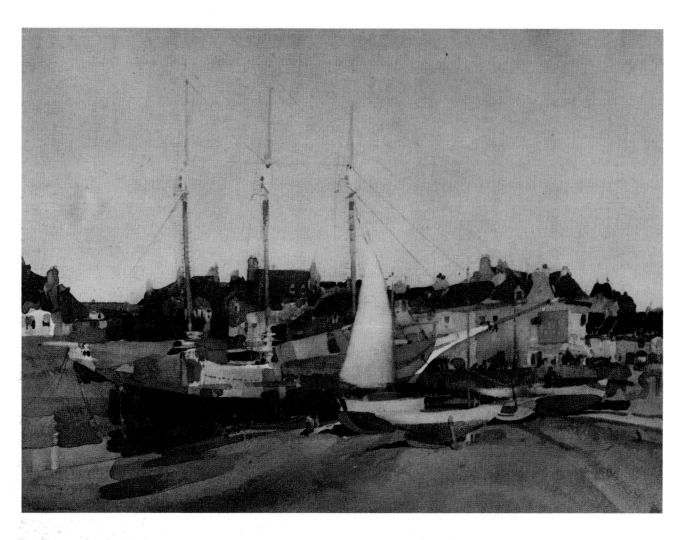

St. Servan-sur-Mare, c. 1925
Water-colour 14″ x 20″

'The fringe of harbour-water and the sand ridges take the eye towards the clean yachts and into the busy background. Note especially how the poetic imagination of the artist has created a delicate pattern from the different tones of humble homes on the harbour side.'—G.Sandilands, 1928.

His Breton interests, however, were not restricted to beach girls and shrimp nets. As an ex-navy man, his eye was constantly being drawn to the pleasure craft, the fishing fleets and the ship-building yards of the Atlantic ports.

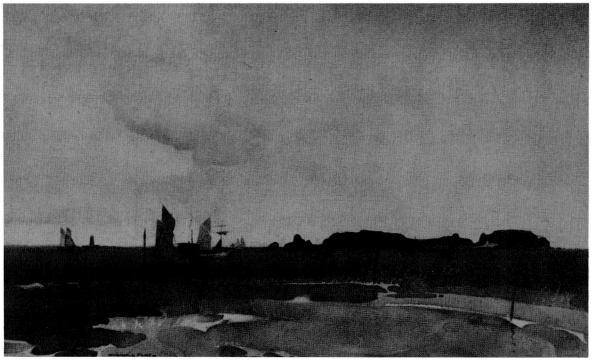

A Breton Sea Piece, c. 1925
Water-colour 13″ x 22″

'The sketch is simplicity itself. The wide wash of level colour is so slight that one can almost see the sand in the shallows.'—G.Sandilands, 1928.

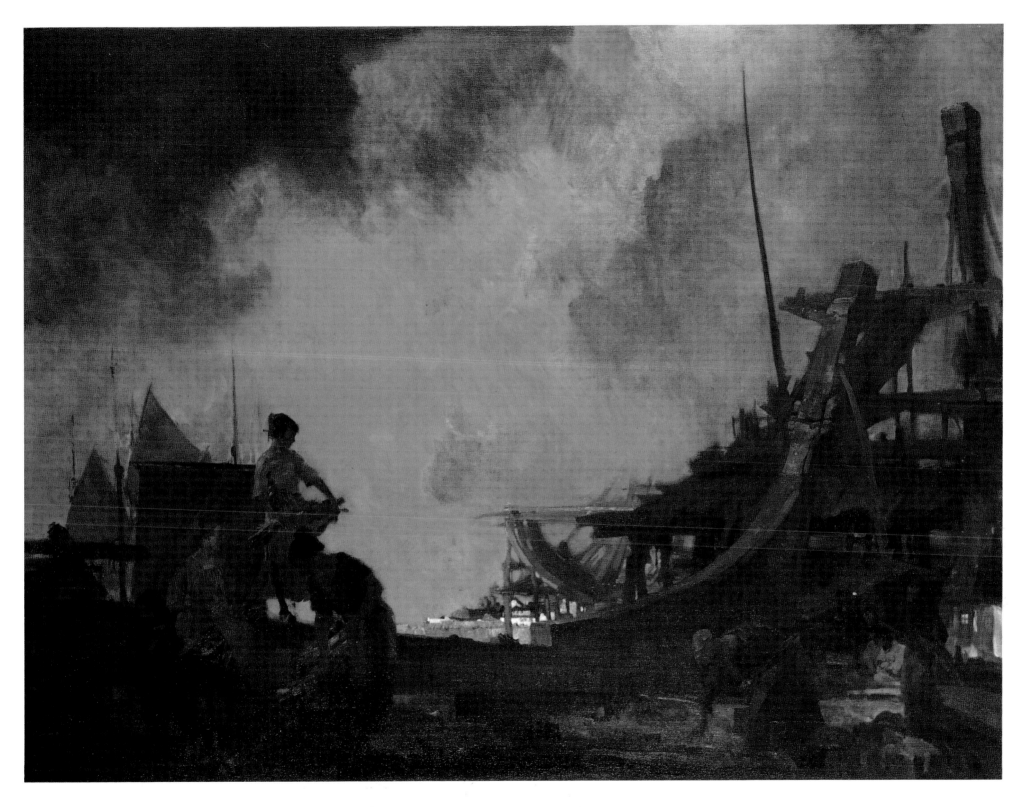

Shipyard Gleaners, 1925
Oil 40″ x 50″
[*Courtesy Birmingham Museums and Art Gallery*]

'Brittany girls gathering chips of wood. My first oil-painting after my election as A.R.A. to be shown at the Academy. The material had been obtained at Concarneau.'—W.R.F.

To adoring public and avant-garde critic alike, the name William Russell Flint is, ironically, synonymous with Spain and her Flamenco dancing gypsies—ironically, because he hardly painted there at all. In his autobiography, he carefully tried to disclaim his image. 'It tickles my fancy to note how some commentators assume that whenever I paint a dark-haired girl she must be Spanish. I have not painted in Spain since before World War II, though I have visited it and often wish I could paint there again. France, not Spain, is my painting country.'

His notebooks show that following his successful exhibition in 1919 he left Helensburgh on the Clyde on the eleventh day of March, 1920, for what was obviously intended as a leisurely three-month reconnaissance trip around Europe. By train from London, via Paris and Biarritz, they spent only ten days touring Spain before passing on to the Riviera and Italy. His notes show under the heading 'Subjects for which material has been obtained' many potential Spanish ones, and the winter of 1920/21 was spent in London painting many European subjects, including those of Spain. In 1921, with his

friend Henry Trier, he returned to Spain for a month's painting, for a total cost of £55! Forty years later, his R.A. catalogue notes against a water-colour of the Guadarrama Mountains state 'March 1921 and my first landscape in Spain'. But Spain was not a content and happy land. He managed one more trip with his wife in 1931 before the discontent erupted into civil war, a war which, in allowing the Luftwaffe to cut its teeth, ran the whole of Europe into bloodshed and horror once again. After the war, in 1952, he toured again, but it was France and not Spain where his true love lay.

Calatayud, 1921
Lithographic chalk $9\frac{3}{4}''$ x $13\frac{3}{4}''$

Cadiz, 1931
Sepia pen and wash $8\frac{1}{2}''$ x $13\frac{5}{8}''$

'Calatayud is the good name of a very interesting and various sort of town. It has (or had in 1931) lush, flat fields skirting the river, the Jalon. In one step one passed from the rich, fertile soil of the valley bed to absolutely arid, crumbling slopes. I used to climb up the Moorish "Castillo de Ayud" and look down on a scene containing more subjects, or at least as many, as anywhere in Spain.'

'This rapid sketch is my only souvenir of a distinctive city which, during my brief visit, was sweltering in midsummer heat. It was too exhausting for further effort, especially as I did not like the look of the lesser police who obviously did not like the look of anybody, particularly, I felt, of me and of my shabby drawing outfit, so suspiciously inconsistent with my powerful car.'

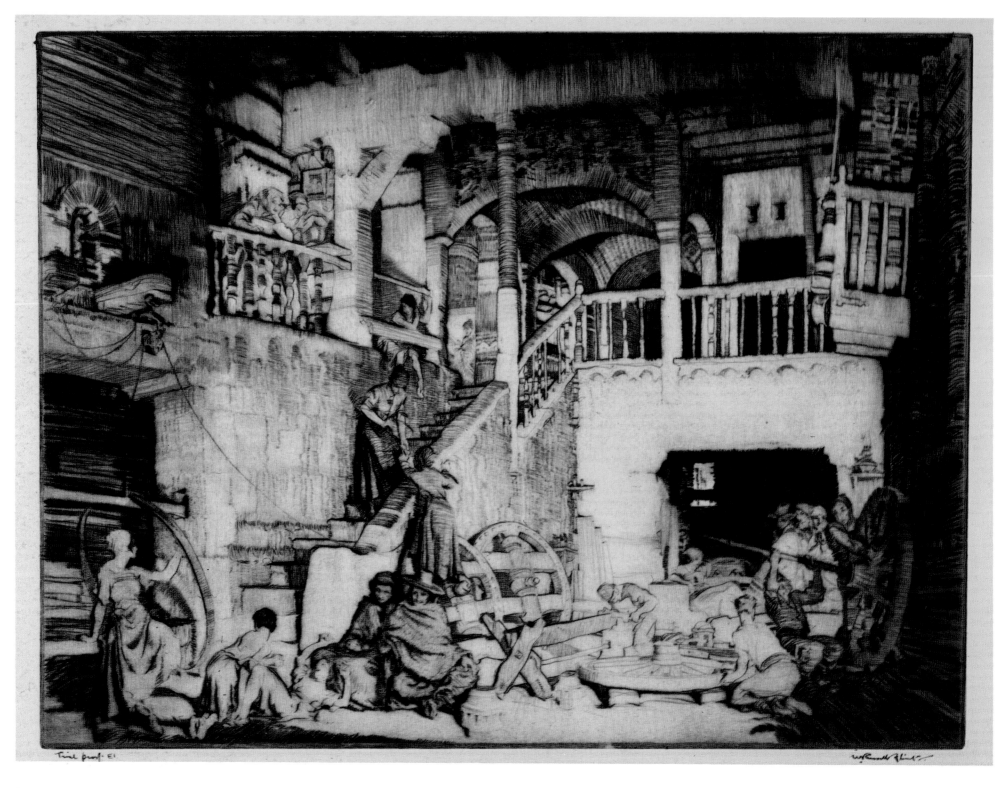

Trial proof. E1 W Russell Flint

Spanish Wheelwrights, 1931
Dry-point $9\frac{1}{2}''$ x $14\frac{1}{2}''$

'As this subject was so attractive I deliberately tried to make it as impressive as possible. It developed from a drawing of an interior of a noble house fallen from its high estate in a sun-bleached Castilian village. All the mechanical details are authentic but the dark central recess is an invention of my own.'

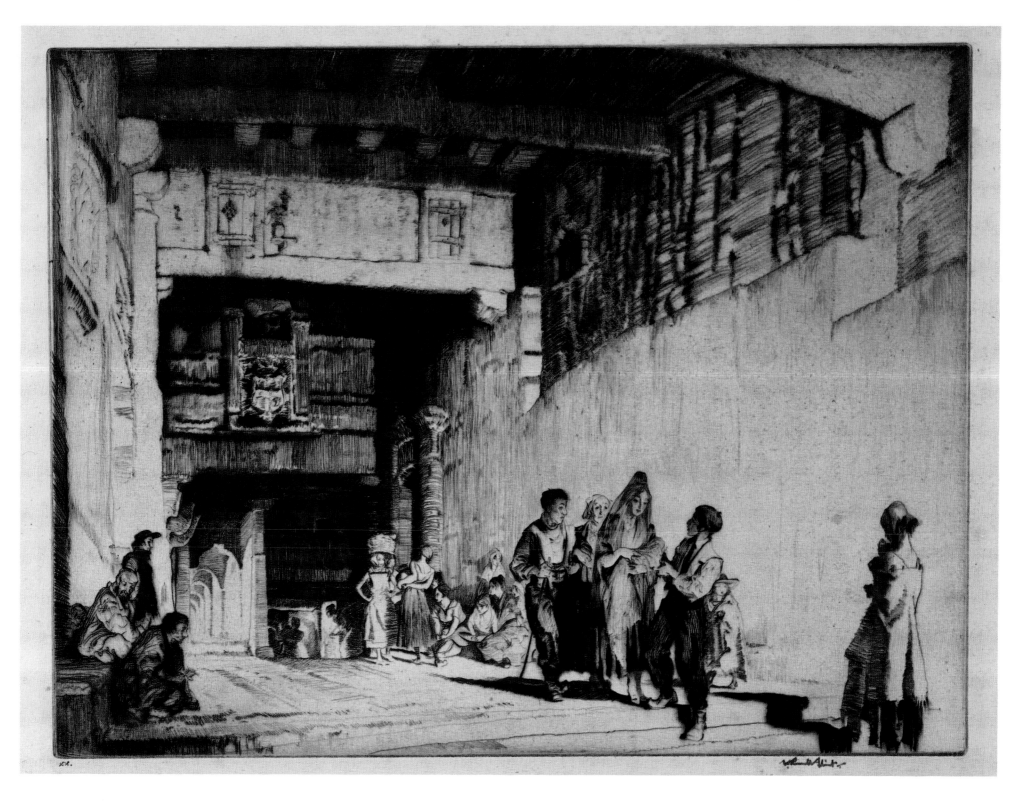

A Spanish Christening, 1928
Dry-point $9\frac{7}{8}$" x $11\frac{7}{8}$"

'Having failed in my first attempt at this subject—doubly attractive in its figure motif and its setting—I made this plate a test piece. The setting was superb. The Cloisters of the church at Orio were one of the finest subjects I ever saw. *Were*. They existed in their ancient dignity in 1921 but ten years later they were gone. Spain made much money in the First World War and spent a lot of it on incredible acts of vandalism towards its own architectural treasures.'

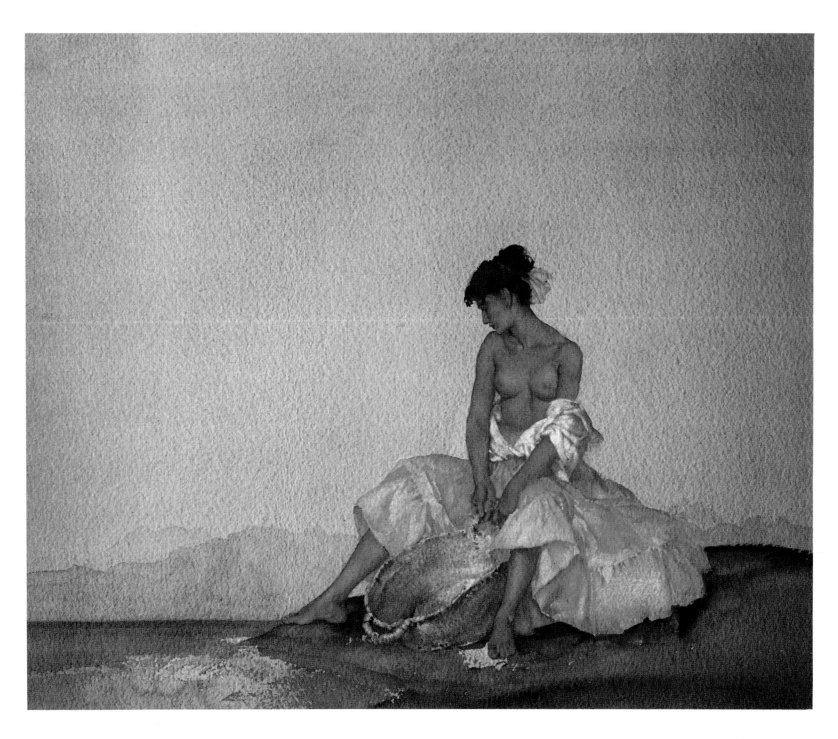

Ariadne, c. 1955
Water-colour 19½″ x 22½″

This is just one of a series of 'formula' pictures. In the warmth of his studio, with model and artist seated comfortably, he could ignore the London winter and create such a scene almost with his eyes shut. The public adored them for their technical wizardry—the simple impression of mountains, the skill of capturing every subtle tone of flesh and fabric alike. The later critics scorned them for their lack of intellectual meaning and used them as a cudgel with which to belabour him.

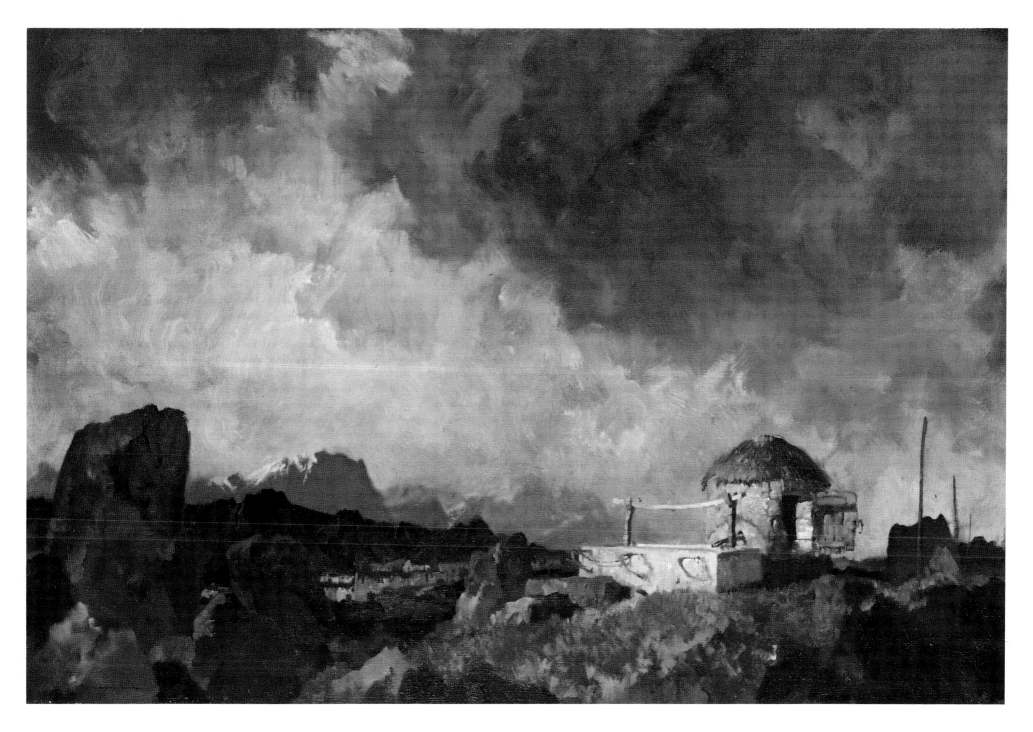

A Well Amid The Guadarrama Mountains, 1953
Oil 20″ x 30″
[*Courtesy Christie's*]

But of course he cared little for the critics' fury, and why should he when he could equally well confound them by such a powerful and magnificently brooding landscape as this, painted after his last visit to Spain in 1952. Even so, it was a landscape in which he was never really comfortable.

Golden Barrier Loch Earn, 1925
Water-colour 14¾″ x 21¼″

'I suppose I have painted more Scottish landscapes than anything else; and I never paint anything with greater pleasure. We once spent a glorious autumn in the Highlands, six weeks of perfect painting weather from the start of October to mid-November. The trees, rowan, beech, birch and oak became more and more autumnal till all was a blaze of vermilion and gold. On the first of November snow appeared on the hill-tops. Each morning there was more of it. Daily it crept down till the whole ground was white. But there was no wind and the blazing foliage still draped the trees. Then one night a wind came and lo, like magic, the trees were bare and the leaves covered the snow. A lot of work was done there: I think I painted forty water-colours.'

Gleams and Shadows, c. 1925
Water-colour 13″ x 19″

'Why is it that on high moors in Scotland one is tempted to go on and on while on the high sierras of Spain there is no allure? Caledonia is stern and wild, they say, but Iberia is forbidding. The vast distances characteristic of Spain, the very real fear of savage dogs, the heat (or the icy wind), the dusty, scaly ground and the uncanny silence all somehow make it prudent to stay close by a town.'

Lakeside in Arcady, 1960
Water-colour 13″ x 22″

To W.R.F. such idyllic surroundings were Arcadian indeed. The whole idea of a pastoral paradise, an idealised rural retreat where nymphs and shepherds dwell in an atmosphere of romantic love, has appealed strongly to artists. Poussin, Watteau, Fragonard and many others have fallen under its spell, and Russell Flint was no exception.

The Promised Land, 1925
Water-colour 14″ x 20″

'... this is not so much a snow scene as a scene from a
whole world made out of snow. The sense of immensity
that is ever present in these illimitable snow-spaces is
conveyed as much by the judicious placing of these two
healthy and hopeful figures in this wide expanse of white
as it is by the great blue lights (which those who are not
artists will call "shadows") and by the hills of a still
richer blue beyond.'—G.Sandilands, 1928.

The mountains called him in many weathers, and in his
younger days the snowy slopes above Flims in the
Engadine would often see him, complete with skis,
painting the grandeur of the Alps.

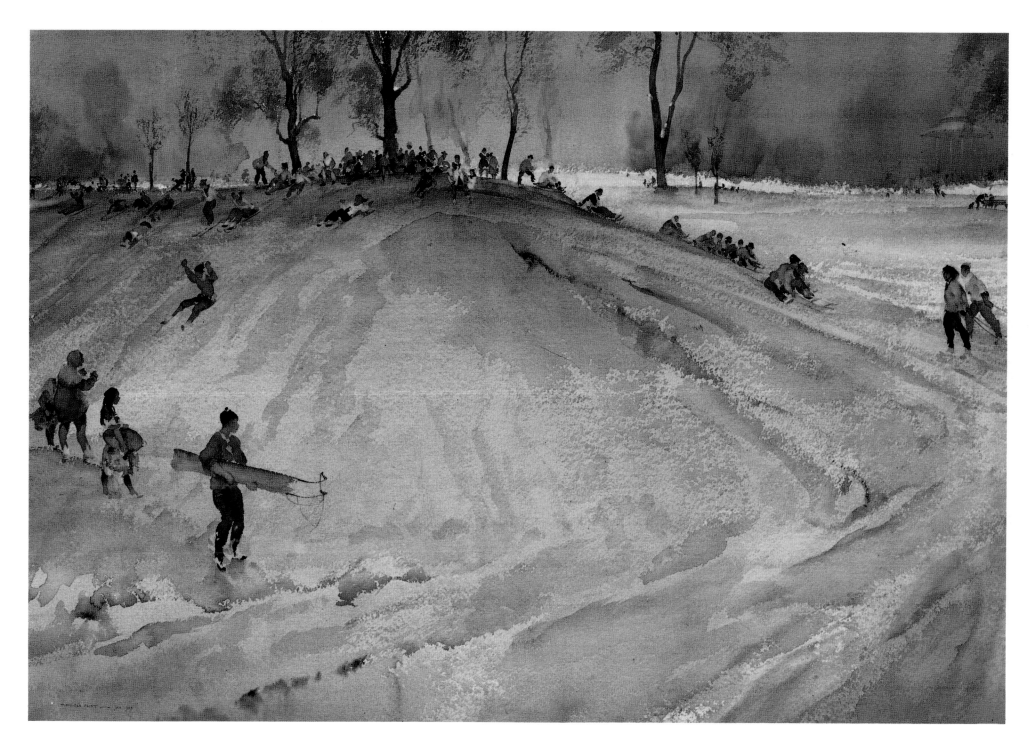

Winter Frolics—Toboganning in Kensington Gardens, 1963
(The Hump)
Water-colour 20½″ x 30″

But he did not always have to travel to Switzerland, or even Scotland, to find his snow. Just around the corner from Peel Cottage lie Kensington Gardens. In the January of his eighty-third year, he proved, once again, that 'as a painter of snow he has few rivals'. All his accumulated skill was brought to bear here. The gaiety and movement of young people, the leaden sky, the grey coldness of a city parkland, brought together with wash upon wash, wet upon wet, blob upon stroke—it all seemed so simple.

A Bend on the Seine, 1968
(Cliffs at Petit Andeley)
Water-colour 11½″ x 15½″
[*Courtesy Alan Gardiner*]

Whilst the London winter had to be tolerated, as soon as the spring sun had warmed the English Channel he was off to the delights of France, never happier in his advancing years than sitting in the shade by some sparkling stream. Here, a bend on the Seine where Richard Coeur de Lion raised his Château Gaillard, there, a ford on the Gascon Baïse which brings the melted snow of the Pyrenees tumbling into the Garonne to water the grapes of Armagnac.

A Ford on the Baïse, 1969
Water-colour 10½″ x 14½″

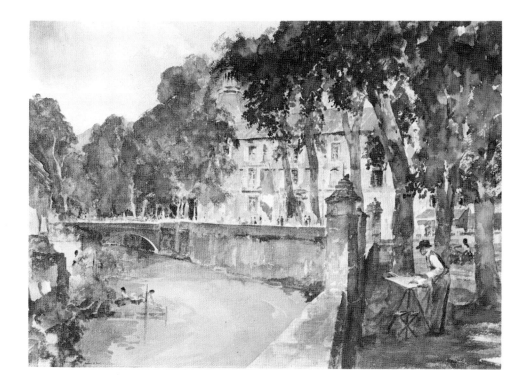

My Father Painting at Brantôme, 1965
(Francis Russell Flint)
Water-colour 21″ x 30″

He loved the gracefulness of the châteaux of the Loire, the cool elegance of the water gardens at Châteauneuf. He had a deep sense of awareness and appreciation for the history of France, often painting with his son in the shade of some mighty fortress or, as here, by the ancient abbey of Charlemagne at Brantôme.

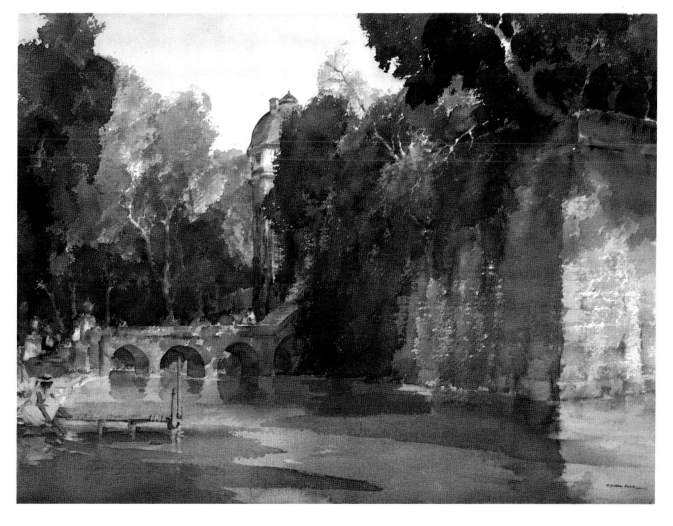

The Water Gardens Châteauneuf sur Loire, 1964
Water-colour 19½″ x 27″

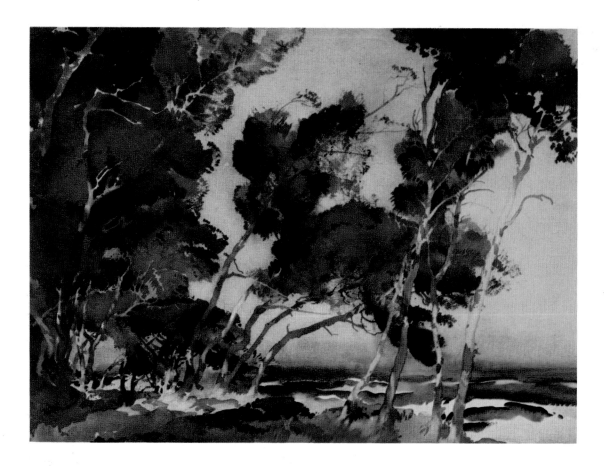

The Mistral c. 1925
Water-colour 13½″ x 18″

Through the good offices of his friend, Admiral John Moore, he gained access on Sundays to the old Devonport Shipyard and painted this work, regarded by the R.W.S. as his Diploma work, although by then he was well into his twenty-year presidency of that august body. It is a picture held in the highest academic regard by the R.W.S., as is clear from the following:

'The handling of the brush is breathtaking in its economy and purpose. Flint has freely depicted the great timbers of this structure as if they were the piers and vaulting of a cathedral. The great vault is, on close inspection, a seeming mish-mash of vigorous sweeps of brown washes, painted wet-in-wet and wet on dry. Standing away from the picture, every timber falls into place and the architectural unity is preserved. The height of the roof is emphasised by angular, dark brush-strokes. Along the right-hand side of the dock and in the middle distance, much greater detail is unfolded and there are some brilliant renditions of figures and machinery, indicated only with the merest dabs of paint.

'Of all the works of our century in the R.W.S. Collection, this must be one of the most satisfying. Its monumentality and historical interest place it as a significant work of modern British art'—M. Spender, *The Glory of Water Colour*.

'The Mistral' —that depressing, irritating wind that flows and funnels from the Alps to the Riviera, down the Rhone Valley to the sea—lashes trees into a frenzy, and turns the usually placid Mediterranean into a menacing maelstrom. Here W.R.F. has captured the very sound of it—the wailing wind, the roaring waves and the crack of trees like whips.

In contrast, *The Woodrick* is a peaceful interlude in war-torn Britain. From September 1940 to November 1941, W.R.F. and his household evacuated themselves from London's blitz to a farm a few miles south of Totnes in Devon where, with petrol strictly controlled, he was forced to paint the quiet English countryside of his immediate surroundings.

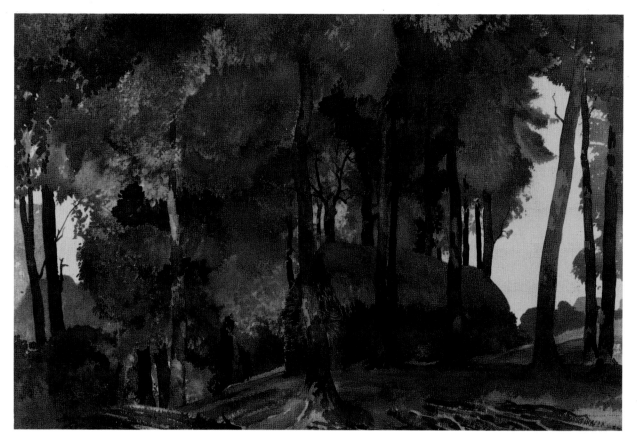

The Woodrick, 1941
Water-colour 15″ x 22″

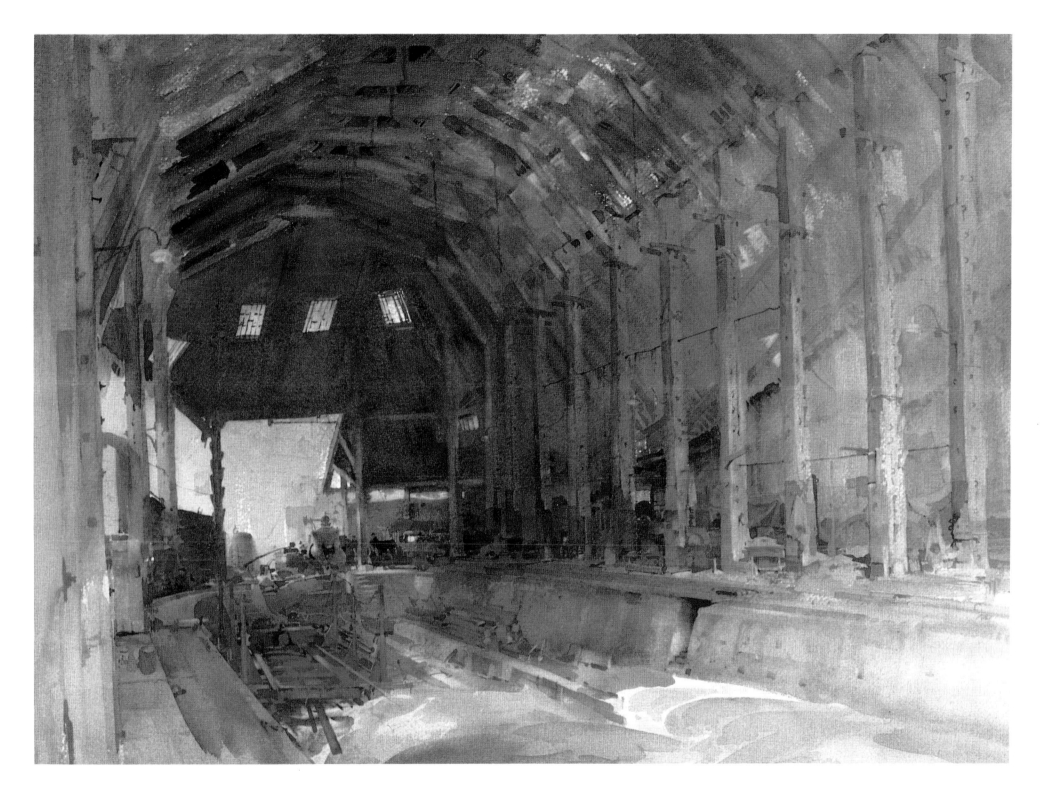

No 1 Slip. Devonport Shipyard, 1941
Water-colour 19½″ x 26½″
[*Courtesy The Trustees of the Royal Society of Painters in
Water-colours; from the Diploma Collection*]

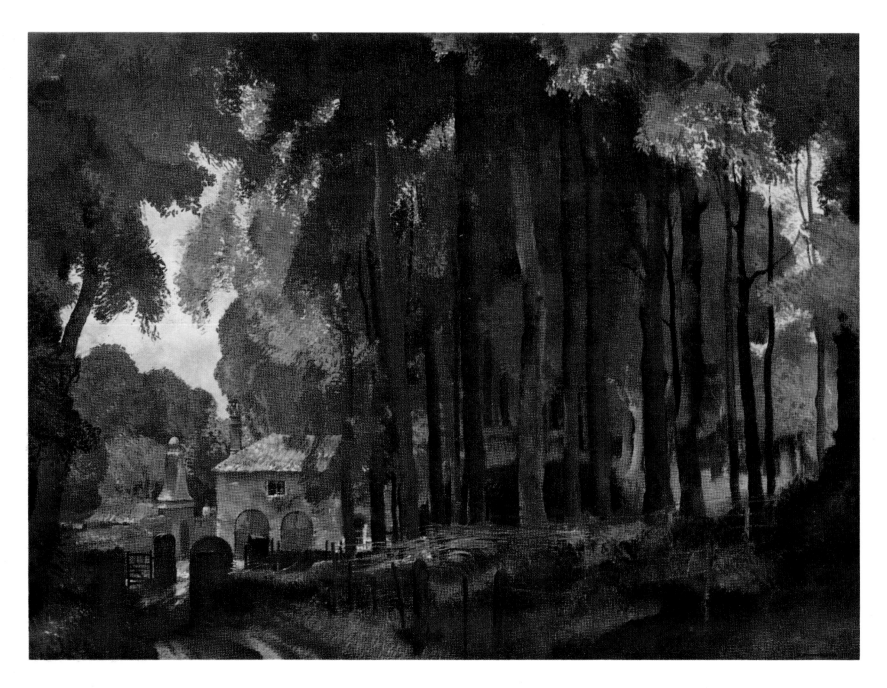

South of Totnes lie the Saxon farmsteads based on the stream known still today as Englebourne. The manor house of Great Englebourne is a handsome, Palladian mansion which masks its medieval forbear, now reduced to the status of a cider-house. In the woodland in front of the coach-house can be seen 'The Woodrick'—still the site of a small wood-pile.

Great Englebourne, 1941
Tempera 20″ x 30″

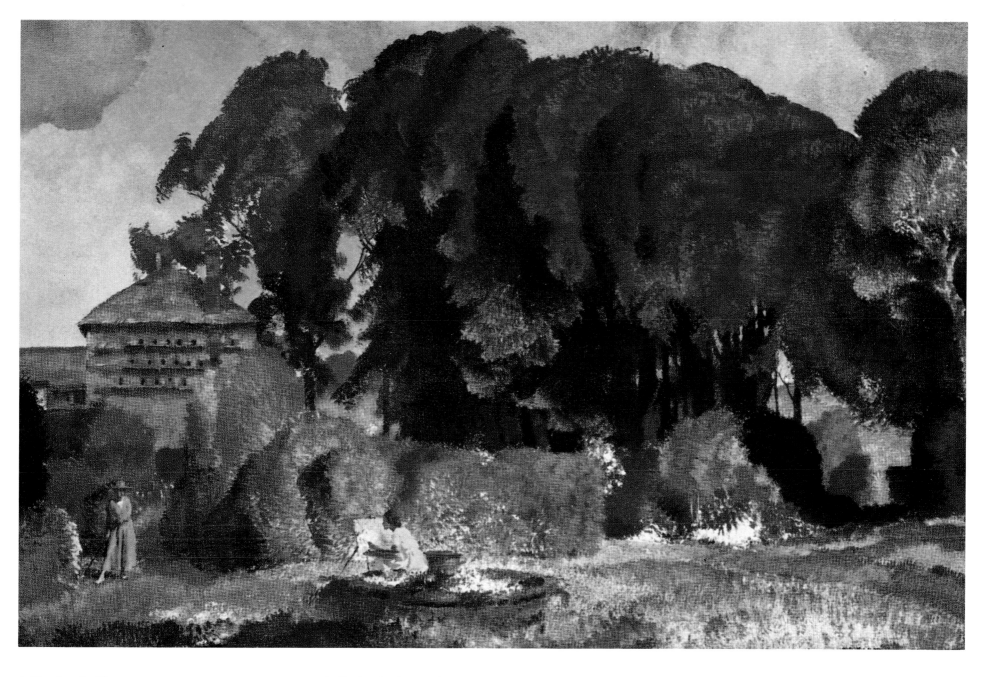

A Garden in Devon, 1941
Tempera 20″ x 30″

A Garden in Devon shows the pigeon-holed gable-end of the coach-house, although W.R.F. has moved the stone flower-bed to improve the composition.

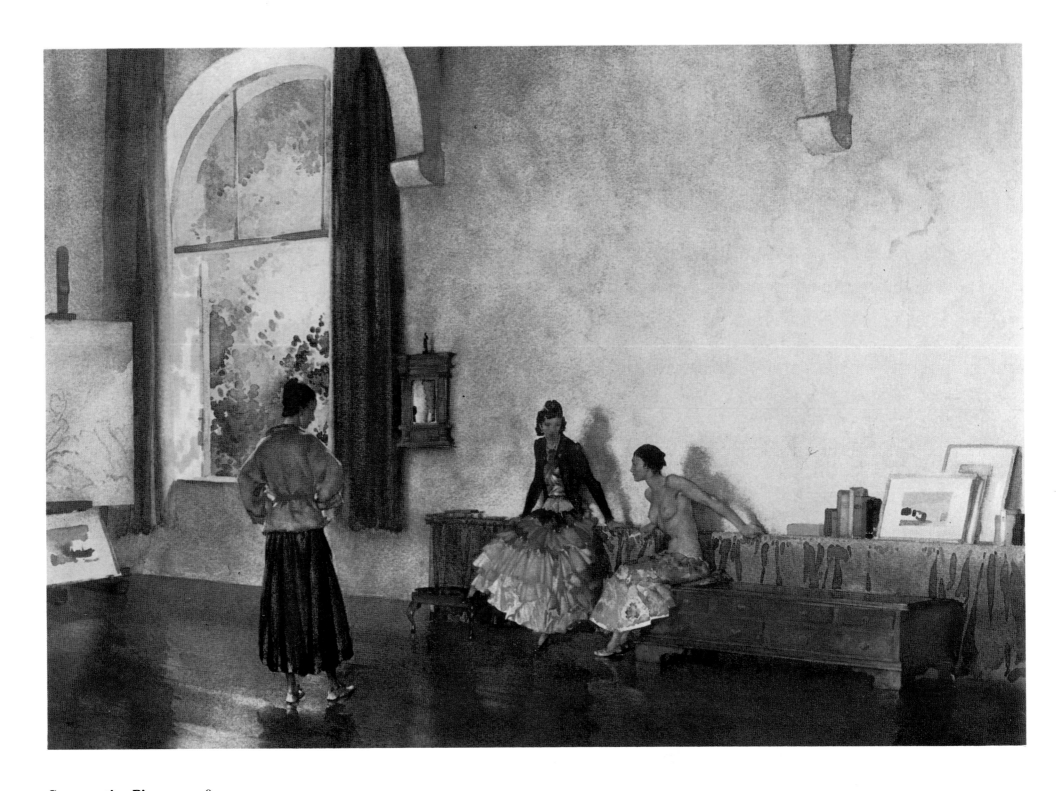

Conversation Piece, c. 1938
Water-colour 14¾″ x 19¼″

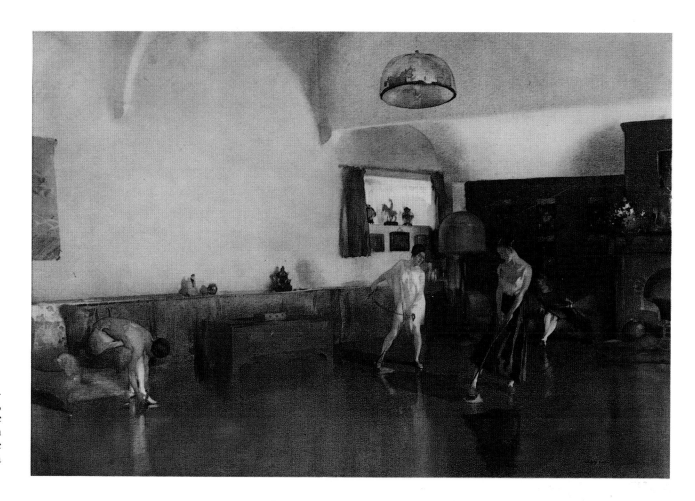

W.R.F. acquired Peel Cottage in Campden Hill in 1925. It had originally been built for a landscape painter, Ridley Corbett A.R.A., and was then rented by a future president of the R.A., the young Frank Dicksee. Even since the death of Sir William, it has continued to be the home of artists, actors and musicians. (It now bears a blue plaque with the legend, 'Russell Flint lived here'.)

The Floor Polishers, 1934
Water-colour 20″ x 27″

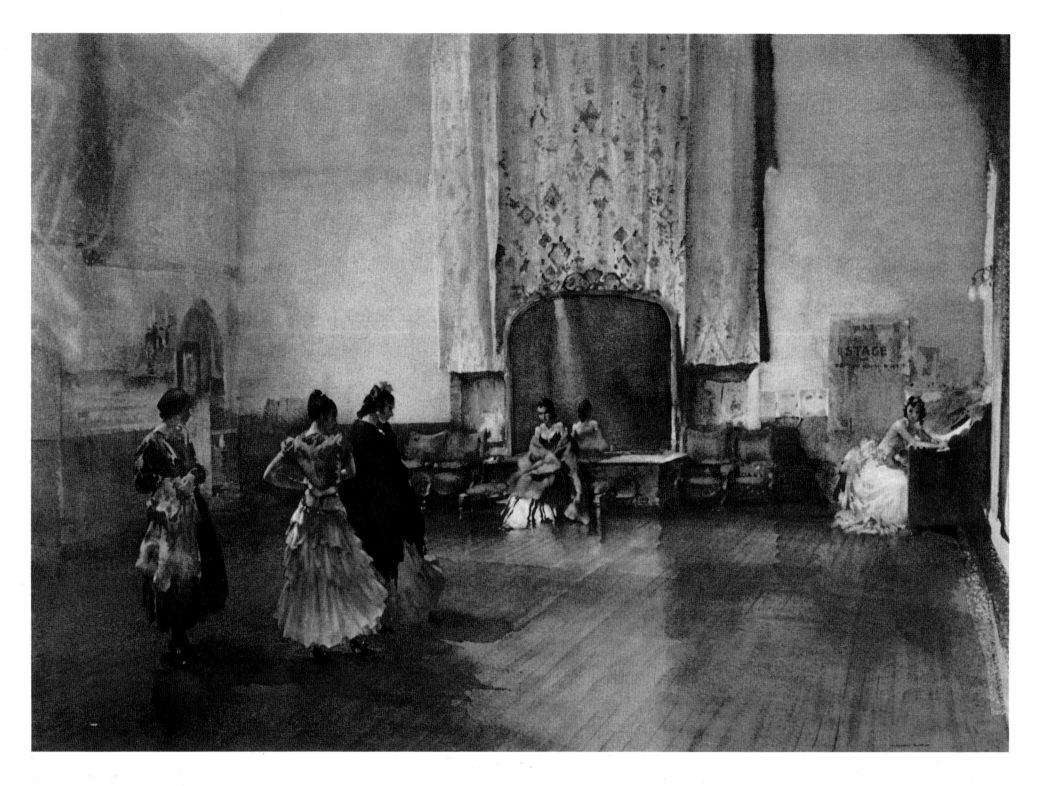

Argument on Ballet, c. 1950
Water-colour 15½″ x 22″

One of his near neighbours was Dame Marie Rambert
whose famous ballet company was housed in the Mercury
Theatre, Notting Hill, once a church hall. They became
friends and she allowed him to sketch in her classrooms,
enabling him to produce such authentic subjects as these.

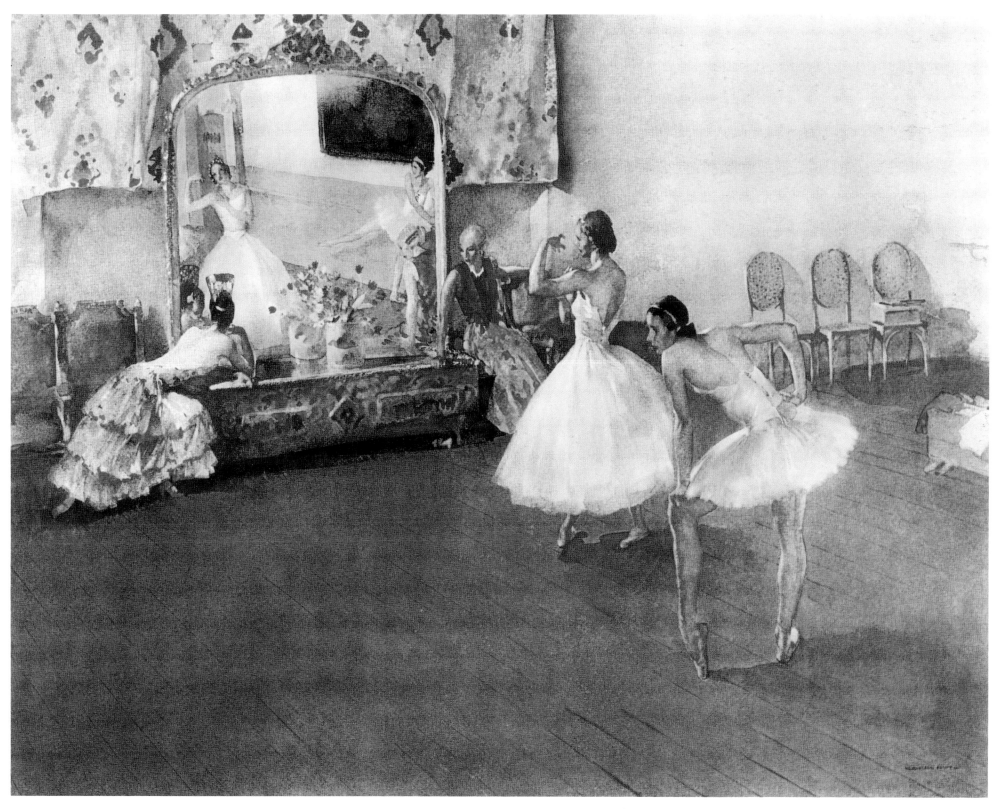

Mirror of the Ballet, 1939
Water-colour 14½″ x 19″

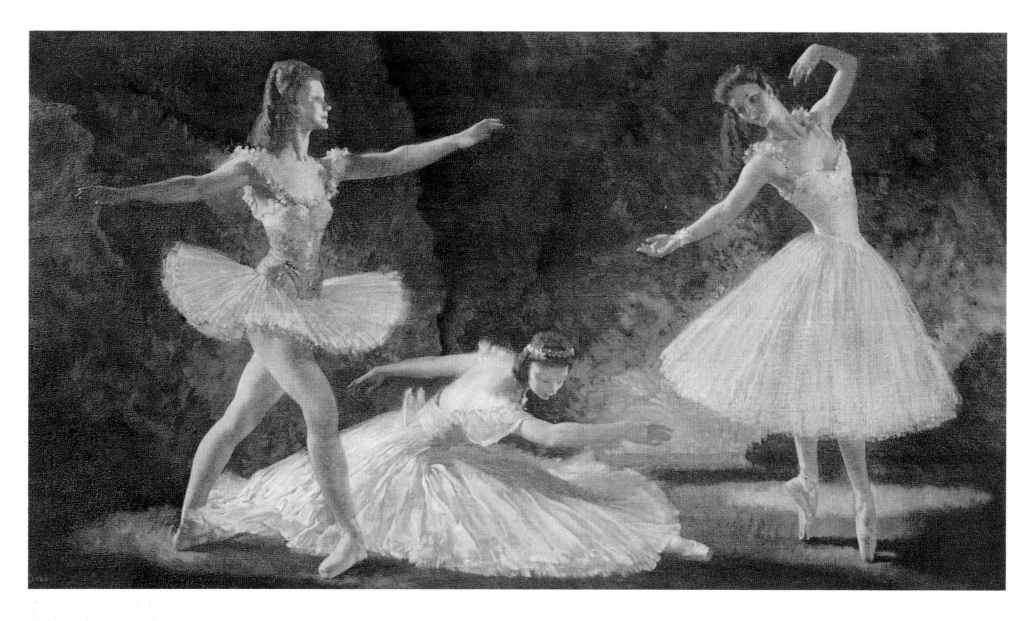

Rhythm of the Ballet, 1948
Oil 15″ x 27″

Another close friend was Moira Shearer, who greatly helped the public image of post-war ballet by starring in the film *Red Shoes*.

'When I was twenty-two and dancing at Covent Garden, William Russell Flint wrote to me. He enjoyed the ballet, had seen and liked the Red Shoes film, and he proposed an oil triptych for the next Royal Academy Summer Exhibition. I was intrigued and flattered and we met at his studio in Peel Street on Campden Hill. Sitting (or, in my case, attitudinising) for Willie was interesting and sometimes uncomfortable. The first oil triptych was the worst as he wanted the central figure on point with the other leg extended high in the air. This position is held, in a ballet, for a second—perhaps two. One simply cannot hold it longer as muscles tighten, then shake uncontrollably and one's leg finally drops. I did my best

but Willie was tremendously surprised. He had expected me to hold this position for a good ten minutes and I don't think he ever appreciated the difficulty. But somehow this figure was accomplished, the other two figures more easily in more comfortable positions and I was allowed to see the finished picture. I didn't like it but of course I couldn't say so. It was the only time I ever felt ill at ease with him. Since then I've realised that I don't really like any of his oils. He was a superb water-colourist and something seemed to change when he worked in another medium. The colours were too bright and hard—and it looked too "pretty", almost chocolate box, and I was very glad that all the later pictures he made of me were water-colour or red chalk drawings.'—Moira Shearer, *WRF A Catalogue Raisonné*.

84

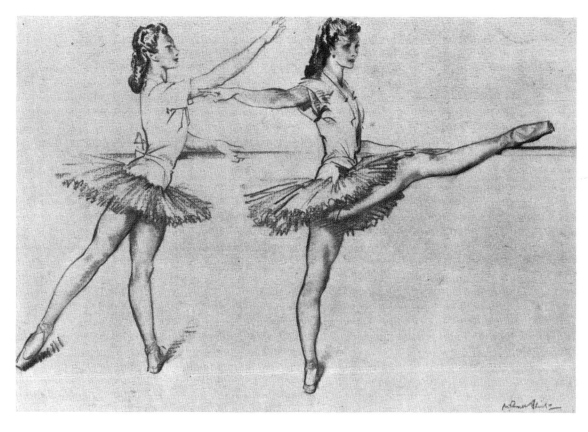

Studies of Moira Shearer, 1948
Red chalk 9″ x 13″

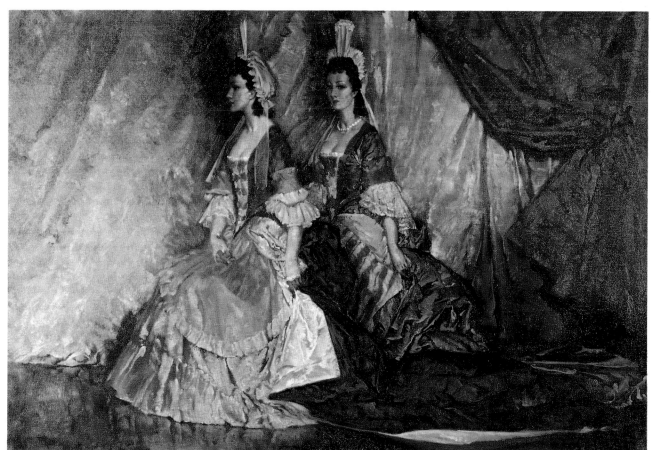

Theatrical Study, c. 1948
Oil 20″ x 30″

His interest in the performing arts coupled with his own fame as an artist gave him entrée not only to the social world of the theatre—Rosalie Crutchley, Peter Cushing and others were among his closest friends—but also to the backstage inner world.

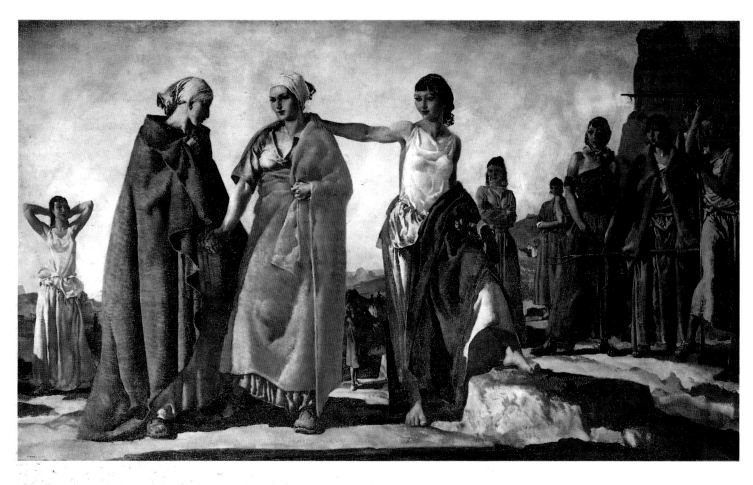

Ruth with Naomi and Orpah, 1937
Oil 36″ x 60″
[*Courtesy Sotheby's*]

Is this just another 'imaginary Spanish landscape' filled with 'olive-skinned gypsies' or is it really a work of great religious significance? What's in a name?

'And Elimelech, Naomi's husband died; and she was left, and her two sons.
And they took them wives of the women of Moab; the name of the one was Orpah, and the name of the other Ruth:'—RUTH, CHAPTER I, VERSES 3 AND 4.

Russell Flint was a very religious man; a Victorian Presbyterian Scot who, moreover, was married to a staunch practising Roman Catholic. He loved her, but he certainly had reservations about her Church; indeed, 'All Churches are pathetic. They search for truth and cannot find it. The more emphatic their creeds, the more ridiculous they become. They can only keep on seeking.'

Useless Arrows, 1968
Chalk 13″ x 8½″

A tongue-in-cheek title for this illustration from *Breakfast in Perigord*. Are Cupid's arrows wasted on celibate nuns?

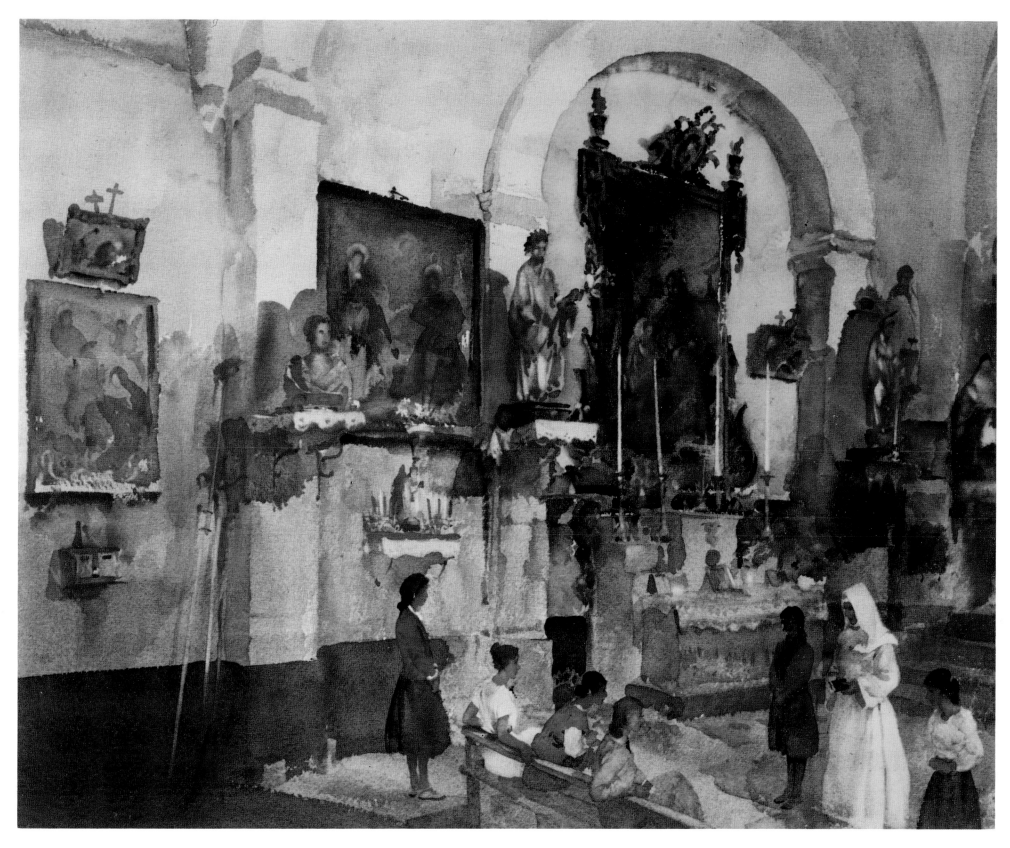

Nun's Class, La Tourettes, 1952
Water-colour 19½" x 27"

However deep Russell Flint's feelings were about the
Church, he nevertheless produced many of his best works
within their walls.

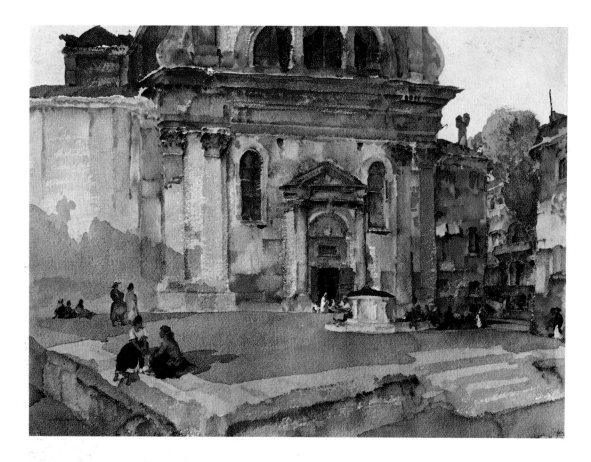

Campo San Trevaso, 1964
Water-colour 19½" x 27"

Whether religion or interest in architecture drew him to paint such works is not clear—generally his answer to any such question was that he found the subject interesting and that the work gave him pleasure.

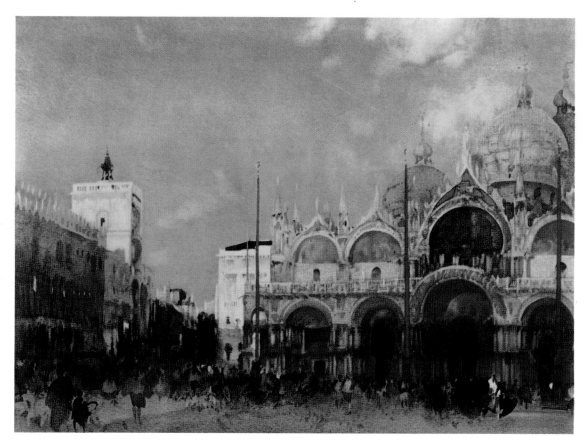

St. Mark's Venice, 1929
Water-colour 14" x 20"

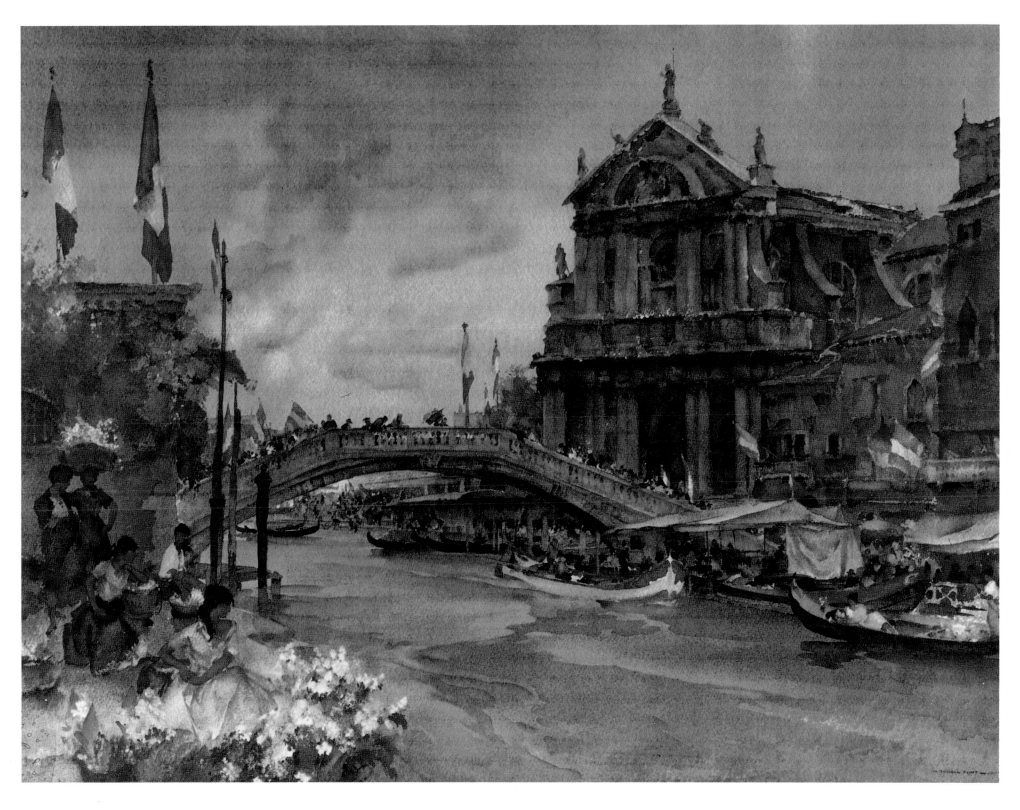

Venetian Festival, 1965
Water-colour 19½″ x 27″

'I must have been crazy to tackle such an elaborate subject in the midst of merry-making Venetians. The façade of the church should alone have warned me to hold my hand and merely look on. However, the theme and the festive atmosphere enticed me. Not only had I to carry my picture as far as possible on the spot, notes of many details were needed to enable me to complete it at home.'—W.R.F.

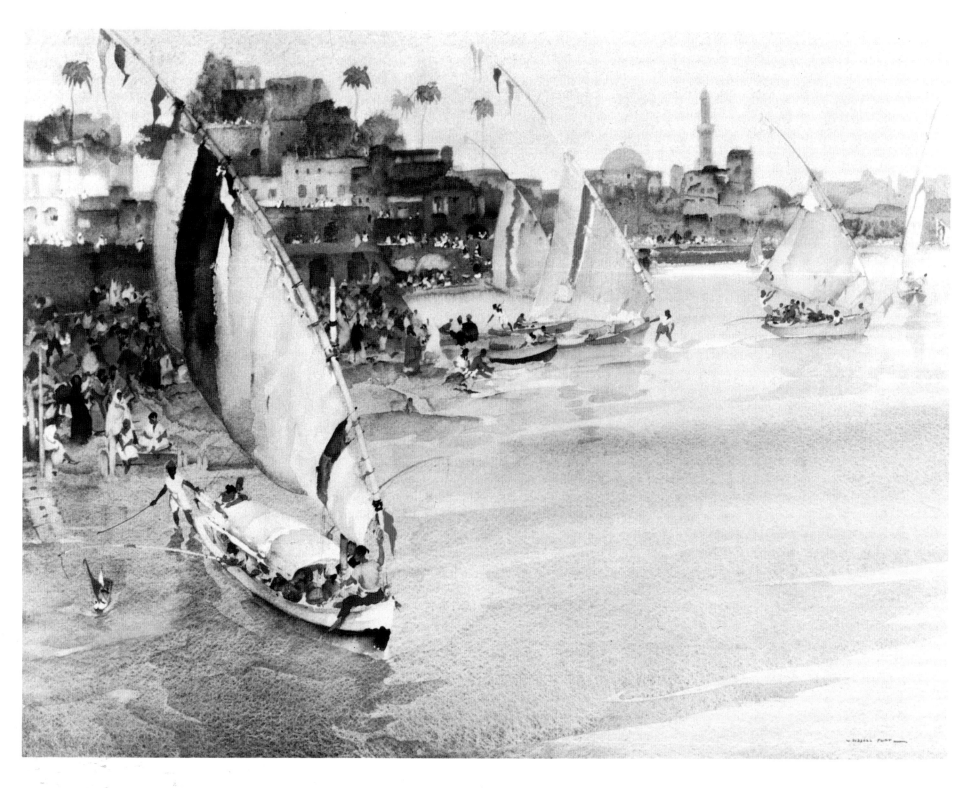

From 12 March to 23 March 1961, W.R.F. toured the Mediterranean by air with Adrian Bury. His notebook records 'R End of Ramadan, Nile', which was published in 1965 by Frost and Reed under the title *Holiday After Ramadan*.

'The Europeanised groups in the crowds were certainly not attractive but western attire could not hide the Egyptian character of the women's features. Away from the centre of the city the native swarms were totally different and well worth watching. They were picturesque in the full meaning of that word—and after their fast they were out to enjoy themselves, and enjoy themselves they did, ashore and afloat. Many took to the Nile and acted as unsecured ballast for the numerous top-heavy sailing craft. My sketch book had never been kept busier.'

Holiday after Ramadan, Cairo, 1961
Water-colour 19½″ x 27″

90

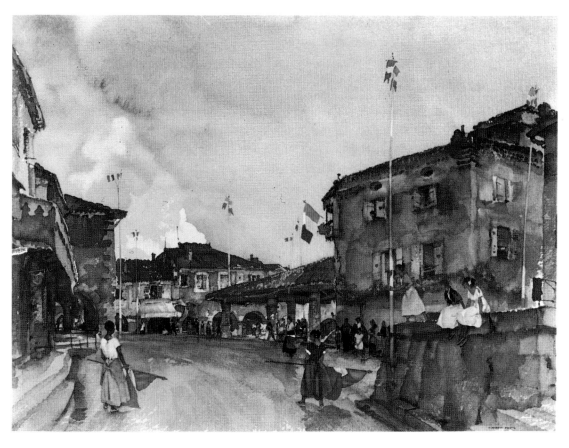

Quatorze Juillet, 1954
Water-colour 19½″ x 27″

The Town Flag, Sospel, 1963
Water-colour 19½″ x 27″
[*Courtesy Richard Green Gallery*]

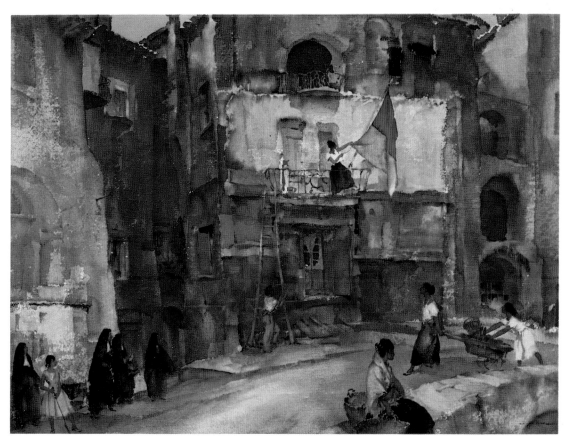

It was not often that Russell Flint tolerated France in high summer. His trips were usually in the florid days of May or in September 'when the grapes are purple'. Bastille day 1954, however, found him with his son in the Gascon market-town of Mauvezin, where 'the weather [was] outrageously bad, so most of the Quatorze Juillet festivities took place under cover in the market hall where tarpaulins, slung between the columns, were used to divide the floor space into sections.' This hall obviously intrigued him, for he wrote of the 'superb Ancienne Halle aux Grains with massive columns, arranged with baffling ideas of perspective. More baffling still was the intricacy of the beams, king-posts, corbels, brackets and what-not supporting the tiled roof.'

His great love, certainly in his much maligned and misunderstood latter years, was just to potter around the ancient alleyways and backstreets of provincial France, capturing both architecture and atmosphere to a degree that few cameras have achieved. That he cleaned them up and filled them with younger and more attractive girls than one may meet today cannot be denied, but then he was the inimitable romantic.

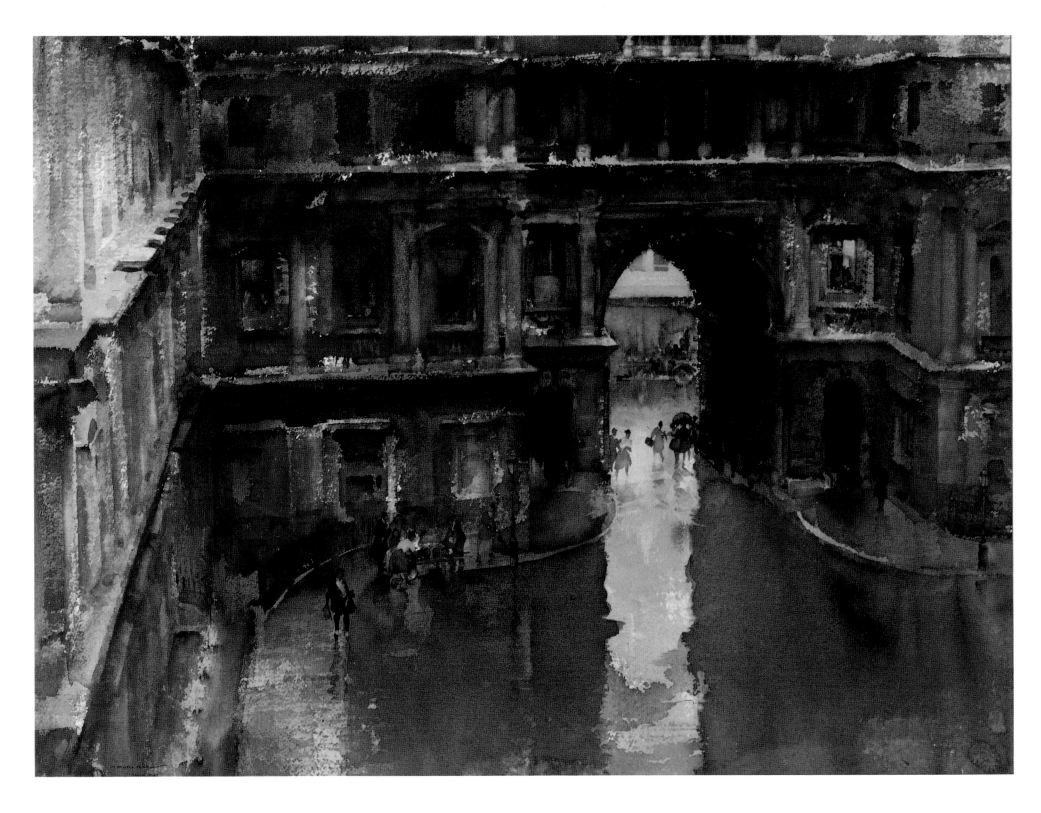

Royal Academy Courtyard, 1963
Water-colour
[*Courtesy The Royal Academy*]

No painting shows the true Russell Flint, in contrast to the Spanish gypsy image, more perhaps than two pictures, the Diploma work of the Royal Water-colour Society and this sombre but magnificent study of the courtyard of Burlington House, Piccadilly, on a wet day.

It is all the more ironic, therefore, that his R.A. Diploma work, released by the R.A. as a signed print and postcard, should be *Castanets*—a water-colour study painted in 1933 of Spanish gypsy dancers!

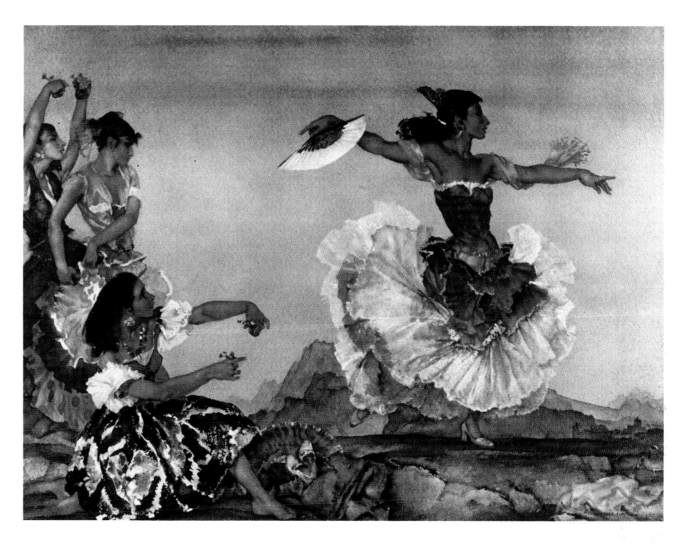

Danza Montaña, 1959
Water-colour 19½″ x 27″

The confidence acquired with experience is apparent in this 1960 study of Tani Morena (main figure and lower left) and Cecilia Green. W.R.F. had close contacts with the Spanish dancers working the London stage. His favourite was Consuelito Carmona, whose sister and niece often posed for him as well. Of this picture, so full of 'clatter and whirl', he wrote, 'Tani Morena deserves great credit. Without her admirable posing for the main figure the whole composition might have collapsed into artificiality.' The difference between these two versions of a similar subject is quite apparent.

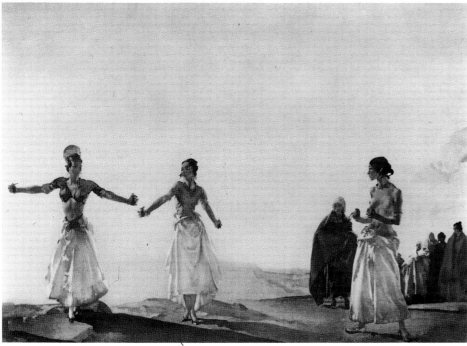

Castanets, 1933
Water-colour
[*Courtesy The Royal Academy*]

93

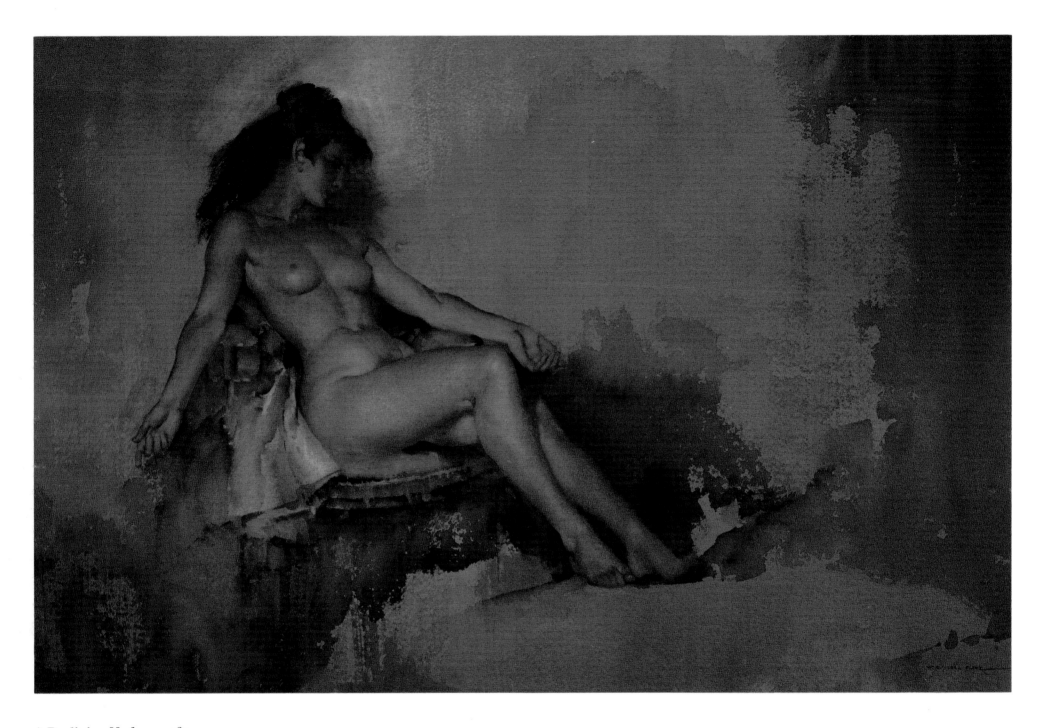

A Reclining Nude, c. 1960
Watercolour 17" x 29"

On 23 June 1953, Cecilia Green came to the seventy-
three year old Russell Flint. She was his ideal beauty.
He had been painting her long before they met, long
before she was even born. She was to become his favourite
model, his elixir of life, and when she finally left him on
23 August 1966 he was devastated.

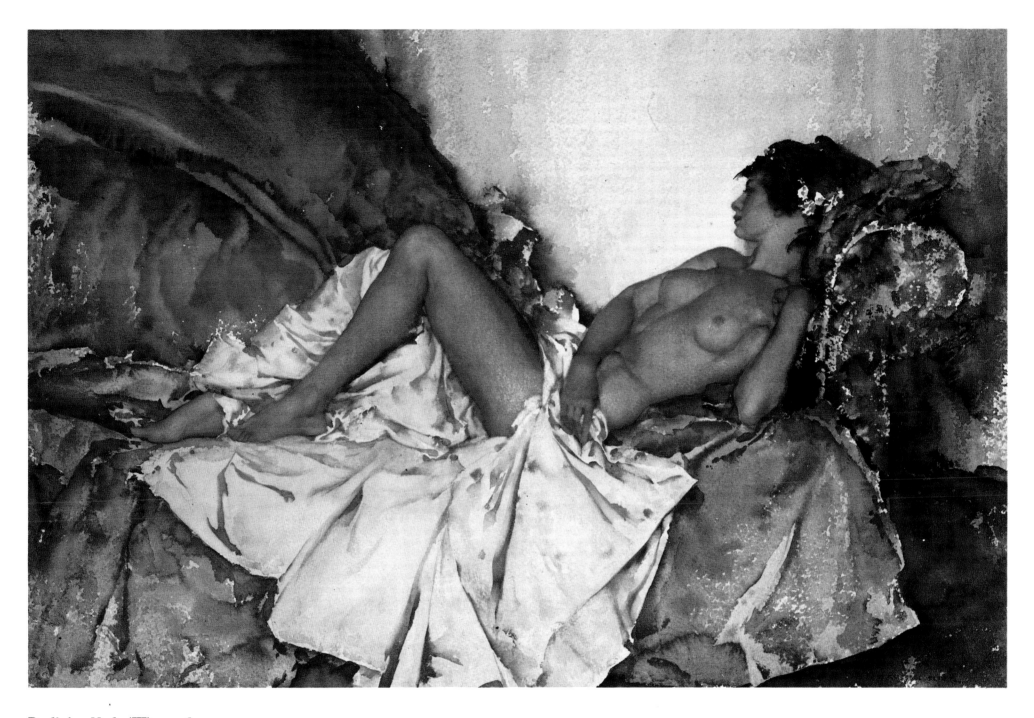

Reclining Nude (III), c. 1960
Water-colour $13\frac{1}{2}''$ x $22''$

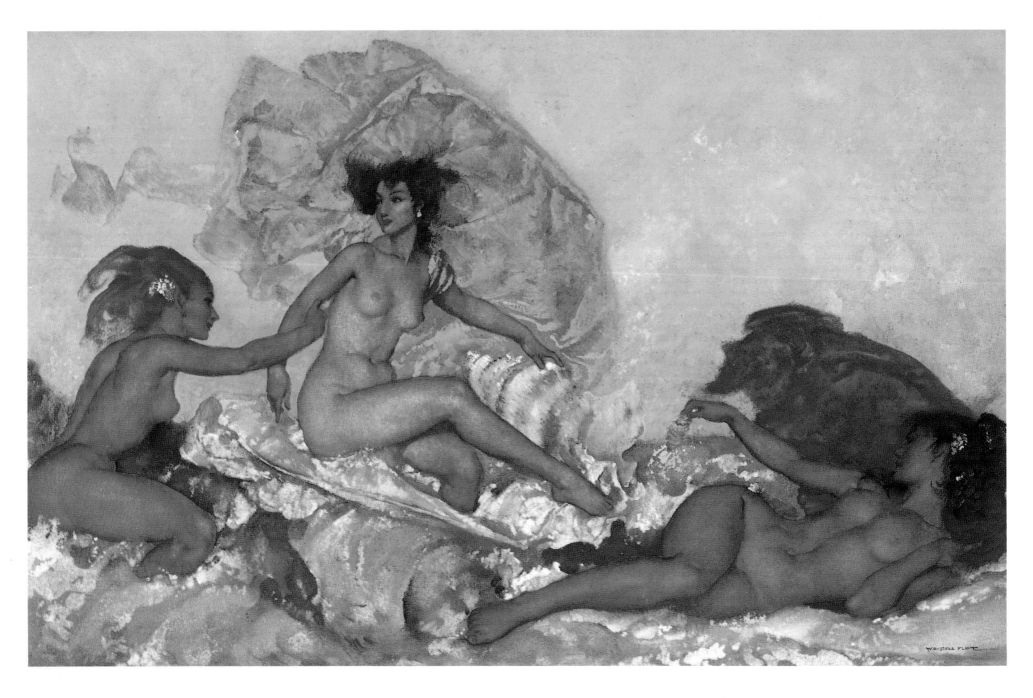

Rococo Aphrodite, c. 1960
Water-colour and tempera 16¼″ x 26½″

Russell Flint originally entitled this *The Birth of Aphrodite*, writing it on the back of the picture. At the last moment, he changed his mind and drew a line through it—writing above in a clear hand, 'Rococo Aphrodite'. Aphrodite, the Greek goddess of love, was the Lisping Goddess of his book with that title.

Zeus called
and a mighty surge coiled wondrously, spiral upon spiral
leaping
and from the foam of those obedient waves
Aphrodite, peerless Aphrodite
was born

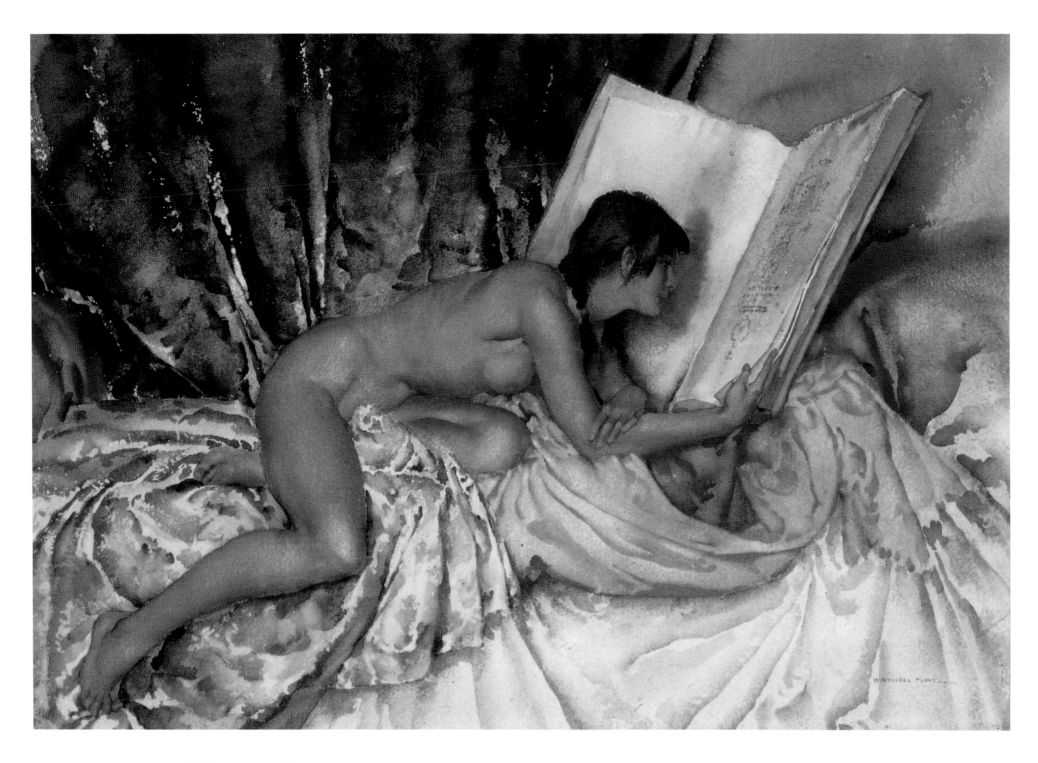

Janelle and the Volume of Treasures, 1960
Water-colour 14½″ x 20½″

In February 1960, Russell Flint was saddened. Cecilia, his beloved model, had temporarily left him. Tired of constant and static posing, she became famous as the Camay soap girl in the television commercials. Her replacement was Margaret Covenay – Maggie – a half-Chinese girl who always seemed to bring a somewhat feline quality to the most awkward pose. 'My nice model was really interested but she could not turn the page without disturbing her pose which was hard on her. The pose itself was not easy to maintain... I have some huge old tomes...[this] once housed a collection of Rembrandt etchings which some unworldly predecessor *had stuck in!*'

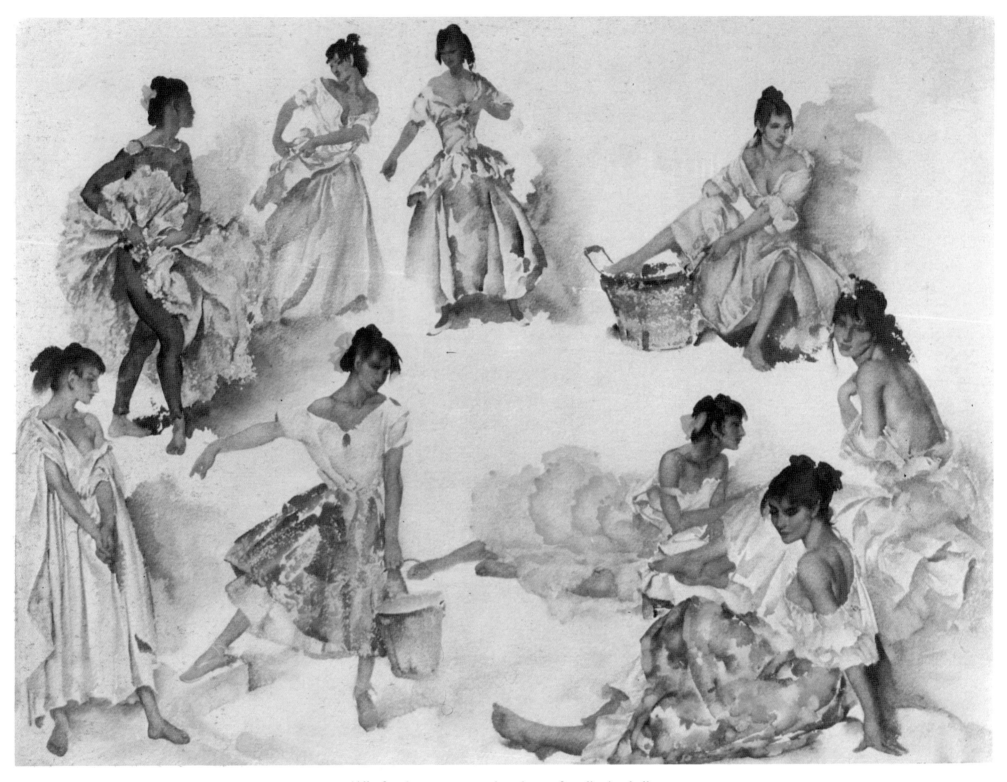

Variations on a Theme, 1960
Water-colour 19½" x 27"

'All of us have seen countless sheets of studies in chalk, pen-and-wash and all sorts of media but seldom, if ever, in water-colour. On paper toned myself it has been interesting to build up these groups unhurriedly and carefully. The first was exhibited in the Royal Academy of 1961 and reappears in this exhibition, the third went to South Africa and the second and fourth have the privilege of appearing here.'

We are pleased to conclude this presentation of Russell Flint's work by displaying all four of the Variation series.

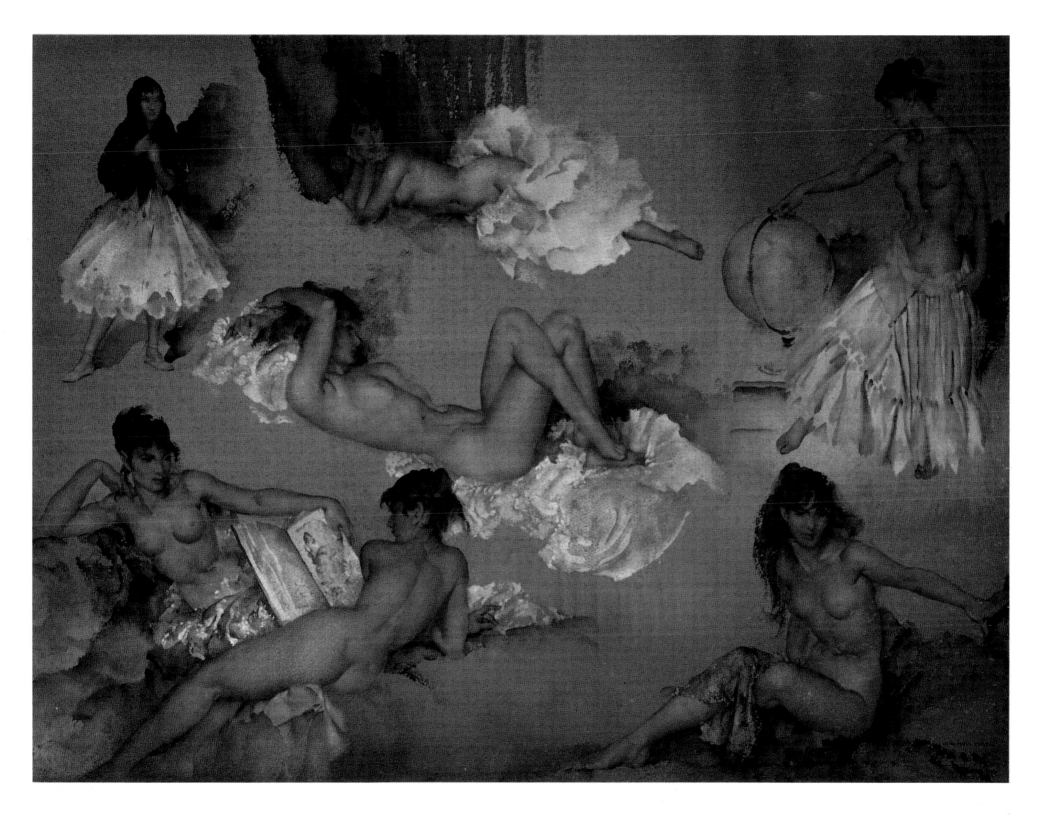

Variations II, 1960
Water-colour 19½″ x 27″

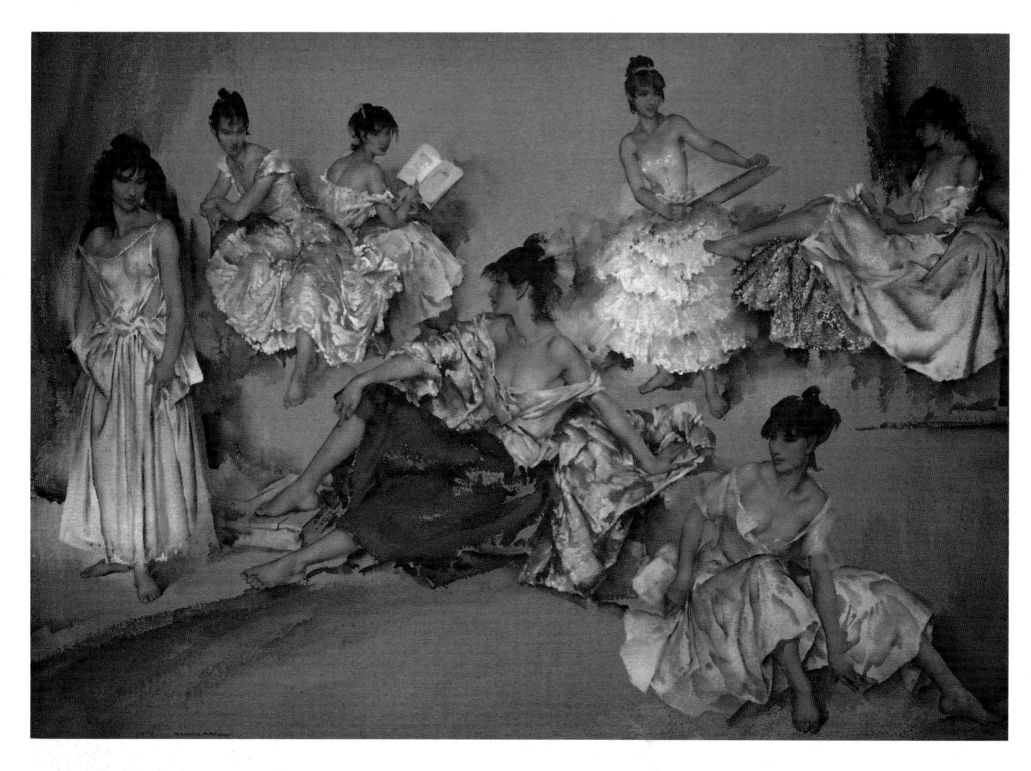

Variations III, 1960
Water-colour 19″ x 27″

Variations IV, 1960
Water-colour 19½″ x 27″

Books Illustrated by W.R.F

1905	*King Solomon's Mines*	(Cassell)
1908	*Of the Imitation of Christ*	(Chatto & Windus)
1909	*The Song of Solomon*	(Lee Warner)
1909-10	*Savoy Operas* (2 volumes)	(G.Bell & Sons)
1909	*Marcus Aurelius Antoninus*	(Lee Warner)
1910-11	*Le Morte d'Arthur* (4 volumes)	(Lee Warner)
1910	*The Scholar Gipsy*	(Lee Warner)
1912	*The Heroes*	(Lee Warner)
1913	*The Canterbury Tales* (3 volumes)	(Lee Warner)
1922	*Theocritus, Bion and Moschus* (2 volumes)	(Medici Society)
1924	*The Odyssey*	(Medici Society)
1928	*Judith*	(Ernest Halton)
1929	*Tobit and Susanna*	(Ernest Halton)
1955	*Herrick's Poems*	(Golden Cockerel)

Some Works in Public Galleries

		
Aberdeen Art Gallery	*A Blue Day, Loch Assynt*	Water-colour
Bath, Victoria Art Gallery	*Rio Terra Catecumeni, Venice*	Water-colour
Belfast Art Gallery	*A Neglected Domain*	Water-colour
Birmingham City Art Gallery	*Shipyard Gleaners*	Oil
	Silver and Gold	Oil
Brisbane, Queensland National Art Gallery	*A Blue Day by the Farne Islands*	Water-colour
Bristol, City Art Gallery	*Dinard, Morning*	Water-colour
Brooklyn Art Gallery, New York, USA	*Clatter and Whirl*	Water-colour
Broughty Ferry Art Gallery	*Quiet Water*	Water-colour
	Court of the Hundred Vanities	Water-colour
Bury Corporation Art Gallery	*Gossip in a Provençal Wood Vault*	Water-colour
Cardiff Art Gallery	*Le Morte d'Arthur*	Water-colour
Chicago Art Gallery, Illinois, USA	*Wet Sands*	Water-colour
Dundee Art Gallery	*A Tug-of-War*	Water-colour
Edinburgh, Scottish Modern Arts Association	*Negro Dancers*	Oil
	Makers of Airships	Water-colour
Eton College	*Ascension Day, Catalonia*	Water-colour
Glasgow, Kelvingrove Art Gallery	*Four Singers of Vera*	Oil
	The Floor Polishers	Water-colour
	Town Lady and Herdsman	Water-colour
	An illustration for 'Theocritus'	Water-colour
Ghent Art Gallery, Belgium	*A Gentle Amazon*	Oil
Harrogate Art Gallery	*Melting Snows, Gareloch*	Water-colour
Hereford Art Gallery	*The 'Francis and Jane' at Birdham*	Water-colour
Hull, Ferens Art Gallery	*A Party of Four*	Tempera
	Snow	Water-colour
Indianapolis Art Gallery, USA	*The Privileged Three*	Water-colour
Johannesburg Art Gallery, South Africa	*Allegro*	Water-colour
	The Island of Rhum	Water-colour
Leeds Art Gallery	*Phillida and her Friends*	Water-colour
Liverpool, Walker Art Gallery	*La Belle Dame Sans Merci*	Water-colour
	August Morning	Water-colour
	Costanza	Water-colour
London, Victoria and Albert Museum	*The Farne Islands*	Water-colour
	A Florentine Masquerade	Water-colour
	Phryne and a Slave	Water-colour
	(several others)	

Maidstone, Bentlif Art Gallery	*Splitting Bamboos, Provence*	Water-colour
Manchester, Whitworth Art Gallery	*Posada Interior*	Water-colour
Nelson Art Gallery, New Zealand	*Athene's Lemon Wrap*	Water-colour
	Among Misty Isles	Water-colour
	The Unembarrassed Five	Water-Colour
Newcastle, Laing Art Gallery	*Veiled Silver*	Water-colour
	The Great Lavoir	Water-colour
Newport Art Gallery, Monmouth	*Gitana Dancers Resting, Albaicin, Granada*	Oil
	Athelea	Tempera
Nottingham Art Gallery	*Romantic Garden*	Water-colour
Oldham, Corporation Art Gallery	*Linen Carriers in a Ligurian Palace*	Water-colour
Ottawa Art Gallery, Ontario, Canada	*The Bather's Arcade*	Water-colour
	Three Little Tents	Water-colour
Paisley Art Gallery	*Basket Makers, Antibes*	Water-Colour
Perth Art Gallery, Australia	*The Delinquents*	Oil
Port Sunlight, Lady Lever Art Gallery	*The Three Green Domes, Venice*	Water-colour
Preston, Harris Museum	*Artemis and Chione*	Oil
	In a Campden Hill Studio	Water-colour
Rochdale Art Gallery	*Maruja the Strong*	Oil
Santa Barbara Museum, California	*Diana*	Tempera
Sheffield, Graves Art Gallery	*The Bravade, St. Tropez*	Water-colour
	The Seven Springs, Vers	Water-colour
Southampton Art Gallery	*Nomads Rendezvous*	Oil
Southport, Atkinson Art Gallery	*Salle-à-Manger Bretonne*	Water-colour
Sydney Art Gallery, N.S.W., Australia	*The Lemnians*	Oil
	Flower and Lacquer	Oil
Toronto Art Gallery, Ontario, Canada	*Aspirants*	Water-colour
Udine Art Gallery	*The Hunter's Return*	Water-colour
Winnipeg Art Gallery, Manitoba, Canada	*Loch Earn* (several others)	Water-colour
Worthing Art Gallery	*Jennifer and Two Mirrors*	Tempera

Chronology

1880 April 4	Born Edinburgh
1894-9	Apprenticed to Banks, Edinburgh
1898	Exhibited—Royal Glasgow Institute
1900	To Europe with Robert Purves Flint
	Work for Bales, London
1901	Father died
1902	Work for Dickinsons
1903	Work for *Illustrated London News*
1905	Married to Sibylle Seuter
	Exhibited—R.A. (Royal Academy)
1908	Exhibited—London
1912	R.O.I (Royal Institute of Oil Painters)
	To Italy for one year
1913	R.S.W. (Royal Scottish Watercolourists Society)
	Paris Salon silver medal
1914	A.R.W.S. (Associate of the R.W.S)
1915	Son born—Francis Russell Flint
1916	R.N.V.R.—Lieutenant
1917	R.W.S. (Royal Society of Painters in Water-colour)
1918	R.A.F.—Captain
1919	Exhibited—London
1920	To France, Spain and Italy
1921	To Spain
1924	A.R.A. (Associate of the R.A.)
	First colour print published
1931	A.R.E. (Associate of the R.E.)
1933	R.A.
	R.E. (Royal Society of Painter-Etchers and Engravers)
1936	P.R.W.S. (President of the R.W.S.)
1947	Knight Bachelor
1953 June 22	Cecilia's first sitting
1955	Senior R.A.
1960 Feb 2	Cecilia left
Dec 5	Cecilia returned
1962	Retrospective exhibition R.A.
1966 Aug 23	Cecilia left
1967	To South Africa
1968	To France
1969 Dec 27	Died

Bibliography

1920 Malcolm Salaman
 The Watercolours of W. Russell Flint, RWS, RSW (The Studio)

1928 G. S. Sandilands
 Famous Watercolour Painters (The Studio)

1942/3 Arnold Palmer
 More Than Shadows, A Biography of W. Russell Flint (The Studio)

1950 Sir William Russell Flint
 Drawings (Collins)

1951 Sir William Russell Flint
 Models of Propriety (Michael Joseph)

1955 Sir William Russell Flint
 Minxes Admonished; or Beauty Reproved (Golden Cockerel Press)

1962 Sir William Russell Flint
 Pictures from the Artist's Studio (Royal Academy)

1962 Royal Academy, Diploma Gallery, London
 Exhibition of Works by Sir William Russell Flint:
 Catalogue with extensive notes by the artist

1965 Sir William Russell Flint
 Shadows in Arcady (Charles Skilton Ltd)

1968 Sir William Russell Flint
 The Lisping Goddess (distributed: Frost & Reed)

1968 Sir William Russell Flint
 Breakfast in Perigord (Charles Skilton Ltd; distributed: Medici Society)

1970 Sir William Russell Flint
 In Pursuit (Medici Society)

1980 Ralph Lewis
 Sir William Russell Flint, (Charles Skilton Ltd)

1986 Keith S. Gardner and Nigel D. Clark
 Sir William Russell Flint, 1880–1969: a comparative (Bristol)
 review of the artist's signed limited edition prints